(LIKE HOME)

Published in conjunction with the exhibition
NO PLACE (LIKE HOME)
presented by the Walker Art Center
March 9-June 8, 1997

NO PLACE (LIKE HOME)
is made possible by generous support from The St.
Paul Companies, Inc., MCG HealthCare, Gary Fink,
Chairman, and the Elizabeth Firestone Graham
Foundation. Additional support has been provided
by the Walker Art Center Community Partnership Fund
with support from the Northwest Area Foundation.

Additional funding for the catalogue is made possible
by a grant from the Andrew W. Mellon Foundation in
support of Walker Art Center publications.

Copyright and Library of Congress Cataloging-in-
Publication Data are found on the last printed page
of this book.

cover images:
Clouds Photograph: Mark Tomalty / Masterfile
Housing Development Photograph: Steve Kahn /
FPG International

NO PLACE (LIKE HOME)

ZARINA BHIMJI
NICK DEOCAMPO
WILLIE DOHERTY
KAY HASSAN
KCHO
GARY SIMMONS
MEYER VAISMAN
KARA WALKER

WALKER ART CENTER
MINNEAPOLIS

NO PLACE (LIKE HOME)

CURATOR / RICHARD FLOOD
CURATORIAL ASSISTANT / DEEPALI DEWAN
CURATORIAL INTERN / EUNGIE JOO

DESIGNED BY / SANTIAGO PIEDRAFITA
EDITED BY / KATHLEEN MCLEAN
PUBLICATION MANAGER / MICHELLE PIRANIO

NO PLACE FONT designed by Matt Eller and Santiago Piedrafita

First Edition 1997 WALKER ART CENTER, Minneapolis

Printed in the United States by
DIVERSIFIED GRAPHICS INCORPORATED,
MINNEAPOLIS.

Distributed internationally by
D.A.P. /
DISTRIBUTED ART PUBLISHERS, INC.,
NEW YORK.

FOREWORD / ACKNOWLEDGMENTS

While we inhabit an increasingly interconnected world, it is one in which social, economic, and political boundaries are recalculated daily by both ancient and new definitions of home, history, and hierarchy. The specificity of individual cultures, too, is apt to blur as people and ideas move with increasing fluency. The artist's practice and mind have always been nomadic, selecting approaches and adopting sources without concerns for chronology or territory. And, yet, works of art also are made out of conditions in which an artist lives as well as his or her autobiography. This exhibition is an international one, involving eight artists who despite the geographic distance between them speak a common artistic language—a syntax composed of a space shared by the viewer and the thing made. Despite this common language of aesthetic methods, these artists create stories that are inextricably tied to the specific dramas of the places in which they have grown up and live, and the cultures they inhabit. As we move forward into a new century, there are lessons to be learned by these artists' ability to create meaning out of both global and local structures.

Museums that support contemporary art are posed with a difficult dilemma; compelling contemporary work is being made on every continent, yet ambitious exhibitions such as this one that involve commissioning new works by younger artists are exceedingly difficult to finance. We are extraordinarily fortunate, then, to be able to turn to funders who respond enthusiastically to our international mission and to our tradition of fostering artistic experimentation. These generous patrons understood they were supporting an expanding vision for the institution and the artists as well as our visitors. We greatly appreciate the magnanimous confidence of The St. Paul Companies, Inc., Gary Fink, Chairman of MCG HealthCare, and the Elizabeth Firestone Graham Foundation, without which this exhibition and publication would not have been possible. Additional essential support has been provided by the Walker Art Center Community Partnership Fund with support from the Northwest Area Foundation.

I also am extremely grateful for the scholarship and engagement of Deepali Dewan, Lila Wallace Curatorial Intern, who worked closely with Chief Curator Richard Flood in developing and realizing this exhibition. Richard's commitment to involving artists in the discussions concerning the place of culture in all our lives is boundless; his historical command allows him to move into the future with unusual grace and tenacity, providing artists with the appropriate context to take the necessary risks to develop new work. Few curators understand as well as Richard the imperatives of providing artists with the time and resources to move the experiments forward, from one place to another.

KATHY HALBREICH Director, Walker Art Center

NO PLACE

I would like to tender my heartfelt thanks to all those who have helped in the realization of this exhibition and publication. To the artists whose vision changes our understanding: Zarina Bhimji, Nick Deocampo, Willie Doherty, Kay Hassan, Kcho, Gary Simmons, Meyer Vaisman, and Kara Walker. To the lenders who shared work from their collections: Penny and David McCall, Ron and Ann Pizzuti. To the dealers whose cooperation was essential: Carolyn Alexander and Ted Bonin of Alexander and Bonin, Barbara Gladstone and Pirosjka Keersebilck of Barbara Gladstone Gallery, Helene Winer of Metro Pictures, Lisa Spellman of 303 Gallery, and Brent Sikkema and Michael Jenkins of Wooster Gardens. To friends and colleagues who shared information and linguistic skills: Clive Adams, Francesco Bonami, Manuel Gonzalez, and Claudio Guinzani. To the organizations involved in facilitating the work of Nick Deocampo: MOWELFUND Film Institute, Metro Manila Film Festival/Short Film Endowment Program, Formation Films Ltd., Channel 4 (London), and the Manila Film Festival Short Film Endowment Program. To those institutions that shared their visual archives: Haus der Kulturen der Welt, Berlin, Lannan Foundation, Los Angeles, Matt's Gallery, London, the Drawing Center, New York, and the Museum of Contemporary Art, Chicago.

Here at the Walker, my gratitude goes out to everyone who makes the museum the creative crucible it is. To our director, who gives permission and support: Kathy Halbreich. To my invaluable colleague on the construction and implementation of the exhibition: Lila Wallace Curatorial Intern, Deepali Dewan. To her irrepressible successor, Eungie Joo. To my fellow curators in the Visual Arts Department who conducted the artists' interviews with enthusiasm and insight: Liz Armstrong, Siri Engberg, Douglas Fogle, Kellie Jones, and Joan Rothfuss. To my colleague in the Film/Video Department, who also served as an astute interviewer and curated the Nick Deocampo retrospective, which is a component of the exhibition: Marlina Gonzalez-Tamrong. To the Film/Video Department's Artist-in-Residence, who provided a wonderful interview with Kay Hassan: Susan Robeson. To my assistant, who transcribed the lion's share of the interviews: Henrietta Dwyer. To the thoughtful and speedy translator of Kcho's interview: Adriana Sanchez. To the catalogue's wonderful, Brazil-bound designer: Santiago Piedrafita. To the very patient editor: Kathleen McLean. To the catalogue's production manager: Michelle Piranio. To our wonderful registrar: Gwen Bitz. To my advance guard in Program Services: Cameron Zebrun, Phil Docken, and Peter Murphy. To our tireless development director: Katharine DeShaw, and her coworkers Sarah Schultz and Aaron Mack. To my creative partners in the Education and Community Programs Department: Karen Moss, Diedre Hamlar, Michelle Coffey, and Craig Seacotte. To the exhibition's caretakers in the Administration Department: David Galligan and Mary Polta.

RICHARD FLOOD Chief Curator

(LIKE HOME) S H A D O W L A N D essay by Richard Flood

"Cut a chrysalis open, and you will find a rotting caterpillar. What you will never find is that mythical creature, half caterpillar, half butterfly, a fit emblem for the human soul, for those whose cast of mind leads them to seek such emblems. No, the process of transformation consists almost entirely of decay."[1]

Art is not life, nor was it ever meant to be. Art is, at its most elevated, that triumph of the cognitive animal over banal necessity. History is not experience, nor a mirror of experience. History is, at its simplest, what has been remembered, or misremembered, for the record. Art and history are not congenial; they don't lie to each other, but they are incapable of telling the same truths. They can both approach the truth, caress it a bit, but truth is something other, something that is neither expressive nor linear. Art and truth are, however, sympathetically conjugal and dwell in the many-chambered cave of life and history. *no place* is an exploration of that cave and its inhabitants. What it reveals is a whispering darkness where an occasional pulse of flame illumines that which we fear the most and that to which we aspire most dearly. It is a darkness inhabited by ghosts and infants, those who have passed over and those who have yet to bear witness or wear the stain of complicity. What light exists is provided by artists who, from the beginning, have transformed caves into civilizations.

1. Pat Barker, Regeneration (New York: Penguin Books USA Inc., 1993), p. 184.

The Duchess "I've done you so much harm in wishing to do you good."[2]

In 1823, a remarkable novel was published in France. Entitled *Ourika*, it purported to be the autobiographical account of a young Senegalese woman who, as a child, was rescued from slavery and subsequently raised in the bosom of the French aristocracy. The book is brief; the prose, eloquently spare. While the first of the San Domingo slave uprisings in 1791 and the French Reign of Terror, which began in 1793, play crucial roles in the narrative, history is not really the issue. Rather, *Ourika* is concerned with a shadowland that eludes the map of history — a place where souls are doomed to wander in search of the history that has escaped them.

Ourika was the creation of Claire de Duras, an aristocrat and a survivor of the French Revolution. Her book, which introduced the first Negro narrator in European literature, was an immediate best-seller. As slavery did not become illegal in the French colonies until 1848, it was also a pioneering work of abolitionist literature — a moral fiction. Duras' heroine was based on fact, but the sensitivity of the author's characterization transcends the limitations of imaginative reportage. *Ourika* is one of those extraordinary novas that illuminate the landscape over which they burn and presage that which is to come.

The tender eloquence with which Duras tells Ourika's story is more than a graceful act of literary imposture; it is a transformative rite of identification. While it is also tempting to view *Ourika*, by extension, as a meditation on the status of women, that would be to miss the greater achievement. Duras was a presiding member of the French Enlightenment, authored novels, maintained a salon in the Tuileries Palace, and served as an intellectual mentor to one of the era's greatest diplomats, Vicomte Chateaubriand. With the exception of the novel's narrator, the women in *Ourika* are liberated. The great achievement of the novel is that it gives voice to nothing less than utter loss. The hypnotic melancholy of Duras' heroine is more profound than self-pity; it is something vast and unchartable. *Ourika* crystallizes the unthinkable awfulness of those cast into the shadowland — of those forced to follow a road map that leads inexorably to no place.

"What did it matter that I might now have been the black slave of some rich planter? Scorched by the sun, I should be laboring on someone else's land. But I would have a poor hut of my own to go to at day's end; a partner in my life, children of my own race who would call me their mother, who would kiss my face without disgust, who would rest their heads against my neck and sleep in my arms. I had done nothing — and yet here I was, condemned never to know the only feelings my heart was created for."[3]

2. Claire de Duras, *Ourika*, trans. John Fowles (New York: The Modern Language Association of America, 1994), p. 46. 3. Ibid., p. 39.

The General "I am sending to France with all his family this man who is such a danger to San Domingo. The Government, Citizen Minister, must have him put in a very strong place situated in the center of France, so that he may never have any means of escaping and returning to San Domingo, where he has all the influence of the leader of a sect. If in three years this man were to reappear in San Domingo, perhaps he would destroy all that France had done there...I entreat you, send me some troops. Without them I cannot undertake the disarming of the population, and without the disarming I am not master of this colony."[4] General Leclerc, brother-in-law to Napoleon Bonaparte and commander of French forces in San Domingo

In 1803, a scant few years after Ourika's fictional death, a real exile died at Fort-de-Joux high in the Jura Mountains along the French-Swiss border. The exile was Toussaint L'Ouverture, the Creole son of an African-born slave and the leader of what would, after his death, become the first successful slave rebellion in the New World. He was fifty-seven years old and a loyal son of France. He died believing in the Rights of Man promulgated by the Revolution and in the man who murdered him through aggressive neglect—Napoleon Bonaparte. Fort-de-Joux was L'Ouverture's "no place." To the end, L'Ouverture believed that Bonaparte would negotiate in good faith, and as an equal, for the freedom of the slaves of San Domingo. Bonaparte, of course, had no intention of upsetting the machinery of slavery and simply sought to silence its most eloquent opponent. At Fort-de-Joux, shamed and separated from all he held dear, guilty of no crime that would warrant a trial, L'Ouverture wrote from his heart to Bonaparte asking for release from the historical cul-de-sac to which he had been condemned.

"I have had the misfortune to incur your anger; but as to fidelity and probity, I am strong in my conscience, and I dare to say with truth that among all the servants of the State none is more honest than I. I was one of your soldiers and the first servant of the Republic in Santo Domingo. I am to-day wretched, ruined, dishonored, a victim of my own services. Let your sensibility be touched at my position, you are too great in feeling and too just not to pronounce on my destiny . . ."[5]

There was to be no justice for L'Ouverture in the shadowland. Perhaps, at the end, he took heart from the words he had pronounced to the captain of the boat sent to remove him from his Caribbean island to France: "In overthrowing me, you have cut down in San Domingo only the trunk of the tree of liberty. It will spring up again by the roots for they are numerous and deep."[6] The tragic irony of L'Ouverture's defeat was that the very citizens of France with whom he believed he shared a vision could not, by and large, accept the loss that honoring the vision would entail. It was, after all, the growing bourgeoisie who fostered and funded the French Revolution, and their continued welfare was deeply and profoundly interwoven with the slave trade. Even as the Revolution brewed in France, thirty to forty thousand slaves a year were still being fed into San Domingo to reap ever greater harvests in trade, harvests that spread the wealth not only in France but throughout Europe.

Historical fact tells us that, in the twilight of the eighteenth century, there were half a million slaves on the island of San Domingo, the majority of whom were native Africans. The recent arrivals were often at odds with their Creole predecessors and both were at odds with the mulattos. Occupying neither world, the mulattos were subjected to the caprices of eugenic classification (there were 128 shades of color culminating in the *sang-melee*, who was composed of 127 parts white, 1 part black, and classified as black) and the whimsy of those who could offer or deny them freedom. It was a system that promoted self-loathing and hubris in equal portion. To be robbed of one's essential identity, and then blamed for the loss by the one who has robbed you, was perhaps the cruelest practice in a litany of atrocities enacted by the French overlords.

L'Ouverture sprang from the fatally abundant soil of San Domingo and formed an army that would, in his wake, topple the French rule and lead to the creation of Haiti, the first black state in the New World. L'Ouverture was, however, much more than a brilliant insurgent; he was a man of the Enlightenment and he believed that he was fighting for the universal rights of man. Had he been less of a man, he might well have survived to realize half of his dream. As it was, that which made him great also destroyed him.

4. C.L.R. James, The Black Jacobins: Toussaint L'Ouverture and The San Domingo Revolution (New York: Random House, Inc., 1963), p. 336. 5. Ibid., p. 364. 6. Ibid., p. 334.

The President "The whole commerce between master and slave is a perpetual exercise of the most boisterous passions, the most unremitting despotism on the one part, and degrading submissions on the other."[7] Thomas Jefferson, Notes on the State of Virginia

One of the most chilling moments in *Ourika* comes when its narrator learns of the first massacre of the white planters by the San Domingo slaves and repudiates her own race, a race she knows nothing of. Later, at the height of the Terror, surrounded by her beleaguered white protectors, Ourika has a horrible epiphany that seals her fate as surely as L'Ouverture's idealism sealed his. "In any case," she reflects, "all the world was miserable, and I no longer felt alone. A view of life is like a motherland. It is a possession mutually shared. Those who uphold and defend it are like brothers. Sometimes I used to tell myself that, poor negress though I was, I still belonged with all the noblest of spirits, because of our shared longing for justice."[8] But, alas, Ourika had by then become a shadow and shadows cannot act; they are merely insubstantial echoes of that which they mimic.

Ourika, the metaphor, and L'Ouverture, the reality, are both seared by drawing too close to the tri-part flame of *liberté, egalité, fraternité*. Shaped by the pen and scarred by the brand, neither ever had the possibility of escaping from the shadowland to see the fullness of themselves reflected in oneness with those whose reality they could only dream into being. The irony is that their dream had been constructed by others less generous than themselves—others whose moral order depended on the extension of the promise and whose economic order necessitated the denial of the promise. The contradiction in it all is bluntly caught in Dr. Samuel Johnson's questioning taunt: "How is it that we hear the loudest yelps of liberty from the drivers of Negroes?"[9] The tragedy in it all is made devastatingly clear in the words of America's greatest advocate of the Enlightenment, Thomas Jefferson: "I tremble for my country when I reflect that God is just."[10] Jefferson (framer of the Declaration of Independence, American ambassador to the Court of Louis XVI, and third president of the United States) was, at the time of his death in 1826, one of the largest slaveholders in the state of Virginia.

7. Stephen E. Ambrose, Undaunted Courage: Meriwether Lewis, Thomas Jefferson, and the Opening of the American West (New York: Simon & Schuster, 1996), p. 35. 8. Claire de Duras, p. 23. 9. and 10. Stephen E. Ambrose, p. 449.

The Curate

"The procession went on, amid that mixture of rites that characterizes idolatry in all countries — half resplendent, half horrible — appealing to nature while they rebel against her — mingling flowers with blood, and casting alternately a screaming infant, or a garland of roses, beneath the car of the idol."[11]

Two years before the death of Thomas Jefferson, Charles Robert Maturin, the Anglican curate of St. Peter's Church in Dublin, Ireland, died of an accidental dose of poison. He was forty-four years old and the author of the last, epic Gothic novel, *Melmoth the Wanderer*. Maturin was Irish (and a nationalist) but came from a Protestant family that had fled France after the Edict of Nantes was reversed and persecution of the Protestants began once more. His novel is a giddy orchestration of ever-mounting horrors within a rat's nest of related stories, all of which are driven by the dementia induced by otherness. Woven through the novel are narrative strands dealing with Thomas Cromwell's subjugation of Ireland and the Roundhead confiscation of Irish-Catholic properties, the nightmares of Bedlam at the height of the English Restoration, and the persecution of Jews and dissidents by the Spanish Inquisition. Everything is overheated and very little is without historical precedent. Maturin had, for example, seen in his own lifetime the long-dormant Spanish Inquisition brought back to papacy-sanctioned life in 1778, and felt the sympathetic, anti-British shock waves that respirated through Ireland during the heady first year of the French Revolution.

While *Melmoth* seethes with all the high discordancy of the Gothic form, it has a noble gravity missing in other examples of the genre. Its protagonist, the Wanderer, is doomed to be an exile from all that he knows, and it is his exile that Maturin designates as the novel's greatest horror. Maturin was a child of the Enlightenment and while Gothic (in its anti-rational hystericalization of all incident) would seem, on the surface, to be an absolute contradiction to the goals of Enlightenment, it served Maturin's humanist concerns quite nicely. The unspeakable despair of a man who belongs nowhere, whose life is an endless search for a resting place, further led Maturin to write one of the century's great soliloquies of the dispossessed: **The terror that I inspired I at last began to feel. I began to believe myself—I know not what, whatever they thought me. This is a dreadful state of mind, but one impossible to avoid. In some circumstances, where the whole world is against us, we begin to take its part against ourselves, to avoid the withering sensation of being alone on our own side.**[12]

11. Charles Robert Maturin, Melmoth the Wanderer (University of Nebraska Press, 1961), p. 223. 12. Ibid., p. 123.

The Marquis "In Marseilles, he had himself whipped, but every couple of minutes he would dash to the mantelpiece and, with a knife, would inscribe on the chimney flue the number of lashes he had just received."[13]

Not so curiously, one of Gothic fiction's most rational supporters was the Marquis de Sade (to admire him, wrote Georges Bataille, "is to diminish the force of his ideas.")[14] For de Sade, who briefly profited from the Reign of Terror when he was freed by the mob from the Bastille, the Gothic novel evidences "the inevitable fruits of the revolutionary shocks felt by all of Europe. . . . For those who know all the miseries with which scoundrels can oppress men, the novel became as difficult to write as it was monotonous to read. . . . It was necessary to call hell to the rescue . . . and to find in the world of nightmare the history of man in this Iron Age."[15] While it would be difficult to advance de Sade as a model representative of the Enlightenment, he was certainly a recipient of its "fruits" and a disenfranchised member of its aristocratic originators. Certainly, in his sense of victimization and authorial role of victimizer, he understood the consummate perversity of master/slave relationships better than his more idealistic peers. Georges Bataille, in his essay "De Sade's Sovereign Man," quotes Clairwill, one of de Sade's most ticklish fictional inventions: **"I'd like to find a crime that should have never-ending repercussions even when I have ceased to act, so that there would not be a single instant of my life when even if I were asleep I was not the cause of some disorder or another, and this disorder I should like to expand until it brought general corruption in its train or such a categorical disturbance that even beyond my life the effects would continue."**[16]

Here, truly, is the demonic understanding of how the well of reason is poisoned and of the monstrous implications when others, namely "we," drink its putrescence. In his summation of de Sade's frightening contribution to Western thought, Bataille states it all quite clearly: "And if today the average man has a profound insight into what transgression means for him, de Sade was the one who made ready the path. Now the average man knows that he must become aware of things which repel him most violently—those things which repel us most violently are part of our own nature."[17]

13. Georges Bataille, Erotism: Death & Sensuality, trans. Mary Dalwood (San Francisco: City Lights Bookstore, 1986), p. 194. 14. Ibid., p. 179. 15. Charles Robert Maturin, p. 15. 16. Georges Bataille, p. 174 Ibid., p. 196.

e road to Casablanca is fogg

nside a movie house we watch

ogart

lays

our f

y las

The Poet

"Toussaint, the most unhappy man of men!
Whether the whistling Rustic tend his plough
Within thy hearing, or thy head be now
Pillowed in some deep dungeon's earless den;—
O miserable Chieftain! where and when
Wilt thou find patience! Yet die not; do thou
Wear rather in thy bonds a cheerful brow:
Though fallen thyself, never to rise again,
Live, and take comfort. Thou hast left behind
Powers that will work for thee; air, earth, and skies;
There's not a breathing of the common wind
That will forget thee; thou hast great allies;
Thy friends are exultations, agonies,
And love, and man's unconquerable mind."[17]

William Wordsworth, "To Toussaint L'Ouverture"

ou s

hat

ll w

ou t

he i

hen

William Wordsworth, the greatest of the English Romantic poets, died two years after the abolition of slavery in the French colonies and eleven years before the start of the American Civil War. By the time of his death, San Domingo had been the black republic of Haiti for forty-six years and Bonaparte had long been toppled and lay buried in his own island "no place," Elba. Wordsworth's tribute to L'Ouverture is filled with eloquent promise and the implicit acknowledgment that what L'Ouverture fought to attain is within reach. It was not, nor is it today.

What we are looking at in *no place (like home)* are artistic responses to legacies born centuries ago and oceans away to parents we never knew. The legacies—colonialism, slavery, cultural and physical displacement—received some of their worst interpretations and the proposal of some of their most eloquent solutions in what Charles Dickens called "the best of times and the worst of times," the eighteenth century. The most fluorescent heritage of the age of Enlightenment—the Rights of Man—was forged by the French Revolution and put to savage use during the Reign of Terror. But, once the guillotine was stilled, nothing much seemed really changed. Instead of a Bourbon king, France raised a Corsican emperor.

Now, in 1997, the progress toward a new age of *liberté, egalité, fraternité*—convulsive as it has been—still seems modest. L'Ouverture's tangled roots have put forth only the plainest of leaves, hardly the vibrant hybrid prophesied by the bloodied frenzy of cultivation. We have, as a civilization, washed up at no place in particular as the road to true Enlightenment has proved more treacherous than ever anticipated. And, while art is far too fragile a creation to significantly alter the course of history, it can allow us, if only for a moment, to draw perilously close to an understanding of what history and life have done to those fellow pilgrims we share it with.

There

No ha

Those

In t

Beca

In a

I re

And

Lure

And

(Eve

To see in movies what I cannot see in life!)

17. M.L. Rosenthal, J.J.M. Smith, Exploring Poetry (USA, The MacMillan Company, 1955), p. 622.

ARTIST INTERVIEWS

ZARINA BHIMJI
NICK DEOCAMPO
WILLIE DOHERTY
KAY HASSAN
KCHO
GARY SIMMONS
MEYER VAISMAN
KARA WALKER

D PLACE

[LIKE HOME] **Zarina Bhimji** interviewed by Deepali Dewan 7/29-30/96

Zarina Bhimji's work is a process of excavation. The body and the body's interactions with systems of power and access in
its daily environment are sites from which she begins to unearth the unspeakable, and the often unnameable.
Her inspiration is often drawn from anything that may spark her persistent and inquisitive mind—a book, an
image, a gesture, an emotion. Yet what she takes away is her own. Her work is a carefully orchestrated collage
of these artifacts and ideas distilled into a deeply personal utterance. Bhimji is the product of two diasporas:
her parents moved from Gujarat, a state in northwestern India, to Uganda, where she was born. African by
birth, she was raised in an Indian household. When Bhimji was eleven, the civil war caused her family to leave
Uganda and move to England. In her work, multiple currents cross; it draws specifically from her East Indian,
African, and British backgrounds, and in general from the experience of multiplicity, a metaphorical sense of
displacement. These experiences, although sometimes working their way directly into the subject matter, more
often than not inform the way she looks at things and how she processes the information received. In July, I
was able to talk with Bhimji over the course of two days at various locations around London.

DD: The body plays a central role in your work, whether it be the subject of your images or implied through more indirect
means. In your work there are recurring motifs such as hair, which you have discussed in depth elsewhere. The breast is another.
ZB: I've been interested in the breast for a long time. There's one at the front of the catalogue for the Ikon Gallery show.
DD: The breast with the hair?
ZB: Yes. I think it is completely different, for example, from the breast in the Photographers' Gallery show. I started off
thinking about a bowl with a sieve, like the one in my kitchen, because I was looking for a metaphor for nipple, and the sieve
was the only thing I could think of as a metaphor for the way the breast was made. The piece at the Ikon Gallery is more quiet or
a more affectionate form for what I wanted to say about the breast. I started reading Melanie Klein's *Envy and Gratitude*,
where she talks about the mother/child relationship with the breast, how there is a love/hate relationship with it; on the one
side the child is dependent on the breast, and on the other, it is carnivorous and wants to destroy it. I then started thinking
about debates about pornography and how the breast is used to advertise, how it is sexual. And when I started making the
piece for the Photographers' Gallery, I remembered looking in anthropology books as a child where women's breasts are very
conspicuous; I often thought that the way the breast was photographed in magazines was very similar to the way Melanie Klein
talks about the child's relationship with the breast—it loves it, but wants to destroy it. I then started reading *Erotism* by
Georges Bataille—which is about states of religion and passion, as if one is high. I felt that the anthropologist had that sort of
relationship with, for example, the African woman.

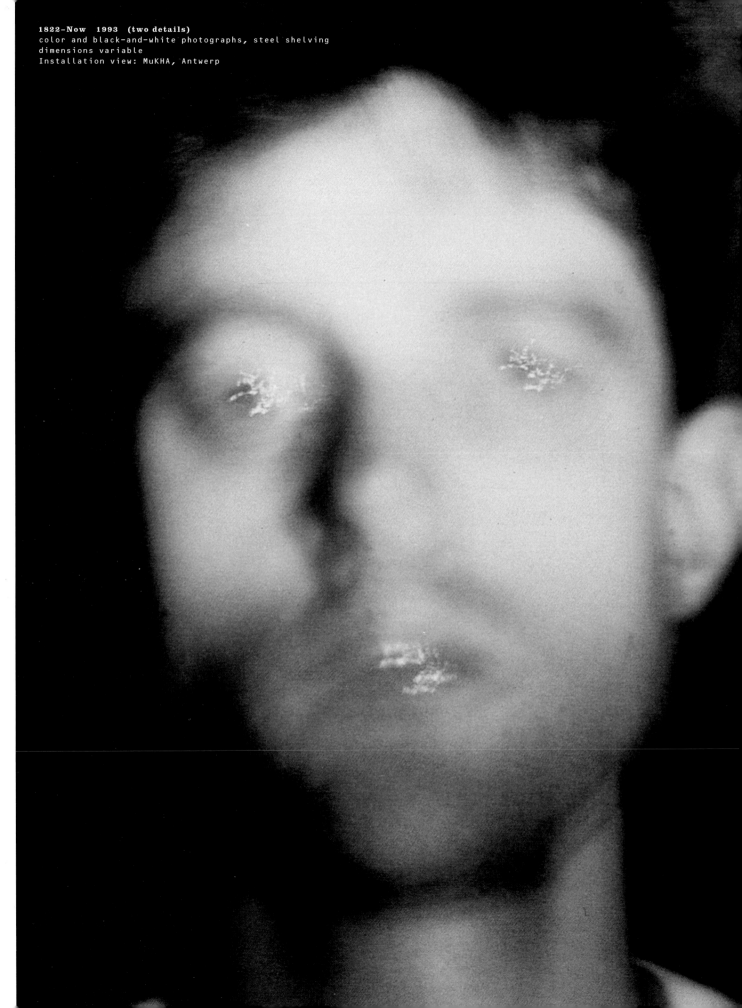

1822–Now 1993 (two details)
color and black-and-white photographs, steel shelving
dimensions variable
Installation view: MuKHA, Antwerp

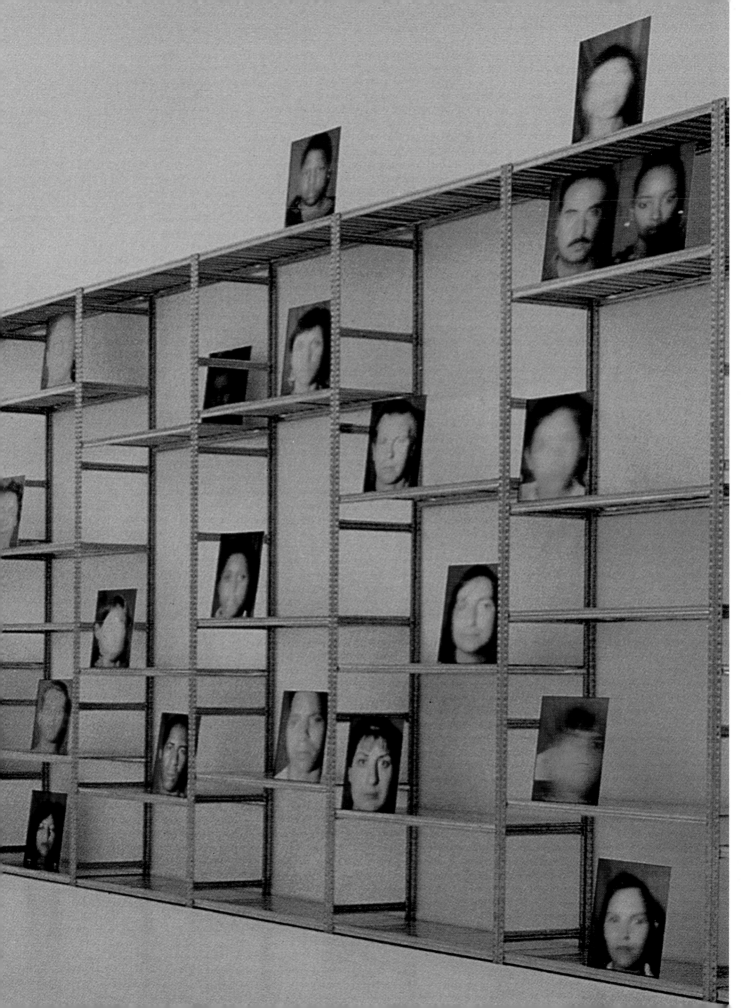

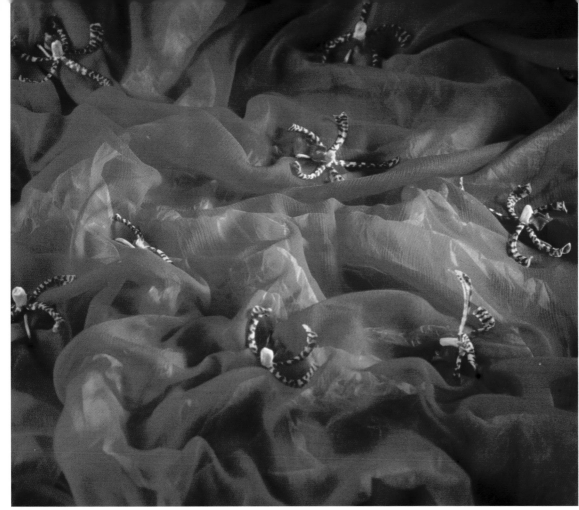

Listen to the Room
1994–1995
cibachrome transparency,
light box
30 x 40 x 9.6 in.
Collection Charing Cross
Hospital, London

Words shred
and splinter 1995
cibachrome transparency,
light box
30 x 40 x 9.6 in.
Courtesy Autograph,
the Association of Black
Photographers, London

DD: And the image shown at the Photographers' Gallery is a black woman's breast?

ZB: Yes, it was from a pathology museum. It had been stabbed and that affected me a lot. But instead, what I wanted to try and talk about, in part, was the seduction element in the relationship between the anthropologist and the body through the metaphor of food. That is, when one eats exotic fruit, it leaks and is delicious; I wanted to try and speak about that as I imagined how the anthropologists feel about the body.

DD: Even the photograph of the dark fruit between the white sheets looks like the breast of a woman of color, but it is very enticing, too. It's set up so that it is very aesthetic.

ZB: It is a fig. To me it suggests a young breast.

DD: Can you talk about your residency at Charing Cross Hospital in London where you photographed in its pathology museum? Did the jars with the body parts have labels identifying where they had come from?

ZB: What I wanted to do was explore my interest in the body in terms of vulnerability and fear. Four light boxes of images of body parts photographed in the pathology museum were exhibited in the corridors of the hospital outside a dissecting room in a no-public-access area. An additional four light boxes of abstract still lifes were exhibited in the public area of the hospital. The museum had a filing cabinet that you could go to and look at the evidence for what it was, but I didn't really want to know. Like these feet—if you look at them, they are incredible, if you've got a strong stomach. They were small and they looked like paper. I didn't bother to find out about any of those, but I wanted to know about the breast. I was really pleased, actually, when I saw the breast, because I felt like it was the only thing there that had something to do with me in terms of issues in which I was interested. Although I was terrified of the institutional power it implied, I was happy to find it. And there was nothing else with brown skin in the pathology museum, and I've been obsessed with the idea of brown skin.

DD: What was the relationship between the abstract still lifes on public view and the more graphic images of body parts that were kept away from public view?

ZB: The titles were connected; a work on public view was connected with a work by the same title away from public view, creating four pairs of images. The images from the pathology museum were more about truth. The works downstairs on public view were about visceral qualities of the body, about leakage, like when the body is sick. I wanted to set up a debate between the staff. They viewed their job from a detached perspective—like it was cooking, or carpentry—although you need that detachment to do such a job. So when they came out of the dissecting room into the corridor, away from the rational, intellectual space of the job, they would become more aware of the human element of the body.

I also wanted to introduce the element of pleasure, to question the detachment. The images on public view dealt with similar ideas, but were more beautifully done. The subject was life: flowers, like tulips. Yet one is not completely comfortable—the tulips are decaying, the red cloth is like a pool of blood in the hospital context.

DD: The photographs of the body parts are very haunting, and I can imagine the effect they must have had being on display within the context of the pathology museum; the blown-up, luminescent photographs call attention to the very thing the pathology museum is about.

ZB: It is interesting that even though the people at the pathology museum look at such images all the time, they didn't want the photographs in the dissecting room.

DD: They can deal with these things every day in the jars, but the pictures add a discomforting sense of awareness.

ZB: Yes, because in reality the light boxes are big, and when the image is blown up it changes. And also the form I used made the image warmer—I gave warmth to the dissected foot.

DD: So the awareness that this was once attached to someone's body was more apparent.

ZB: It is the isolation that is familiar. While they are operating, say on the back of the neck, the whole rest of the body is covered.

DD: Do you think the photographs work as well outside the context of the pathology museum? For example, a few of those light boxes were displayed in the Guggenheim's show on contemporary African photographers. How do you think the different context changed their effect, if at all? How were they received?

ZB: The context changes and they are read differently. In the hospital they looked less beautiful. I was able to relate to the gallery space easily.

DD: In all the photographs that you did for the Photographers' Gallery and for the public part of the pathology museum display, there is a sumptuousness, whether it is in the luxurious materials you use or the colors you choose, which are very dark and rich. Even the objects you photograph, such as flowers, have a sumptuous quality to them that is opposite their decayed condition when you photographed them.

ZB: I like to photograph things that are familiar and give them a charged feeling. There are many levels, but usually only certain aspects are exposed. I am interested in speaking of that which it is hard to speak about. Also, I am very inspired by literature that is quite intimate in the way it will describe something. I tend to read particularly authors like Michèle Roberts and Marguerite Duras. There is an intimacy in the writing so that you can almost feel the details from the way they are described. It is a real kind of pleasure involved. What I'm saying in my work, in terms of the subject, is harsh, and so there is a part of me that feels that art should be pleasurable. Something about having pleasure is important.

DD: What does the date 1822 refer to in the installation *1822 – Now*?

ZB: It is the starting point of eugenic theory, the point to which I traced it back. In 1991 (I made *1822 – Now* in 1992), there were loads of demonstrations going on with the Nationalist Party in Great Britain, and sets of organizations that were opposed to other cultures and wanted a pure sense of Britishness. One day, while I was driving to see a friend, this person from

left:
Listen to the Room **1995**
cibachrome transparency, light box
30 x 40 x 9.6 in.
Collection Charing Cross Hospital, London

above:
We are cut from the same cloth **1995**
cibachrome transparency, light box
30 x 40 x 9.6 in.
Collection Charing Cross Hospital, London

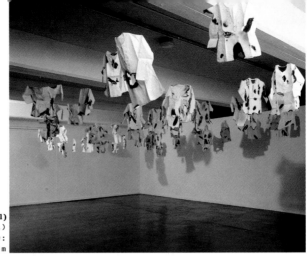

28

the Nationalist Front Party came with a crowbar to the car and I instantly ducked. Nothing happened, but I was quite freaked by it and so I started reading about the desire for a pure race and what it is about. Francis Galton, one of the main writers on eugenics, started his research in 1822. That is where the title comes from. Loads of materials about eugenics were set around that period which reinforced the desire for a pure breed and the protection of what was defined as the strongest breed, that it grow and not mix. At the library in Cambridge there is shelf after shelf of books on eugenics, in an area that actually is not open to the public. I wanted access to the tools they had used for measuring the brain and the head. I wanted to expose privilege.

DD: What did you want to achieve in the photos by doing half-hour exposures of each face to create a blurred effect?

ZB: I had been reading a lot about Julia Margaret Cameron, the nineteenth-century photographer, and how she talked about capturing the soul with her photography. Images of people's faces are often like a passport; people assume a certain face in front of a camera. With a half-hour exposure, I wanted to take that away because, in that time, they would forget and start to think about other things. In eugenics, there is a classification of facial features. I wanted to answer that in the blurriness, that is, to get away from that kind of ideology of classification. At the same time, I also like something about blurry techniques. The viewer then needs to really think about what is there. They need to piece it together themselves. It is unannounced; the decision is not made for them. In theories of eugenics, everything is classified. And when you start talking about people of mixed race, they don't have a space in that ideology. They both defy definition and begin to define something else.

DD: In all of your work, even the installations that used other materials, photography has always been the constant.

ZB: I like using the camera. When I look into it, I can see that it expresses the way I think, which I don't seem to get with other materials. I've been asked to make a film, which I'm a bit anxious about because I did make films before and I stopped that. I used to hate photography—I had a difficult relationship with it. And I'm talking not theoretically but just with the process. But since I've started making light boxes, I've felt like I'm on to something. A light box seems to satisfy me a lot more. The other thing is that when you are in a group show, you can't always make an installation, you have to make a single image and it has always been difficult to make just a photograph. But making light boxes seems to answer that—it's not flat. And color is very important to me. Black-and-white photography has become less important.

DD: Can you talk a little about being in Uganda and the process of coming here?

ZB: My father came to Uganda from Gujarat when he was fourteen. He had a store in Uganda. When the civil war started, we were not able to go out and didn't know what was going on because the curtains were always drawn. Two years after the civil war, in 1974, I arrived here at age eleven.

DD: Was the Guggenheim show of contemporary African photographers in which you participated a turning point in terms of thinking about yourself as "African"?

ZB: No, I've always thought I was.

DD: So where does India fit in, or did it fit in, or did it matter?

ZB: Well, it did matter. Culturally I was brought up as Indian. At the same time, I'm very different from Indians in India. And I like the idea of being Ugandan.

DD: I am also interested in how you choose to put together the materials for your still-life photographs. Can you talk a little bit about that process?

ZB: Well, in this photograph, for example, the flowers were fresh tulips when I started off. I spent three, four days in the studio trying to get it right. And on this photograph with the orchids, I spent one day. At first it didn't work so I cut them because straight orchids were too pretty. It looked too much like a shot for a magazine. And that is a danger and problem with photography. I want more to try to express what I feel internally. And what I like about photography is that I can manipulate the effect by the type of lens I choose.

The stuffed peacock is from a private house in West London. You don't notice it when you go upstairs, but when you photograph the thing, it is all you see because it is all you remember. Also, because the light box is huge, it is illuminated and the peacock seems actual size. The title is *Armour* and the work is all about layers of disclosure. People have things at the entrances of their homes, like ornaments, that act like armour. At the entrance, the ornaments say who they are.

DD: You were talking earlier about gathering things in your studio and things out of books. I keep thinking back to the Ikon Gallery installation, *I will always be here*, where you used partially burned shirts as part of the installation. But you also had the photograph of the burned shirt in another part of the installation. How do you come to choose what you want to

photograph as a photograph and what you want to use as actual objects in the installation?

ZB: Well, when I tried to photograph it, it didn't say what I wanted it to say. I was interested in this feeling of loss and the photograph didn't say it truly. So I just kept going at it. And finally I knew I had arrived. When I put the work up it freaked me out. The shirts are in a room suspended in the dark. It was like they were birds trying to get out of the door, because they were hung wide on one side and reached to a point, the way birds fly in the sky. And that was in fact inspired by the book *The Poetics of Space*, where they talk about wardrobes and spaces. I was amazed when I first read that because I remember hiding in the wardrobe as a child, and the thought of someone writing an essay about that is incredible to me. The idea is that the shirts had all flown out of the wardrobe like angry children.

DD: The idea of childhood . . .

ZB: I have been thinking about going to Uganda and taking aerial shots of the places my father talked about when I was a child. It is funny how someone names a place and, as a child, you create your own art around it. So I was thinking of going back to it. But, I've been thinking about it more from a distance, about how I was there and now I'm not there, I'm here.

In Uganda, what I did at school was one thing and as soon as I came home I changed into Indian clothes, ate with my hands, ate Indian food, spoke a different language. And I suppose what I do with the work is that I start with myself, but I like to consider the context it is in. What I was thinking is taking images of blurred architectural details. It is important about it not being specific. I think it is about loneliness and separation. And it is about surveillance as well. I want the aerial landscapes to be panoramic. They could look like airports, or bunker spaces. Airports have a significance because of having to do with immigration, and escape, getting out. I want it to have to do with that edge.

I keep looking at this [archival] image from a book written by someone who traveled to Uganda. What I'm interested in is the way these two guys are standing, and also the landscape in the background, and that they might be dead now. When I look at this image, it evokes. . . . I haven't even articulated it. That's why I keep it around. I don't know. It's something about what they are wearing, their relationship to each other, the fact that it is early morning and they are alone with the landscape.

(LIKE HOM**Nick Deocampo** interviewed by Marlina Gonzalez-Tamrong 8-9/96

During the last years of the Marcos dictatorship, a generation of Filipino alternative media artists emerged who needed to find venues of self-expression outside government control and censorship. Weighed down by the urgency to resolve (even in their lifetime) the unfinished business of unraveling and healing the deep damaged caused by six centuries of cultural homelessness, these artists developed a counter-cinema. They encouraged a new Filipino filmic language that challenged the easy linear structures popularized by the tabloid news, the noon-time radio soaps, and the "bomba" films (a genre of Filipino exploitation films).

Nick Deocampo was one of the strongest voices, if not the leading exponent, of this wave of counterculture. Grainy, seamy, dark, ambient, noisy, confusing, crowded, his films and tapes—shot in Super-8mm, 16mm, 35mm, and small-format videos—are unflinching portraits of a country stricken with poverty, pollution, overpopulation, and the hopelessness of the *bahala na* (come what may) mentality that comes with internalized colonization. Amid such social turbulence and in conditions of extreme poverty, the body is the only place one can call home; it is, in the end, the only mechanism left for economic survival. The following is the result of interviews conducted in English and Tagalog by phone and fax in Bangkok, Manila, and Minneapolis in summer 1996.

MGT: Cultural and social displacement seem to be recurring themes in your work. Is this a conscious decision on your part?

ND: Displacement has been a theme in many of my films. I do acknowledge it was a conscious effort insofar as my films have become my way of understanding the realities that surround me. Philippine society has been in a state of flux since the time I started as a filmmaker. Around me displacement happened in all levels of social life—physical, political, economic, cultural. The 1980s was a turbulent decade in Philippine history—[the country was] caught up in a dramatic divide between dicta-torship and democracy. My films have become documents of that tumultuous transition that put a face to every experience of poverty, repression, revolution, and hope.

In a decade, I realize, I have survived three regimes: those of Ferdinand Marcos, Corazon Aquino, and Fidel Ramos. Considering the social upheaval which marked our struggle for change, I made a conscious effort to record the experience of living dangerously and surviving with dignity.

My films have always been about people displaced—prostitutes, homosexuals, the poor, women, children, student radi-cals, artists, natives. Displacement has been a way of life for these marginalized peoples. Their bodies have become instruments by which they survive. Gender lines have been transgressed as moralities of gender are sacrificed over functionalities of sex. In turn, streets have become homes because homes have turned into battlegrounds. Fathers have become tyrants and children become their murderers. This is the social tapestry that has become embroidered in my films.

Throughout my films, one can see and hear a deliberate effort in making sense of the events which I know will be lost in Film stills from **Oliver** **1983** Super-8mm 45 minutes time. My films are a coming together of the social narratives being spun by society. Through them I make my personal intervention hoping, even with my own self, to find meaning in the chaos that has engulfed our lives.

MGT: Filipino independent filmmakers like yourself make feature-length Super-8mm films or short 35mm films, a seeming opposition to American or European use of such formats. Pure pragmatism or a "choice of weapons?"

ND: Pragmatism and subversion have become strange bedfellows in my filmic practice, from the use of formats (whether Super-8mm, 16mm, or 35mm) to the choice of genres or viewing intentions. The use of Super-8mm at the start of my career could only be pure pragmatism that created an even more effective use as it subverted the form and functionality identified with the small format. Now, I find it hard to imagine how I was able to contain in the small-gauge Super-8mm an epic narrative of our transition from dictatorship to revolution told in a trilogy that lasts for almost three hours. (*Oliver, Children of the Regime*, and *Revolutions Happen Like Refrains in a Song*).

What started as pragmatism in the choice of medium resulted in a subversion of forms which paralleled the use of the same medium by guerrilla filmmakers in Latin America. Indeed, Latin American filmmakers have become more effective influences in my use of the medium than the Americans and the Europeans.

MGT: Talk about the differences and/or similarities in the way American, European, and Asian audiences read your works.

ND: It is hard to talk about those differences and similarities. It was in Europe where I first received notice — understandably, because my formative years as a filmmaker were spent in Paris and Berlin. I studied in the atelier where Jean Rouch held great sway in the pedagogical formation of filmmakers. Documentaries, instead of Hollywood entertainment, were my first staple film fare. Encounter with reality rather than creating filmic illusion was my early challenge. Social engagement rather than profit, and popularity and independent filmmaking rather than commercial filmmaking have become abiding forces in my film practice.

As such, my films have created greater resonance in the cities of Europe through my screenings, from Paris to London, Berlin to Belgium, Bilbao to Rotterdam. In many of these European screenings, the viewing experience has always been serious, with a determined effort on the viewers' part to go beyond the illusion of cinema into an understanding of the reality the film tried to capture.

It was a few years later when I was a student at New York University that American festivals started noticing my films. On two circuits my films found much attention: festivals for Asian and gay films. In America it seemed like a film had to be defined first by its race, gender, or politics for it to find an audience (in short, branded first as a "gay film," "a black film," "a feminist film"). This is something which I did not find to be very strong in the selection and appreciation of films in Europe. Branding was not so much the issue as experimenting with the film being shown.

In Asia, reception of my films is still in its exploratory stage. Although my films are coming to be the most sought after in several Asian festivals, this may have happened because of the reputation my films may already have earned in the West. Asian people take time to adjust to films like mine because of the explosive themes, confrontational attitude, and no-holds-barred style of filmmaking. Knowing the Asian nonconfrontational attitude, my films are shown and presented as radical efforts appreciated mostly for their candidness. But for a mainstream audience, the many who are still under the spell of commercial, narrative cinema, my films may have difficulty in being appreciated even in my own country.

MGT: *Oliver* was your first film and yet this has become a seminal work, at least as American scholars and critics have written about it. How did you stumble upon Oliver?

ND: Meeting Oliver was one of the important turning points in my life. Unable to finish a film on child prostitution which I started much earlier, I looked for a subject for a film that I could work on after I came back from Paris. In 1982, I met Oliver in a gay bar and after watching his impersonation shows, I knew he was the person I was looking for. My first talk with him led to an interview and finally the making of the film, which lasted for ten months.

The reason I was drawn to Oliver was because of the way he symbolized all that we were during the time of the dictatorship. His acts of denial of his poverty and gender became a replica of the social repression happening in the society he was living in. Most of all, his "Spiderman" act—a dance in which he spins a web on the dance floor with a ball of thread from his anus— was a metaphor for the kind of life Filipinos were going through. Day in and day out, the people spun their thread without knowing they were getting entangled with it. Consciously or not, Oliver symbolized, in that act, the horrors of living under the dictatorship. But with what grace! What courage!

MGT: The body is often the focus, especially of the plots of the "bomba" films that began to emerge in the 1970s. In *Oliver* and *Children of the Regime*, the body is homeless, pushed beyond the limits, like a piece of clothing so worn from use that it's frayed at the seams. Your films also have this frayed look.

ND: My films have a frayed look, yes, but how can they be otherwise without betraying the commitment that ought to go with films touching such sensitive topics as child prostitution, homosexuality, and poverty. They look frayed because the subjects are frayed at the seams of society. The condition of production is frayed (meaning, a no-budget production). The medium, Super-8mm, is frayed because it is noncommercial. In short, and in a McLuhan sense, my medium was consistently my message.

MGT: Your views on gay issues have been controversial in the West. So have your views on feminism. You have maintained that these views are culturally different in the Third World. I agree with you. Prostitution, for example, is more than a choice of lifestyle; it is often the only economic recourse. This is clearly evident in *Oliver*.

ND: Without meaning to be controversial, I found myself defending the lifestyles of prostitutes (like those of Oliver and the children), only because I made a case out of their being human beings first, deserving of their rights, rather than condemning them for the morality of their acts.

Survival offers a terrain that has unpredictable contours. Prostitution becomes an act of survival for the likes of Oliver, the children, or women because of social displacement. They become bodies in unmapped territories of desire and commerce. In a Third World context where economic options are few, choice of lifestyle becomes a luxury. People like Oliver have only their bodies to survive on as instruments of production. Orthodox feminism may find contradictions governing the lives of Oliver and the like only because they defy the fixed notions and political correctness so prevalent in the rational West. In the Philippines, the lives of prostitutes as lived experience beg for new ways of understanding rather than becoming mere theoretical slogans, as is often done by Western thought. How a person like Oliver can manage to support a dysfunctional family by feeding them through his work in gay bars may be too hard to understand for a Western mind. But in the Asian context of the family, personal sacrifice, even by prostitution, can be deemed a noble deed. Working on this different cultural frame of reference, Western feminism really needs to be reassessed.

MGT: *Ynang Bayan: to be a woman is to live at a time of war* was more of a collage of genres mixing your documentary style with your performance work. You also used the "classic" stock footage I've seen in other videos about the Mendiola Massacre.[1] What was your motivation in doing a film about women's history? You had mentioned there were reservations from some feminist groups.

ND: *Ynang-bayan* in a sense was a turning point in my formation as a documentary filmmaker. In my earlier works, a certain kind of linearity prevailed in the formal construction of my films. In terms of its narrative, for example, *Oliver* was a simple portrait of a homosexual performing in gay bars to support his family. The same with *Children of the Regime*, where there was no effort to veer away from the story of street children through formalistic devices such as estranging.

In *Ynang-bayan*, I have introduced artifice into my work. Reality, or the idea of reality, which was foremost in my earlier work, became merely a "material" in *Ynang-bayan*. Other elements, mostly cinematic in motivation, interplay with reality. In a sense, this film became an audacious incursion into the formalized world of documentary filmmaking. This came about through my fascination with other types of documentaries. I drew inspiration from works like those of Trinh T. Minh-ha. In fact, Trinh's essay "Documentary is not a name" became my one great inspiration while preparing for *Ynang-bayan*.

The fragmentation of narrative, use of narration, music, actual sound, and commentaries as well as the incorporation of other devices of estrangement to affirm, deny, oppose, criticize, or question the "realness" of reality are all products of this fascination with the formal possibilities of cinema as it tries to record and depict reality.

Guided by Trinh's writing in the construction of the documentary, I was also guided in terms of the film's contents by the works of Filipina artists, particularly the feminist poems of Joi Barrios, from whose poem "to be a woman is to live at a time of war" the title of the movie was taken. Other artists included in the film are Julie Lluch (sculpture), Edna Vida (dance), Mila Aguilar and Marra P. Lanot (literature), and Upeng Galang-Fernandez (theater), who plays Ynang-bayan.

1 In 1987, tens of thousands gathered at Mendiola Bridge near Malacañang Palace in Manila to protest Aquino's land reforms. Government troops opened fire, wounding and killing civilians.

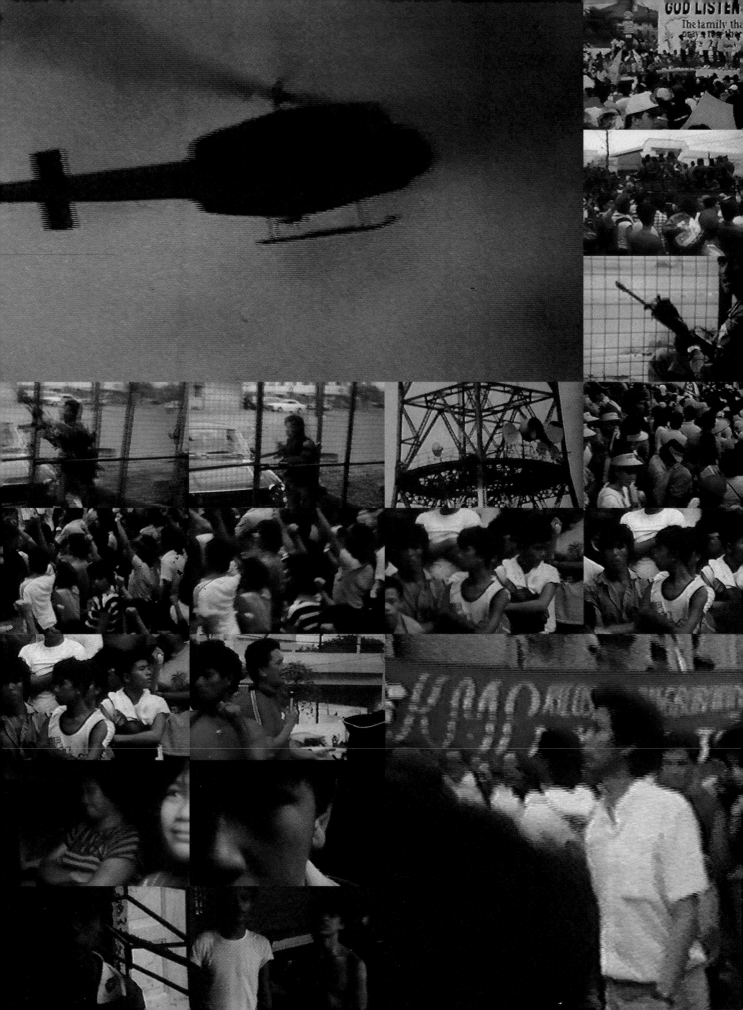

Film stills from
Revolutions Happen Like Refrains in a Song 1987
Super-8mm 50 minutes

The motivation in doing a film on women's history was grounded on the fact that it was my reflection on Cory Aquino's ascendance as Asia's first woman president. Like my other films, it too became a reflection on the historical, political, social, and cultural realities surrounding our lives while a woman undertook the monumental task of leading our country to democracy after the years of terror under a dictatorship.

MGT: *Isaak* and *Memories of Old Manila* were more theatrical pieces. But here again I feel a sense of displacement. In *Isaak*, it's the unwanted son, and in *Memories*, it's an old man roaming and searching the metaphorical streets of Manila. What made you shift your style in these two films?

ND: *Memories of Old Manila* became my first fictional work, followed by *Isaak*. But because I was making a transition from documentary to fiction, *Memories* turned out like a hybrid documentary-fiction, because this film undoubtedly contained a lot of the marks that could be found in my documentary works. Real-life street children comingled with actors, political issues comprised the narrative, prostitutes appeared as surreal characters, and there were many other strange and bizarre mixtures of reality and fantasy. The strong mark of my documentary influence on this film has made a lot of festivals program this work under the documentary category, although I insist this is a fictional work. In *Isaak*, I became more clear with my fiction by making a biblical story come alive but still creating an unexpected twist in the end.

Displacement is indeed apparent in the two characters, the old man in *Memories* and the boy in *Isaak*. Displacement happens to the old man as the conjunction of the past and the present goes awry. A historian by profession, the old man finds himself displaced because of the temporal disjunction that happens as history progresses in time.

MGT: I was rescreening some tapes and jumping back and forth and I noticed you have the actor Behn Cervantes playing your fierce father, and then you have him playing the old man in *Memories of Old Manila*. In *Private Wars* he is the pursued father who's running away. Your choice of actor reveals a subconscious running thread here, don't you think? Tell me if I'm splitting hairs.

ND: Getting Behn Cervantes to appear in my film is a story in itself. Behn was my drama teacher in college with whom I had a turbulent experience because he strongly resembled my father. I always felt uneasy in his classes. I remember having screaming bouts with him. His almost sadistic (to my mind) way of handling his students created a deep impression in me. It took ten years after I graduated to gather courage and talk to him again.

The opportunity came when I was commissioned by Channel 4 London to make *Memories of Old Manila*. I had only one person in mind to play the role of the historian: Behn Cervantes. I took hold of myself and called up my former professor. To my surprise, he sounded cordial on the phone. While working with him, I realized how he had mellowed through the years. During shooting he followed all my instructions with great precision and emotion. One incident I will never forget was that scene where I told him to wallow in the mud because a street gang would attempt to murder him. I was anxiously waiting to see how he would take this order from a student he used to shout at. He meekly followed what I said, but only after saying, "You really want to get even with me." I could only smile.

It was after his high-caliber performance in *Memories* when another opportunity came to make a film, this time about my problematic relationship with my father. I knew this was the perfect opportunity to have Behn play the father that I thought him to be. He was living in New York and I incorporated his ticket fare into my budget. But the worst situation came when he arrived in the country and told me he could only shoot for one day and had to fly back again to the U.S. the next day. And I had to shoot in Panay Island outside of Manila. It was a nightmare! But we did Behn's scenes in *Private Wars* overnight. It was quite a feat, but it was done with great results that can be seen in Behn's superb acting.

Indeed, working with Behn Cervantes satisfied a subconscious need. It seemed like I resurrected my father, and using Behn as a medium, I was able to relive my anger and my fears, my love and longing for the man who has remained absent in my life. Making the films with Behn fulfilled some therapeutic effect on me. I took control of my abstract emotions. I gained insight to the dark recesses of my mind. Behn's uncanny resemblance to my father has done something good: I learned to purge secrets I have kept for so long to myself.

MGT: *Private Wars* is your most personal film. I watch your face as you search for your father at the *palengke* (market) of Ibahay and I don't see the Nick that I know—not the filmmaker or art administrator. And I am conscious of the fact that you had a camera following you around during these highly personal instances. Knowing how people behave at the sight of cameras in the provinces, how did you manage to capture such private moments of silent anticipation as you questioned the market vendors in such a public place?

ND: My years of working on films that dug deep into the lives of other people have made me become at ease with the camera. The whole team did not bother me, because from the start, I had cleared things up with them. Production meetings were turned into interpersonal sessions of knowing how my story could be understood by my film partners. So when we went to the places where we shot, my crew knew what to look for (even if they did not understand the language we spoke). I also cared little about the camera and was able to focus on my search. At the start of filming, I dropped all other personae as filmmaker and administrator to assume my *actual* persona of a son in search of his father. I, too, could not believe the expression registered on my face when one man declared he saw my father. In a series of hopeless searches, I stumbled upon someone who insisted he saw my father. It was a hair-raising moment, and I cared very little if I was being filmed or not. This was an experience only a documentary could offer: when reality would assume a life of its own, far exceeding anyone's expectations. I thought that scene at the *palengke* was one of the major "documentary" highlights of *Private Wars*.

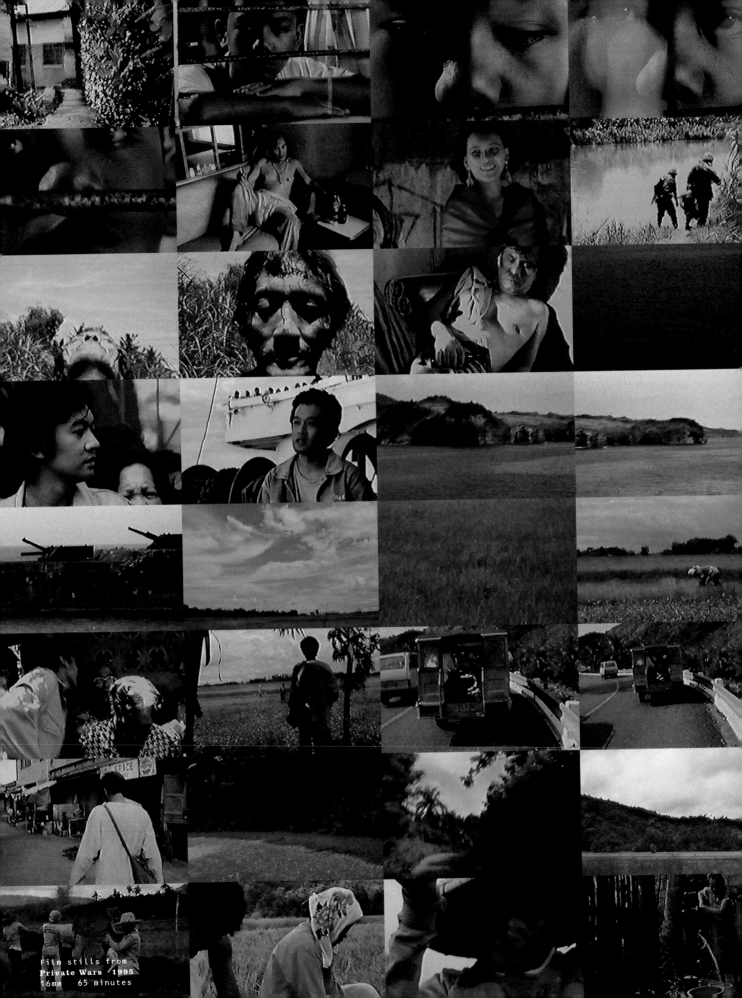

film stills from
Private Wars 1995
16mm 65 minutes

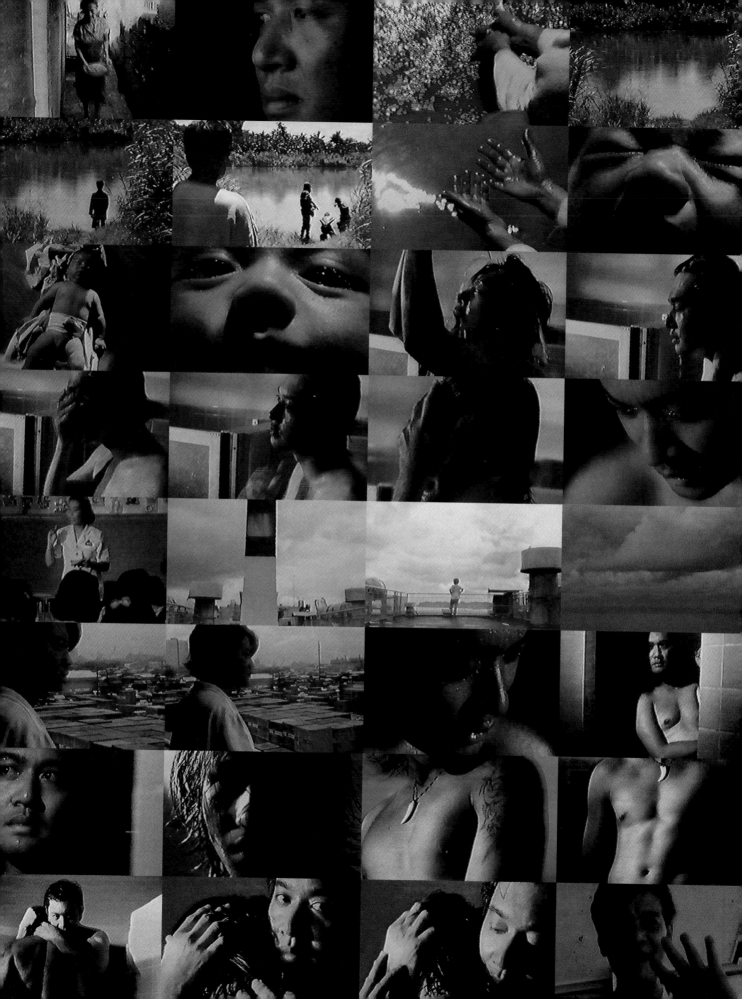

left:
Film stills from
Isaak 1993
35mm 10 minutes

MGT: You were also able to capture your mother speaking candidly with such clarity of memory about her past. The same thing goes with your grandmother. And once again, I observe how you seem to become transformed into a little boy sitting at your mother's feet, hanging on to her every word. How did you set up these scenes or moments?

above:
Film stills from
The Sex Warriors and
the Samurai 1995
16mm 26 minutes

ND: I guess when one talks about things that are close to one's heart there is no need for setups or even rehearsals. After deciding on location and setting up the camera, I warm up my mother (or whoever I will converse with) by briefly talking about the subject matter I want to discuss in the film. The only setup I need is to make the subject know the first question I will ask in order to ready the subject before the camera starts. The moment the camera starts to run and the subject grapples with the issue, everything happens naturally. If I became transformed as a little boy before my mother, I guess it was because I became absorbed with the issue being discussed. One has to find sincerity during such moments.

MGT: Can the process of making such a personal film lead a filmmaker to self-revelations? Did you launch into this project as a filmmaker or as a son in search of a father? Was this film an act of purging yourself of the burdens of the past? Or did it take on a life of its own in the process?

ND: A personal film like *Private Wars* is always a journey to self-revelation. I launched into this project first because of the opportunity to make a film for NHK (Tokyo). I was lucky enough to have been chosen as one of three directors in Asia to reflect on the fiftieth anniversary of the end of World War II. Although it gave me some discomfort to use the money of someone my people used to consider "the enemy," I made a film I thought would be honest enough to reveal my personal story.

There are three existing versions of *Private Wars*. The first was the Japanese version (for television) shown on NHK Cable. I was the least happy with that because the producer imposed his conditions: i.e., no homosexual scenes, an inclusion of scenes about the New People's Army (Japanese TV's stereotypical idea of Philippine "reality"), and clips from my former films to fully establish me as a filmmaker.

I did what my producer wanted me to do, knowing full well I could make a film version later that would satisfy me. Since the Japanese producer wanted only TV rights, I obtained the rights for the film version. I made a second version, which I rushed for screenings at the University of California-Irvine and the University of Southern California, where I was invited as the Chancellor's Most Distinguished Lecturer. But even this version did not satisfy me. When I came back to Manila, I made a new version that incorporated documentary footage I was able to scavenge and recycle from old U.S. propaganda films and anti-Marcos newsreels. This footage filled in the gaps and provided a much-needed historical context for the film.

I feel more satisfied with my third version. The long creative process offered me the opportunity to reflect not just on the story itself but the form of the films, too. Indeed, the story took on a life of its own. The visuals were pieced together through associations. Notice how the imagery of water recurs in the film as a leitmotif. The film opens with water (the heavy rain) and it closes with another image of water (the sea where the father drowns). In between are other images of water: the river where the beheading happens, the mother pumping water, etc. In retrospect, I felt the image of water coincided with the psychoanalytical appraisal of water as a medium of healing. In dreams, water symbolizes healing.

MGT: I really can't help but see a strong tie between *Sex Warriors and the Samurai* and *Private Wars*. You can't seem to escape the omnipresent but always absent patriarchal figure. You search for him even in other people's lives, as in this film. How did you find your subjects for this film?

ND: When I was commissioned again by Channel 4 London to make *Sex Warriors*, I made my rounds of gay bars looking for the transvestites who could fit the intentions I had for my film. On weekends, I went to gay soirées in Tondo where a whole tribe of homosexuals would close down streets in order to do their gay beauty pageants and other gay events.

It was a long elimination process. From around twenty gays I interviewed, I narrowed down the prospects to ten, then five, and finally three. It became hard to decide which among the three would work. I wrote a treatment for each story and made my producer in London decide which would work best. My producer thought Joan's story would work best because of the way the element of the family wove into Joan's struggle to survive. His story became a family story of survival.

MGT: The scene of the father's homecoming, which comes when Joan is about to leave for Japan, belies, I think, the Filipino male's enigmatic sentiments toward homosexuality. The father is loved painfully by his son, and he in turn loves his son fiercely. But the gay son is able to articulate and express his emotions with ease, whereas the father has to maintain the machismo expected of him by Filipino society. The love that happens between the two men can only be expressed through the tension of these oppositional traits.

ND: Oppositional values are all that you see in the Filipino society and therefore in this documentary. It is amazing how Filipinos themselves are able to live by such contradictions without even resolving them.

I guess what I have captured on film is the contrast of emotions between the son and his father. Truly, the son is more candid and has tears to show his affection for his father, but the father cloaks his emotions with a forced smile and a litany of contrite quotes. While the son unleashes a dam of genuine emotion, the father hides in so many unoriginal declarations. For its subtle depiction of emotive contradictions, this scene has touched viewers in all cultures.

MGT: Scanning through your films, I realize how you hark back to images from past films. *Revolutions Happen Like Refrains* is quite like sewing together images and moments from your past documentaries. In *Ynang Bayan*, you reused the Mendiola Massacre and revolution scenes. *Memories of Old Manila* has visual echoes from these films as well. Your practice of reusing footage from your past films is becoming a style. It's a revelation of the images and issues that are foremost in your mind. Do you think that's motivated by economy or a search for style?

ND: My style and my material coexist in ways that have given definition to my films. They're interdependent. I resort to re-using footage over and over again because my need to transcend my poverty of resources is more overwhelming. I have to continually make films. It's an obsession. Besides, I respond to the needs of the times, where reality needs to be obsessively seen from changing perspectives. Underlying this demand of economy is the fact that my films are now a naked manifestation of the workings of my mind. My films contain my neuroses.

In my mind, I see images over and over again. These are images from my traumatic past that disturb me every day of my life. This pattern of thought has assumed a physical rendition in my films. It seems as if my thoughts coagulated into strips of film containing my diseased mind. My films allow me to look, from a distance, at events that happen not only in my life but in my society as well. Then I realize it is not only me who is diseased, it is the world I live in. In short, my personal life contains markings of social tension. And my films have afforded me the chance to visit and revisit these historical moments in order to see in them — as in a kaleidoscope — various perspectives. By seeing these various perspectives, I begin to create my stories. In the end, it is only the story that matters.

(LIKE HOME) **Willie Doherty** interviewed by Joan Rothfuss 8/7/96

Willie Doherty's photographs and videos of Northern Ireland examine the conditions of living within a divided country. Doherty is a native of Derry (also called Londonderry), a walled city balanced on the border between north and south that has been the site of sectarian violence since 1969, when Northern Ireland's so-called "troubles" began. Doherty uses the tools of the news media—photography, video, and language—to explore the sometimes ambiguous distinctions between victim and persecutor, between truth and fiction, between image and reality. His work adds an important voice to the public dialogue about the Irish conflict. We spoke on the phone about his work in August.

JR: You live in Northern Ireland, where you were born, and your work is closely connected to the physical and emotional place you call home. Do you feel that your work needs to be made inside rather than outside Northern Ireland?

WD: Initially that was one of my reasons for starting to make this work. I felt frustrated by the fact that most of the images that were produced about this place were produced by someone else, and often by someone who didn't live here. The predominant images were those from the news media, and I felt that they were in some ways inadequate and really didn't describe the situation. You could say that's the nature of that job. Journalists come here on an assignment, maybe for a few days, and they're looking to find a newsworthy image. The problem is that that need begins to frame what they see. So it was really out of a sense of frustration that I made the decision to live here and to use this place as a starting point for the work.

JR: Were you born in Derry?

WD: Yes, I was born here, I grew up here, and the current phase of "the troubles," as it's called, started when I was about ten, so the experience of growing up through that framed how I see things.

JR: I've read that you witnessed Bloody Sunday[1] as a child and that that was a really important experience for you because it made clear to you how unreliable news media images were. Can you talk about that?

WD: Bloody Sunday was a very traumatic event. Not just for me but for the whole community. It's an event that to some extent is still unresolved, a piece of unfinished business. But what was significant about the experience for me was that I was an accidental eyewitness; I had grown up with the belief that what I saw on television news and what I read in the newspapers was in some way related to the truth. After Bloody Sunday, it became clear to me that what I had seen on TV and what I had read in the newspapers didn't in fact bear any relationship to what I had seen happen myself. So it was an experience that politicized me to some extent about how what was happening around me was being managed. It reshaped a certain set of ideas that I thought I had. Before that, I didn't really have an occasion to question them.

1 On January 30, 1972, British soldiers of the First Parachute Regiment shot and killed thirteen people during a march organized by the Derry Civil Rights Association.

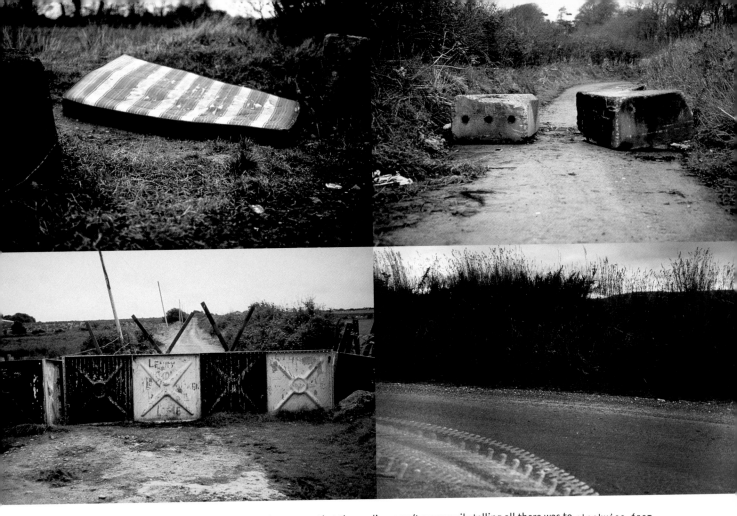

JR: You said that it politicized you, that it became clear to you that the media weren't necessarily telling all there was to be told.

WD: It became clear to me that the situation in Ireland was being very carefully "news managed." It wasn't just that the British media were misrepresenting the story or were unable to tell the truth. I think to a large extent they were being fed a line. So that whole process of news management was something that became obvious to me at that early age.

JR: How did you become involved with photography?

WD: My involvement with photography was a little bit accidental. I didn't study photography; I actually studied sculpture and I became involved in using photography because at the time I was making temporary and performance-related installations. I ended up having to document these things, so my first photographs were actually documents of other work that I was making. I think that's the relationship a lot of artists have with photography. But at the end of this period of study, all I ended up with was a box of slides, and that was my work.

So I thought about becoming more directly involved with photography as a medium that I could actually use within the work. My involvement grew out of that relationship. I also was looking at conceptual artists and their use of photography and text. In retrospect, I can connect my experience of looking at how photography was used in the context of describing a war, and the attempts to problematize photography that I saw in conceptual work in the 1970s.

JR: It's interesting that your work has the feel of documentary photography, but you're saying it doesn't really come out of that context at all.

WD: It doesn't come out of that context directly. But I suppose I was interested in the status of photography as something that is understood culturally as being about the truth. Though, for me, that's one of the paradoxes of photography.

JR: Right, it sits on a line between what we know to be true and what we believe to be true.

WD: I'm not really interested in the documentary value of the photograph. I'm more interested in what's been called faction, the area between fact and fiction—the fantasy that photographs propose rather than their relationship with any idea of the truth. For me they exist in a kind of a gap, and the gap is related to memory and to a whole series of pre-existing images of what a war looks like.

JR: Which most people get out of the news media.

WD: Exactly. In a way, that's the form that the work takes at its most simplistic reading. Some people see an image of a burned car and they want to believe that car was burned in some kind of terrorist incident. I think that's part of the cultural understanding of the role of the photograph.

JR: It also speaks to the notion that one only photographs something that's somehow newsworthy or important. A tire lying on the ground wouldn't be interesting unless it were the relic of something that was news.

clockwise from
upper left:
**At the Border V (Isolated
Incident) 1995
Unapproved Road II 1995**
Collection Imperial War
Museum, London
**The Outskirts 1994
Border Road II 1994**
Collection
Albright–Knox Art Gallery,
Buffalo, New York
Sarah Norton Goodyear Fund,
1996

all works:
cibachrome on aluminum
48 x 72 in.
edition of 3

WD: Of course, people expect the photographs to be of an event or of an incident of some sort. But actually my photographs are of non-events or non-incidents.

JR: What are the subjects of your photographs? Are they in fact documents of war or terrorist events?

WD: I would say that the subject matter of the work is incidental; I'm more interested in what happens in the gallery. For me, the true dynamic is what happens in the space when someone confronts the work. The work is actually a sheet of photographic paper mounted on a sheet of aluminum and hanging on a wall in a gallery. I'm not really so much interested in the particulars of the car or the tire or whatever. I'm interested in the process whereby the viewer encounters this.

JR: What part does the composition and presentation of your images play in this process?

WD: The images have a very central viewpoint, a frontal relationship to the viewer. Often if there's an object, it's in the center of the frame.

JR: They are presented as if you had just encountered them yourself.

WD: They're presented in a very unproblematic way. They conform to one of the most basic ideas in art about representation, the idea of a window on the world. In that sense they're deliberately very straightforward and don't initially appear to pose any problems. But they're printed on cibachrome paper, which has an incredibly shiny surface, so in a way they're about the idea of negating that pictorial space. While the viewer is in one way invited to engage with the work, to enter the work, it's very difficult to get past the surface. The surface is extremely reflective, so the viewer is immediately reflected in the work.

JR: The paper becomes another barrier, like the barriers and borders that you photograph.

WD: It gets in the way of this desire to have a relationship with the image and with the imaginary space. The viewer is taken back to the experience of standing in the gallery in front of it.

JR: Pushed back into their own space.

WD: Yeah. So in that sense they're confrontational, but for me the confrontation is really about what happens between the work and the viewer.

JR: And yet that confrontation would be very different if it were an abstract image or photograph of a face. Clearly, the content is crucial.

WD: Yeah, the content is crucial. I'm not denying the content of the work. I'm trying to establish an order.

JR: So the presence of your photographs as objects, and the interaction between viewer and object, are the key issues for you rather than the content.

WD: For me, those things have become increasingly more important. In the earlier works, the concept of place was crucial and I added a text that was often descriptive of the place, trying to map out how the territory worked. The viewer was implicated in the reading of the text and in the process of identification and in positioning himself in relation to the viewpoint of the camera. I suppose at some point I realized that this work was very dependent on local knowledge, both in terms of the history and the geography of the place.

JR: Were the texts specific to news media accounts or well-known texts locally? Or did you write them?

WD: It was a mixture of all of those. Some the texts I wrote and some of them were almost like sound bites from news reports, bits of graffiti on a wall. They came from different sources, but I think the relationship between the viewer and the work was a little different from what it is now.

JR: Text seems to me a very important structural element in your work, not only in the earlier images, but in your more recent videos and slide installations and even in the photographs without text directly on the image.

WD: In the earlier black-and-white work, I was attempting to provide all the text, and I think the color cibachrome photographs also have a text, but eventually I felt that I was closing down possibilities too much, that the text and the image began to cancel each other out. I wanted to open the whole process up a little bit for the viewer. This also coincided with the time when I began to show the work a little more internationally, so I couldn't make any presumptions about who the viewer was. I wanted to create a little bit more space in the works for the viewer.

JR: In reading reviews of your work, I was surprised to see two very different interpretations of the function of the titles. One reviewer said she thought the photos did not need titles, that they were immediately readable by anybody as images of war. Another said the opposite: that you had to have the titles because otherwise you might think this was just an innocent photograph of a broken-down car by the road. How do you see the titles of the photographs functioning?

WD: The titles allow the possibility for varying levels of engagement. They can be either extremely banal and descriptive or else they can be used as another component or element within the work. They form part of this gap between different geographical, political, and cultural spaces. I'm trying to position the viewer somewhere in this gap. So the titles are more triggers than anything else. I'm interested in the relationship between the images I make and a whole series of pre-existing images that the viewer knows from somewhere else before they encountered this work. And that might be specifically images and information that the viewer has about Ireland and about this particular conflict.

JR: Many of those pre-existing images come from the movies, which you've said have been important to your work.

WD: I think a lot of how we visualize very extreme events, such as being shot or being involved in some horrific event like an assassination, is related to our experience of cinema.

JR: So, film is important for your work in the sense that it provides people with images of experiences they haven't had.

WD: Yes, it forms the subtext of the work, and this is information that I haven't really directly given the viewer, but I'm very aware that the viewer brings to the work. The work is completed by this process, so I don't perceive myself as being the sole author. It's more a process of facilitation, where I choose a certain number of elements that I bring to a particular place. The coincidence of the viewer coming in contact with it takes the process in any number of directions that I don't really have control over any more. So, let's simply say that I choose very particular kinds of images and present them in a particular way. I'm not

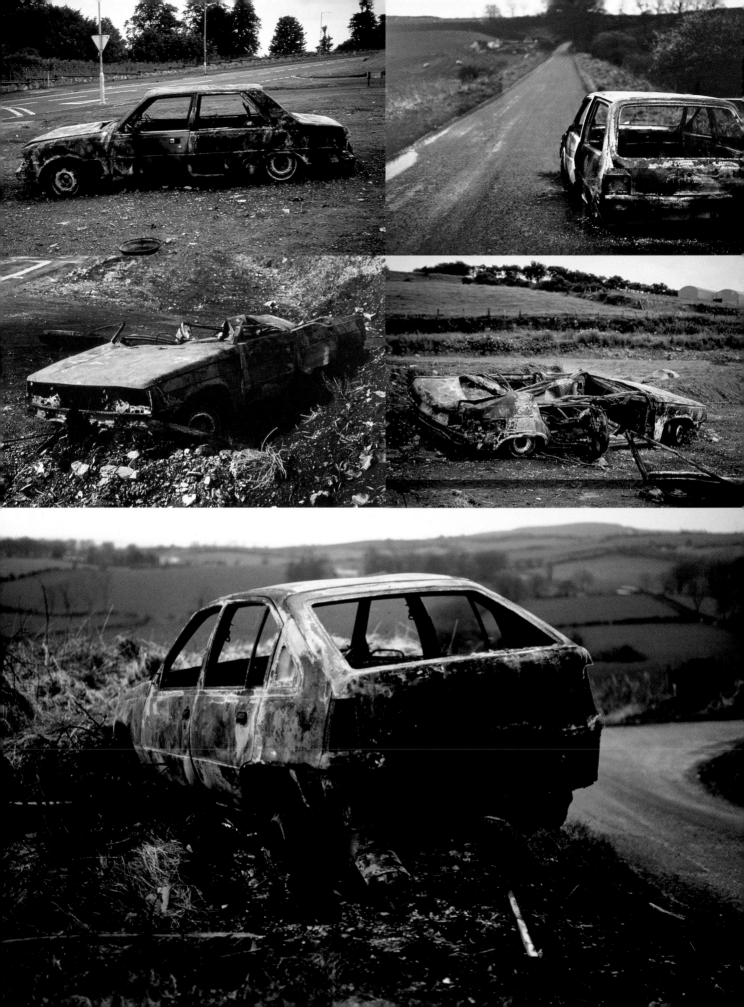

clockwise from upper left:
Incident II **1993**
Incident **1993** Collection Carolyn Alexander, New York
Abandoned Vehicle II **1994**
Border Incident **1994** Collection Penny and David McCall, New York
Abandoned Vehicle **1994** Collection The Progressive Corporation, Cleveland

all works: cibachrome on aluminum 48 x 72 in. edition of 3

denying responsibility, I'm just acknowledging that the process is open-ended, and there's an aspect of it that I don't have control over and I don't want to have control over.

JR: Many of the images that you make seem to be about traveling and moving through space — roads and tunnels and bridges — what happens on the road, at the side of the road.

WD: Well, the idea of traveling on the road has been a recurrent image in the work right from the start. And that's partly related to the experience of living here. Derry is a border town, so there's constant movement across the border.

JR: And when one moves across a border, one's very conscious of that movement?

WD: Yeah. It becomes a very self-conscious act. For me, the idea of how the terrain works here and one's relationship and position within it is something that's extremely self-conscious, which also may be related to not wanting to be in the wrong place at the wrong time. So we're constantly making decisions that involve a whole series of coded movements. Where you choose to live, the road you choose to travel, the places you visit, the space that you organize as a safe area — all these are very conscious decisions. In that sense the idea of movement on the road, the relationship between a place and an idea of identity, is fundamental to this work. And that's one of those things that, to a larger or lesser extent, is only available to some viewers because, obviously, that kind of tension doesn't exist everywhere. But the idea of the road as a metaphor is something that is more non-specific.

JR: Many of your images are shot at night, or in darkness. This also seems to reference cinema, an experience that revolves around seeing images — often very frightening ones — in the dark.

WD: When I began to make the color photographs — quite a few are shot at night or in the dark — it was just before the cease-fire, and we were in the middle of a very vicious cycle of random sectarian murders. I think everyone who lived here felt extremely frightened and intimidated by the situation, both because of the random nature of the murders and the fact that they often took place at night and the victim was surprised or not directly confronted, but ambushed in some way.

JR: Some of the titles of those photos are strongly narrative in quality, almost like movie or thriller titles. They suggest somebody has been there or there's been an incident.

WD: They propose a narrative, and I'm interested in how the viewer completes that narrative and locates these images within it. For example, to show work in the United States is interesting because there's a very strong Irish-American community. A lot of people have ancestors or relatives from Ireland, and they have ideas about what Ireland looks like, about the role of their family within that, their status within America as Irish Americans. Yet, many Irish Americans have never actually been in Ireland. There are many layers of narrative overlapping between memory and less-than-reliable accounts of private and public history. So that kind of encounter, for me, is very strange.

JR: Our image of Ireland is really romanticized: rolling green hills, small villages, a travel-brochure fantasy.

WD: Exactly, but the other side of that coin is what the war looks like. These photographs look like what a lot of people want the war to look like. In that respect they're more about a fantasy. But for me the paradoxical aspect of that is that the photographs are not manipulated in any way. They have a documentary value.

JR: It seems to me that one's images of war must be based on the cumulative effect of living in it, so that in the course of one's "daily looking," all of that experience comes to bear on the thing one is looking at. It's something that I've wondered about in your images. Violence is at the center of them, and yet you never actually depict a violent act. Your photographs usually depict a vista or object that looks like it could have been part of a violent incident, but it's not exactly clear. That seems to me a really accurate way of depicting what it's like to live in such a place.

WD: When I began to make these images, I established a series of ground rules, one of which was that I wasn't going to represent the violence directly, to be on the ground when something was happening. I was more interested in looking at it from another perspective or trying to find another way of dealing with it. Because it seemed to me that most of the ways in which the violence functions here are psychological. That's really where most of the tension and the strain in people's lives is.

JR: I wanted to ask you about boundaries and borders in your work. In Northern Ireland it's a way of life to label things either/or. Can you talk about how that tendency to classify has informed what you do and the images that you make, what you choose to photograph?

WD: This kind of labeling is an essential part of life here that in a way is invisible. We do it automatically, especially in Derry because, historically, the place has two names, Derry and Londonderry. The town is divided by a river, so there's always this dynamic of "the other side" and what's happening on the other side and what you perceive the other side to be about. Here, one side of the river is perceived to be Nationalist/Catholic, and the other side of the river is perceived to be predominantly Loyalist/Protestant. So where you choose to live here is a major decision. To live in this place, we have to make a series of choices every day, and that has been a device that I've used. The work often appears to propose a choice to the viewer, so the recurrent images of borders and blocks are part of that relationship. Another thing that interests me about the idea of a border is that it's something that exists here in a very specific way. Derry is located on the border between the north and south of Ireland, a relationship with the border that is quite specific.

JR: While some of the borders in your photos are real physical objects that you can see, others are metaphorical.

WD: I think, again, it's part of this desire to both make the work about this place, but also to give it a life outside of here.

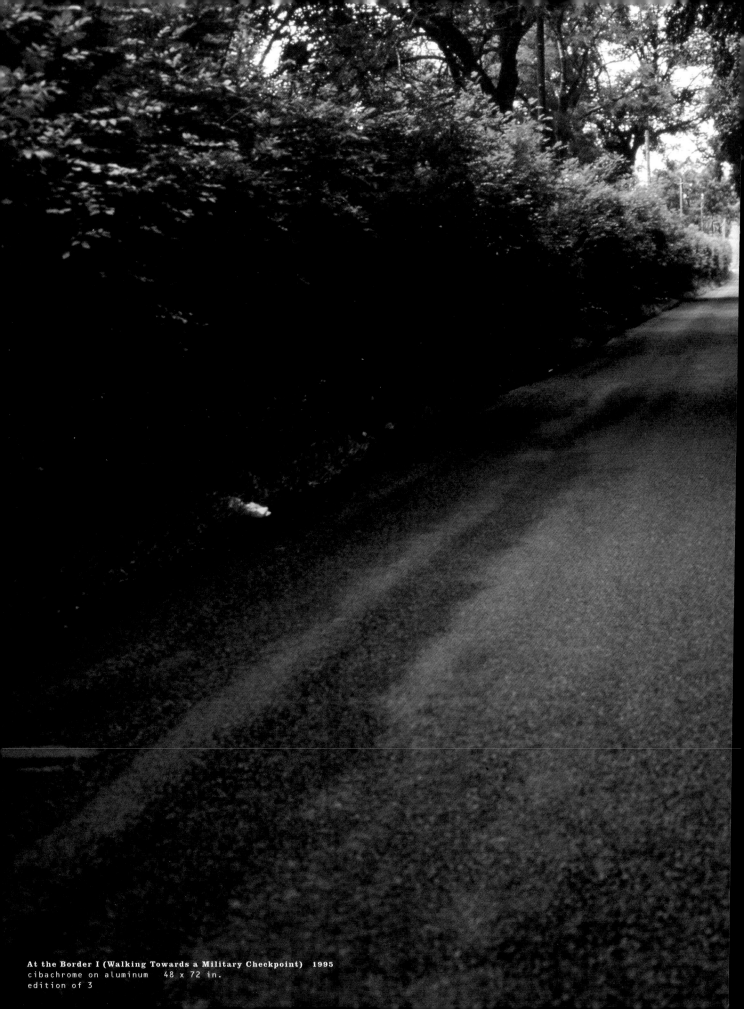

At the Border I (Walking Towards a Military Checkpoint) 1995
cibachrome on aluminum 48 x 72 in.
edition of 3

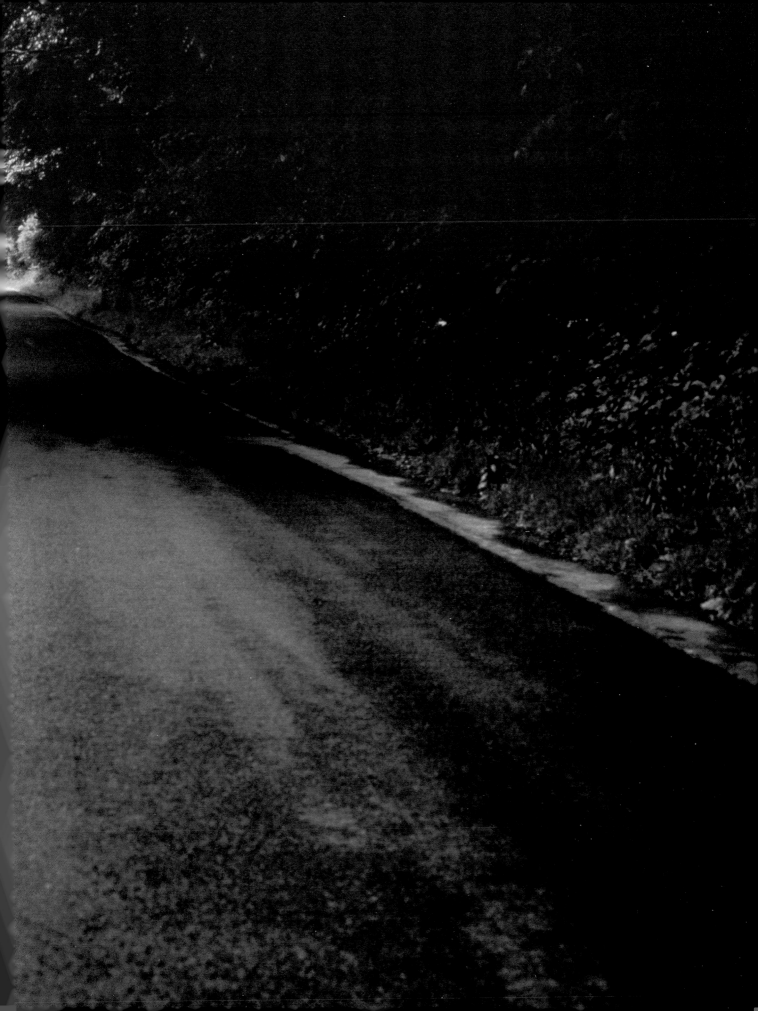

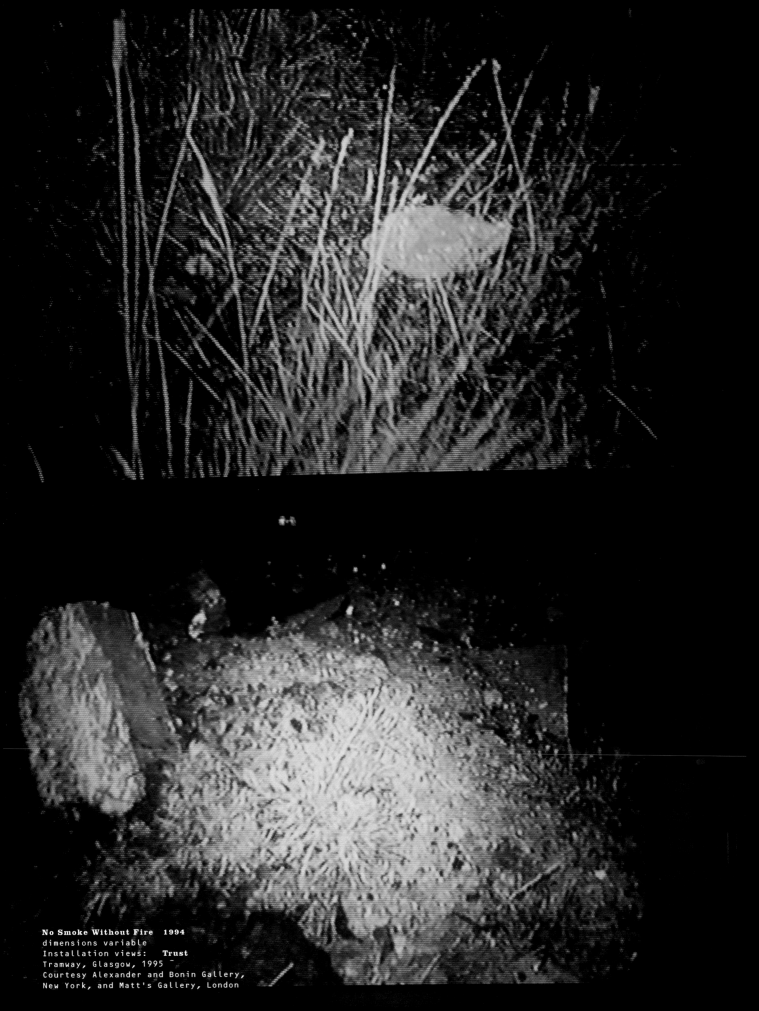

No Smoke Without Fire 1994
dimensions variable
Installation views: **Trust**
Tramway, Glasgow, 1995
Courtesy Alexander and Bonin Gallery,
New York, and Matt's Gallery, London

People make their own borders, their own limits, so it's a metaphor people get a handle on or relate to very quickly.

JR: But there's an ambiguity of viewpoint in your work that problematizes a division into categories, so that often when I look at an image that you made or listen to a videotape, I can't really understand where I stand in relation to the image or the text. So that makes it difficult to find the border.

WD: That's because it's part of this process of identification and is dependent on where you position yourself both politically and physically in the landscape. The viewer has to position him or herself in some way in relation to my work. I'm interested in breaking down that process of identification so that what looks like an apparently easy choice becomes more difficult and even contradictory as you get involved in it.

JR: So one could identify with the victim, but also with the victimizer.

WD: Yes, as in the video piece *The Only Good One Is a Dead One*, where the viewer is asked to identify both with the person who is planning the assassination and with the person who fears being assassinated. I'm interested in breaking down those two apparently unbridgeable positions both in terms of making what might be an interesting work, but also in terms of relating that directly back to the political dynamic here, where often we're given no choice. You're either a victim or you're an aggressor, and there's no space for someone who has become a victim to experience anger or rage or the desire for revenge.

JR: So, in a way, the work is about creating space for a more complex response.

WD: Yeah, creating a different kind of space that somehow complicates the conventional way in which these positions are presented.

JR: Is this related to the idea of linguistic paralysis that you've spoken about in earlier interviews?

WD: In a way it's related to that, and it goes back to the idea of news management. The situation here has been so carefully managed that the control of language and the production of images have become the real battleground. Things have changed a little bit, but before the cease-fire we were living under what was called the broadcast media ban, where the voice of Sinn Fein and various other proscribed organizations were banned from radio and television. For example, you could see the face of Gerry Adams on TV, but you couldn't hear his voice. There were two ways in which this was dealt with, either by subtitling or by voice-over where the voice was spoken by an actor.

JR: So Gerry Adams' words could be spoken, but not by him?

WD: Yeah. It became kind of crazy because the actors who were doing the voice-overs became so good that you could actually believe that you were listening to the person. It was the end of a series of measures taken by the British that formed what the conflict looked like and how it was presented. When the ban was imposed in 1988, Margaret Thatcher, who was Prime Minister at the time, said that it was her intention to starve the IRA of the oxygen supply of publicity. This established a link between the war and publicity.

It goes back to the situation that led to the hunger strikes of 1981. Previous to that, political prisoners in Ireland had special category status, which meant, essentially, that they were being treated as prisoners of war. The implication of this was that there was a political intention behind their activity. Political status was removed and we then had the "dirty protest"[2] and consequently, the hunger strike. What was significant was that through this linguistic shift these prisoners were changed from being people who had a political intention with the status of political prisoners to criminals and terrorists who were involved in this activity for no apparent reason.

We became locked into the position adopted by governments worldwide, i.e., "We don't negotiate with terrorists." But the fundamental question was how these people became labeled as terrorists in the first place. The language that framed that position was actually very carefully constructed over a number of years, so that eventually there was no possibility for movement. That kind of manipulation of language is something that is referred to in the work, but is also visible within the bigger political context here. Of course, it's not particular or specific to Ireland. Language is used to shape events and control possibilities in many other places.

JR: How did you get interested in making video? Did that come after you started photography?

WD: Yeah. I really became interested in making a video because I had this image in my head that I couldn't realize in any other way.

JR: Which was the first video you made?

WD: The first video I made was *The Only Good One Is a Dead One*, which is an installation with two video sequences, one shot from the interior of a car which is driving around on an old country road at night. The scene is lit by the headlights of the car. And the other sequence is again shot from the interior of the car, stationary on an urban street. This image of the car driving on the road was one that I had embedded in my head and it was interesting because it reminded me of a cinematic image. I was actually doing a lot of driving at the time at night and in the early morning, so it was an image that was familiar, but because of this cinematic connection it was also the image through which I visualized my fear of being assassinated. I felt very exposed because I was doing a lot of driving across the north and crossing the border in the dark.

I made the video in a straightforward way. I got a VHS camera and just shot the footage in the car with a hand-held camera. It was a very direct use of the medium and characteristic of the way I use video, because it sets up a direct relationship between the camera and the subject, and consequently, a direct relationship with the viewer. The viewer is asked to identify with a point-of-view shot. The viewer is in the center of the action, so to speak.

JR: Is there any relationship between your use of video and surveillance tactics in Derry?

WD: Yeah, there is. In this work that we've been talking about, *The Only Good One Is a Dead One*, in the second sequence where the car is stationary in the street, there's an ambiguity: What is this car doing here? Is someone being watched? Is it a kind of surveillance vehicle? Is the camera hidden? What's this footage being used for? So, again, here it's

2 In March 1976, after "special category status" for political prisoners in Northern Ireland was with-
 drawn by the British government, many inmates took part in the months-long "dirty protest," smearing
 their cells with their own excrement and refusing to clean them or wear prison clothes.

something that people are very conscious of living with.

JR: How about the video *No Smoke Without Fire*? That's a little more ambiguous. There's no narrative over that, no spoken text.

WD: Well, there's no direct narrative, but again I think it's one of these works that very much depends on a pre-existing image. For me, that work is like a scene out of lots of movies that you've seen before, except that in a movie the scene might last two seconds. Someone is stalking someone else or approaching a house or looking for something. And it's a kind of incidental scene within a bigger plot. What I've done is make that small action the subject of the whole work. I'm interested in the lack of narrative in this piece. There are no clues. A reading of the work is determined by this absence.

JR: Let me ask you one last thing. I was wondering if you considered your work political in the tradition of artists who have thought that their images could directly affect or change a political situation.

WD: Well, I consider my work to be political, but not really in that way.

What I think is maybe a more interesting question is the nature of my political intention. If one were to read the subtext of the work and make an analysis of the images over a number of years, it would be very easy to see that the work is a product of my particular background: I'm Irish, from a Catholic, Nationalist background. And the work politically comes out of that experience. I don't really know what it is like to be a Loyalist and don't really share any of that political aspiration. My political aspiration is different. I think that subtext of the work is visible.

But it's not my intention to use the work as a Republican propaganda tool. So, for me, the real intention is to locate the work within the realm of language, and specifically the control and constructed nature of language. And one of the intentions of the work is to implicate the viewer in this process.

(L I K E H O M E) **Kay Hassan** interviewed by Susan Robeson 5/10/96

Kay Hassan portrays scenes of everyday life in South Africa, and many of them pivot around the constant displacement of
families and workers he witnessed while growing up in the townships of Alexandra and Soweto. Some of his
most dramatic installations use two-dimensional collages of reconstituted billboard posters that are made to
look like paintings from afar. These occasionally become backdrops for three-dimensional scenes that
poignantly recreate a moment in everyday life by incorporating found objects, such as the battered suitcases
and tattered bundles of squatters who are becoming a permanent part of the landscape.

This June, I met Kay Hassan while he was in Minneapolis making arrangements for this exhibition, and we spent a day
hanging out—at a neighborhood soul food spot, at the local Black bookstore, at my loft overlooking the
Mississippi. To top it off, Gordon Parks was in town for a screening of *Shaft*, so we took that in and had a late-
night meal with Dr. Parks, who dazzled us with stories of his many adventures. While Kay was soaking up his
first experience with African-American culture on its home soil, I was taking in everything I could from him
about growing up in South Africa, the challenges facing Black artists today, his work, and how he sees the
world. As we talked the day away and into the night, my tape recorder was always on.

SR: Describe your work—the kinds of materials you use and your vision, your process.

KH: My work has to do with me growing up and being moved—bulldozed—from one area to another. My parents moved
from Alexandra and we went to Kliptown; from Kliptown we moved to Diepkloof. Growing up as a young boy in a township, I
always saw people on the move—carrying bundles, cases, boxes. I always questioned myself—what's in those things? I wanted
to know. I really didn't understand, but I kept on seeing people moving, moving, moving. And today they are still moving, but
not for the same reasons.

If you look at my installations, I concentrate on the objects people carry when they move, objects people carry when
they're running away from political, economic, and social violence. And now, in South Africa, there's land invasions—I call it
land invasion. It's people who are desperate for accommodation, so they invade naked land and construct their shacks—so-
called squatters—because those people have no land and they are tired of living in backyards. They want their own spaces. So
they always carry objects with them. Those things have stayed in me from youth and now they're coming out.

So in my work—I deal with objects, everyday objects, objects with which people identify themselves—I re-create scenes
similar to the scenes of displacement I lived with as I grew up.

SR: For example?

KH: Take a suitcase. You see a man with a suitcase in the streets or a woman carrying a suitcase. Perhaps you have a pic-

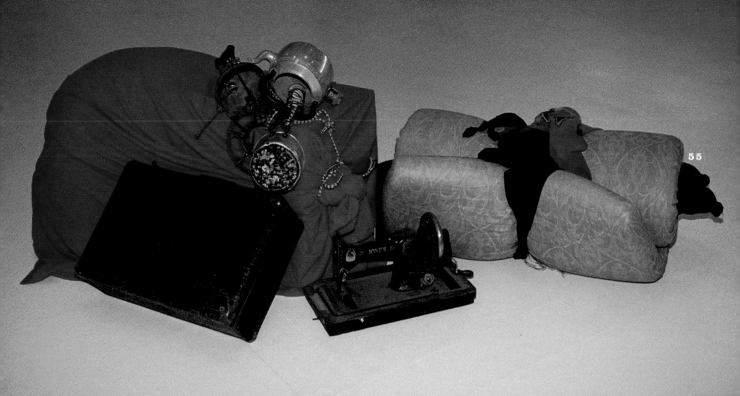

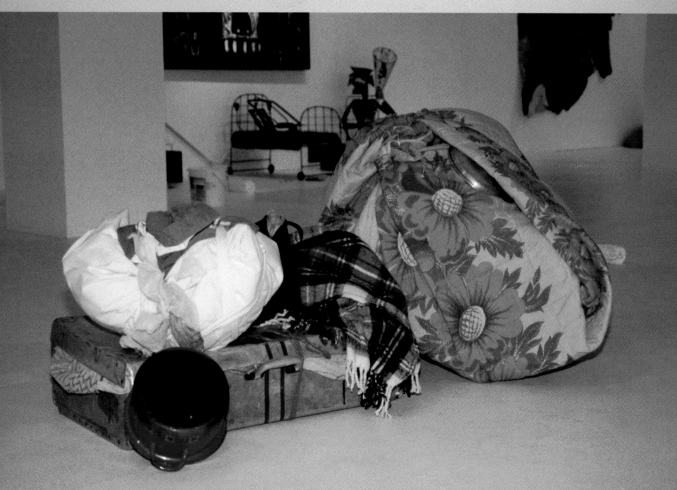

Flight 3 1994
mixed media
dimensions variable
Installation view:
Newtown Galleries,
Johannesburg

ture in your head that he is going to visit somewhere or he's moving to a new apartment. If you see somebody with a bundle in his hand, you might say, "This man is selling second-hand clothes" or "This man is carrying dirty laundry." Those are the kinds of objects I use. I want people who look at what I'm doing to become involved and question themselves, unlike in the past, where one could say, "Oh, it's a man with a clenched fist" or "It's a man running" or "It's a woman carrying a baby." Now, we have to portray that differently. That's why, today, a lot of artists are trying to find their way out of that old cycle and move into a new cycle.

SR: What other images from growing up under apartheid influence your work?

KH: When I was a kid I used to go to the mines—the mining compound—when the miners were no longer there, and it was very striking because I could see those bunkers, those cement beds.

SR: And why were you going into the compounds?

KH: Just being kids during school holidays—because you never had recreational facilities—so it was where we played, and we'd even go into dangerous areas where you're not supposed to go.

SR: In the late 1960s I discovered South African photographer Ernest Cole and his book *House of Bondage*. Those images seared themselves into my memory—especially the photos of miners and life in the compounds. What do the mines and the compounds represent to you?

KH: Exploitation of my people by White capitalists who kept all the benefits, all the national wealth for themselves, while the miners were working under extremely difficult and dangerous conditions, often losing their lives.

SR: Did you know what these places were for and what was going on in them when you were a kid?

KH: We knew, because in the area where I lived, there are mines and we used to play on the mounds. It was dangerous because there was quicksand. A friend disappeared in the quicksand.

SR: He died?

KH: He died . . . slowly. We used to do a lot of dangerous things. When the people from the compound moved—it was called Shaft 17—we went to Shaft 17 and we moved from room to room. You could smell what it was like and the images, they really stayed with me.

SR: The shebeen is a place that shows up in your work and it definitely has a resonance for Black folks here, because our version of the shebeen is the juke joint—shacks where everyone from steel-mill hands and field workers to hustlers, drifters, and even church folk came to drink, dance, listen to music, gamble, and party till they dropped. I think the word "juke" evolved during slavery from certain African words—like the Bantu word *juka* and the Wolof word *dzug*.

KH: Well, my mom was a shebeen queen, so I grew up in a shebeen. I was nine, ten, eleven, twelve. My mom was selling traditional beer. She used to brew it and hide it in the yard. And cops would come and raid.

SR: Why would the cops raid—the traditional beer was illegal?

KH: It was illegal, so people were defying the so-called law. People had to have fun even though it was dangerous. And that culture keeps going on because people have to go to those joints to socialize, drink, dance, listen to music, make friends—and I still hang around there.

SR: But it was in an illegal place.

KH: It was in my house, so my mom was defying the so-called White man's law.

SR: Was she ever arrested?

KH: Oh, yeah. She was arrested. It's something which never stopped. Although today people are no longer harassed by

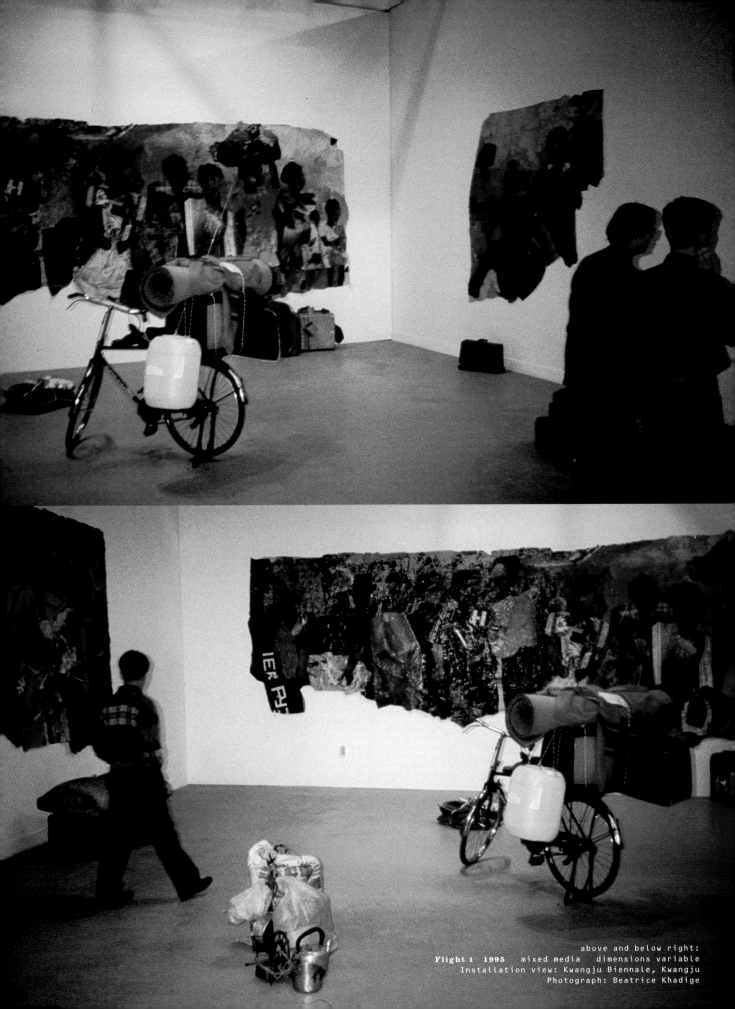

above and below right:
Flight 1 1995 mixed media dimensions variable
Installation view: Kwangju Biennale, Kwangju
Photograph: Beatrice Khadige

the cops. It's very educational, the shebeens. It's eye-opening in that you listen to all kinds of conversations going on there— **First Time Voters 1995** paper construction 79 x 315 in. Collection National Museum of African Art, Smithsonian Institution, Washington, D.C. Photograph: Andrew Bannister political conversations, day-to-day incidents, what's happening in town, problems with the White man—you even found stolen goods in the shebeens. If you get married, you can have a Pierre Cardin suit, shoes, groceries, house furniture, you name it.

SR: You can get it there?

KH: You get the connections there. They were social places, but also, if I want this, you know, I have to go to such and such area, or if I want this and this, I have to go and talk to the shebeen queen or king and they would connect me to people selling stolen goods. They were criminals, but they were a different kind of criminal—highly politicized ones. They wouldn't terrorize people from their own community or their own kind. They don't steal from people of their own community because they are politically clear, consciously so. They would say, "I simply repossess what is stolen from me." So they would go to White areas, move in there, and take whatever they could take. They were people who worked in shops . . .

SR: A redistribution of the wealth?

KH: Exactly. But the only thing they could not take was their stolen land.

SR: The Soweto Uprising in 1976 must have had an enormous impact on you—it certainly affected us here—because it was led by students. In essence, they made the townships ungovernable and helped set in motion the chain of events that eventually led to the release of Nelson Mandela. How did those times affect you? You were twenty years old then.

KH: During 1976, right after the uprising, there was a period when there were no schools—a whole year with no schooling—and that was a very tough period. That was a period when we started to identify ourselves—who we were, where we came from, and where we were going. Cultural activities started taking place in the township—there were poets, there were writers, actors, musicians, painters. It was a period where we moved away from the streets because the streets were dangerous—the army, the police were patrolling the streets and provoking and shooting at whatever group of people they came across. So we moved inside to whatever spaces we could get. There were no available spaces because houses in Soweto—in the townships— are very small, but fortunately I had a friend and his family had a garage. So his parents allowed us to use their garage.

A movement emerged called Creative Youth Art Association, which was based in Diepkloof—the area in Soweto where I come from. The objective was to encourage people to write, be actors, be painters. So all the youth came together and we used to have workshops. We had a program—at such and such a time, the theater group would use the space, and at such a time, the group that played music would use the space. It's when we started discovering ourselves—we could do things, we could write, we could enjoy painting, listen to poetry. We were educating each other. There was no schoolteacher.

We became consciously aware, political. Guys started to talk about politics from the subcontinent or Europe or America— like cultural problems in America, like Marcus Garvey while he was there. I started to discover that in Soweto, along with Malcolm X, the Black Consciousness movement, listening to jazz—John Coltrane, Charlie Parker, Nina Simone, Billie Holiday. So

whatever record collection our parents had, we would take it and listen as a group and in the evening take it back and our parents were not aware we borrowed their things. It was wonderful. Literature was also circulating. Once you read a book, you finished it, you passed it on. It was a chain. That's how we stayed informed. Those are the things we discovered in the streets and all that culture enriched me, we were enriching each other.

I had this friend, Matsimela Manaka—he's a playwright, painter, musician, very talented—and one of the founding members of Creative Youth Art Association. We also started Art in Motion. Our aim was to have exhibitions in the townships and encourage people to appreciate and collect art at very reasonable prices. It really worked. Artistic activities—exhibitions—were not really happening in the townships and a lot of people were not exposed to those things. Artists were not in touch—it was the only way to bring them together and share ideas as painters, because writers, musicians, actors were together. We started having exhibitions in the townships and abroad. It made a difference in the community and it also helped artists to exhibit outside South Africa. We used to have organized exhibitions in the parks over the weekend—display our artwork. It was really amazing.

SR: When did you become an artist?

KH: My artistic life started at a very early age—making sketches, drawings, woodcuts, using my own hands just for the fun of it. But I had a cousin who was a painter—William—and during school holidays he used to visit or I paid him a visit. I used to spend most of my school holidays, summer holidays, winter holidays with him and he taught me how to draw and use color. He was a self-taught artist. He died in early 1980.

SR: Did you ever study art formally?

KH: Yes, I did. I decided to go to art school in Natal in 1978 and guys in the group started protesting—"You don't have to go to school because you've got it in your blood." They nearly convinced me and I nearly changed my mind, but I felt I had to go because there's a lot to learn. I had to learn techniques in painting, watercolor, drawing. Rorke's Drift was based in Natal and it was the only art center in the country for Black people. We were not allowed to go to the White technikons, the White universities. It was a missionary school run by the Swedish. The intake was very small—we were ten. I started now to learn how to draw. I thought I knew how to draw. But it was really tough because the place was in a rural area.

SR: So you lived there, you moved there?

KH: It was a boarding school. We had to integrate into the rural lifestyle and be part of the community, which was not easy coming from the city where the ghetto life is fast—music, going out at night. The first couple of weeks it was very tough. I nearly packed my bags and left, but I stayed on. The villagers used to invite us over the weekends to build those round mud houses. And while they were teaching us how to build them, they would brew traditional African beer in huge calabashes. They would prepare food and we would build the houses in a day. And we'd drink, eat, sit in the kraal with the one who smokes—

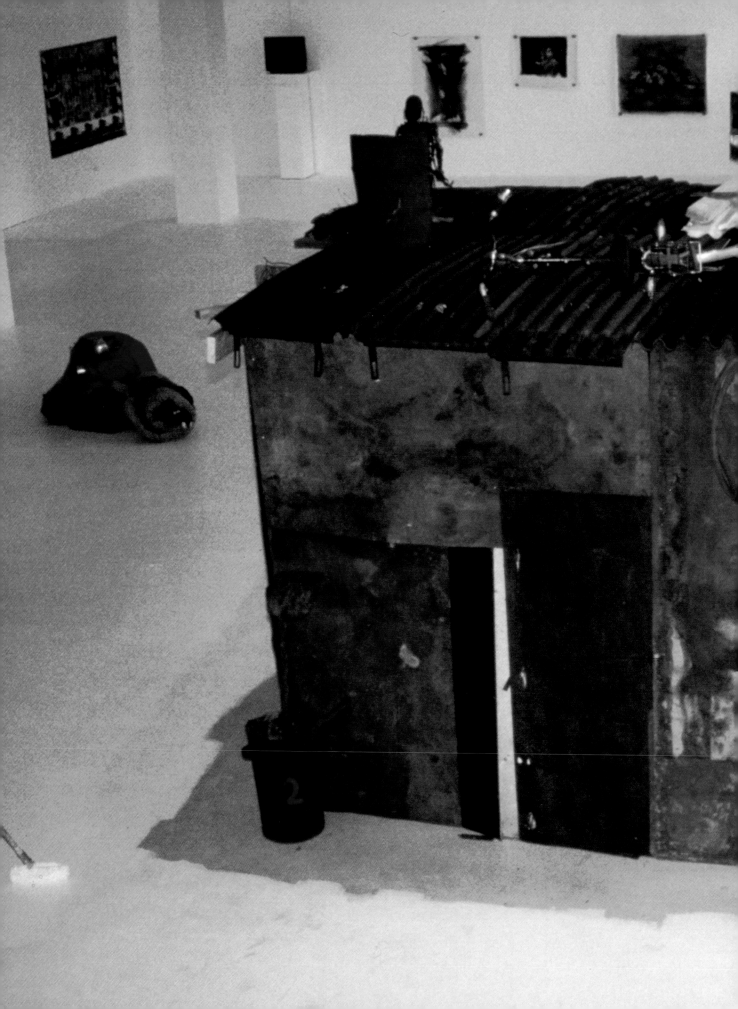

Shack 1996 (exterior)
mixed media
dimensions variable
Installation view:
Haus der Kulturen
der Welt, Berlin
Courtesy Pat Mautloa
and Kay Hassan

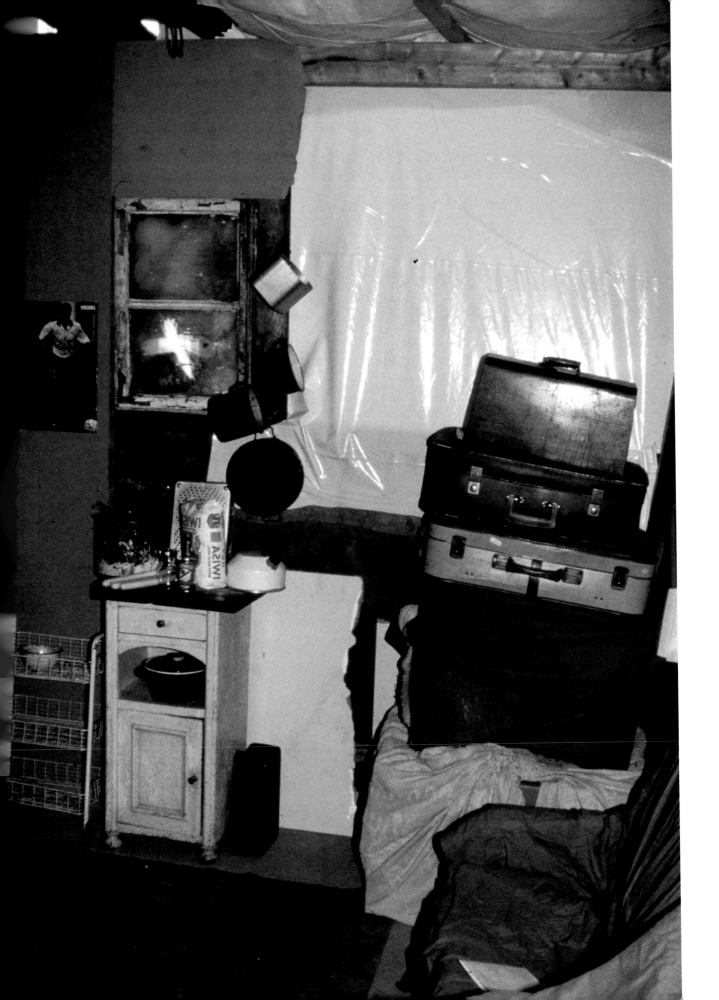

left and above:
Shack 1996 (interiors)
mixed media
dimensions variable
Installation view:
Haus der Kulturen
der Welt, Berlin
Courtesy Pat Mautloa
and Kay Hassan

there's a pot there with marijuana—it's life! It's life! The smoking of marijuana there was accepted. It wasn't like in Soweto, in the city, where it's a taboo to smoke. And it wasn't just young people. You could sit in a kraal with elder people who would smoke and tell us stories. It's like being re-educated; you start to discover who you are, your culture, and you start to appreciate it, because now you see it in a different light and through the eyes of elderly people who have never been to the big cities, so it was wonderful.

SR: So how did it affect what you were doing with your painting, your drawing?

KH: My way of seeing things really changed, deepened, and so my work became more expressive. For assignments, we were doing still lifes and life drawings. We used to go out and paint villages because we were fascinated by that, and those people really liked it because we were down to earth and they have a respect for people who come from big cities. We became part of those people, we shared what we had with them. During holidays when I went back home, it was different. I couldn't fit that kind of lifestyle. It was too fast for me. Too fast in the sense that it was noisy, the kind of music people were listening to—I couldn't take it. I thought I was the only one who was suffering. I missed that rural environment.

SR: You were telling me about how controversial it was when you tried to get the instructors at Rorke's Drift to teach not only the history of European art, but of African art as well. What specifically were you trying to deal with in terms of African art and artists?

KH: The problem is—and it's still a problem—we know nothing about the art which comes from the subcontinent. We don't know ourselves. It's very important to understand European art—all those movements—the Impressionists, the Expressionists, Dadaism, but we also have to understand the development of art in the subcontinent. If you talk about African art you don't only talk about Benin sculptures and Nigerian sculptures—the Ife and all that—but what's happening in Zaire, in Mali—the Dogon people—the Yoruba, what's happening in Angola.

It's really sickening that you know so much about Europe, but you don't know much about yourself. Fortunately, there was a subscription to *African Art* magazine, published in America, which we had access to. We discovered the artist Twin Seven Seven in Nigeria, we started discovering a lot of artists from the subcontinent, we started looking at different sculptures, traditional attires, and all that opened our eyes. It made a difference because this was a period when we really needed to start developing our own culture and our own language. We started seeing things differently, developing our own strong identity.

It was so important for us as artists, as human beings, since the apartheid regime had tried to destroy our culture, our values, by discouraging the learning of African art in depth. We felt cut off from our roots. That is why we were so hungry to discover the art of the continent. And then we discovered that the Picassos, the Matisses, the Braques, the Giacomettis, and the Brancusis only copied and readapted our essential art in the modern world.

SR: What's fascinating to me is that, quite independently, in America, we as young African-American artists and activists

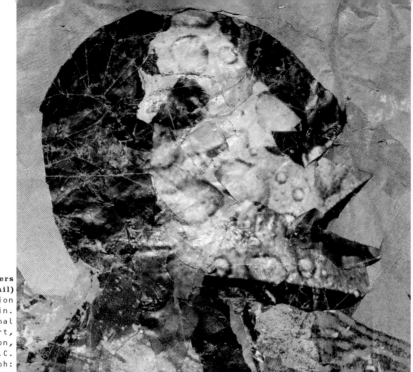

First Time Voters
1995 (detail)
paper construction
79 x 315 in.
Collection National
Museum of African Art,
Smithsonian Institution,
Washington, D.C.
Photograph:
Andrew Bannister

64

were going through a similar process and discovery at the same time you were.

KH: When I finished my studies I went to England—had my first exhibition over there in Birmingham. I did workshops with West Indian kids from Jamaica, Trinidad, and Barbados, so it was really fun and eye-opening. I started to explore different things—look at artists working over there—South American artists, North American paintings, African paintings, European painting. I could see how they were different and how these artists each had a very strong identity with the area they came from. It really worked on me and gradually I started developing my own way of working through experimenting.

Today, there's a very strong movement, especially in South Africa, where artists are developing new languages, using different materials—especially found materials, objects—and at the end of the day when you look at the work, the work is very refreshing—very, very strong.

SR: I'm curious what the politics are—the dynamics of power—within the art scene in South Africa today. Who runs the galleries, who owns the galleries, how do you get exhibited?

KH: The people who organize exhibits, like the Johannesburg Biennale in 1995, were serving in the old structure so they pushed their White boys. Galleries were pushing them as *the* South African artists. Now, it's no longer working well for them. Now, there's this trend of Black guys—the indigenous artists of the country—who were never recognized by their White counterparts. But we survived during the hard times.

We have learned from the past mistakes made by so-called veteran artists because many were selfish. We, as young artists, share and push the younger ones who are not recognized. In that way, once you're in the door, you keep the door open so it exposes the young and coming artist. In the past, once the gallery was tired of an artist . . . a lot of artists who were big in the country are nothing today; they are no longer active, which is very painful. Now, in order for us not to go through the same experience, we started to develop our own way of doing things. We all sit down as a group and come up with a strategy of how to call our own shots.

Galleries are still run by White people, but something very interesting is happening now—art is being taken to the people and away from galleries. It's becoming accessible to communities that have no access to the galleries, because all the galleries are in the big cities. We're moving back to the townships now, and shows are taking place in the townships. There was a very big exhibition last June 16th to commemorate the twentieth anniversary of the uprising in Soweto. They used big shipping crates—sea containers—and placed them in central areas of Soweto where people could go and see the exhibitions. So the exhibitions were inside those huge steel boxes used for shipping goods.

SR: So it's totally self-contained, mobile exhibition space that gets trucked in?

KH: Right. There's one country—I think it's Nigeria—where they've developed those sea containers into living areas. They're also now used in the townships for public phone facilities; they run shops in them, small restaurants. You'll see them when you go back to South Africa—it's a new thing. So they are used now for exhibitions.

SR: Where do you see yourself in five, ten years? What's your vision of how you want to make your way through the world?

KH: I'm a world artist. But I have to come up with a new kind of work. Because today, that is a big problem in South Africa. We have to develop a new language, we have to move away from protest art to a different kind of art. It's really not easy to move away from this point to a new point. But some artists have managed to develop a new language.

In the past, we had a very important role to play as artists—to inform the world of the brutalities which were taking place in South Africa. A lot of people outside South Africa, in Europe and America, became aware of what was happening here through writing, through poetry, music, theater, movies made underground in South Africa. And it was also about preserving and edu-

cating the people—they have to like themselves first and have hope. The question of identity was crucial because culture was discouraged. If you want to destroy a people as a colonizer, you have to destroy their culture and their roots, it's very important. Once you destroy their roots, you neutralize them. They become a confused people. So that was the aim of the system.

In the 1960s, the cream of South African artists left the country; they went to America—Miriam Makeba, Hugh Masekela, Jonas Gwangwa, Letta Mbuli, Keefus, Ernest Cole, the painters, Dambuza, Chris McGregor and the Blue Notes—the whole wealth of the country had to leave. And what happens when those people leave the country? The space becomes vacant.

SR: So there was an older generation of artists who were not available to you—to your generation. You were out there on your own.

KH: We were out on our own and it wasn't easy. It's just like a house without a father. You have to have guidance. And who's guiding us? So that was a very big problem, but we survived because as I said, the street culture started developing.

The agenda of the State was also to frustrate those who remained in the country, to refuse to publish their material, refuse to record their music. Even to stage a play in a municipal center, or any of the community facilities, you'd have to submit a script and they had to decide if this was desirable for the community; they could decide not to hire the space to you. So we used to use public parks. We came up with alternative venues—churches. But we also made use of those community facilities because when they'd ask for a script, we'd send the wrong one and they'd approve it.

The churches played a very important role—they started to be used as political venues, artistic venues, music venues. So the artist was playing a very important role—making the community aware of what was happening. And also helping them appreciate the arts.

SR: How does that transfer to the situation as it is today?

KH: Art has an important role to play in this new society. We still have to make people aware of who they are and instill respect and trust and hope in the people. And we have the duty—if politicians can't do it, then we have to do it.

NO PLACE

Lo Mejor del Verano (The Best of Summer) **1993–1994**
mixed media dimensions variable
Installation view: **Cocido y Crudo,** Museo Centro de Arte Reina Sofía, Madrid

(L I K E H O M E) **Kcho** (Alexis Leyva Machado) interviewed by Kellie Jones 5/5/96

Kcho's almost obsessive reconstruction of the boat form in his installations appears to address the processes and problems
of migration that particularly affect Cuba—a nation that fights a daily battle against its increasing economic,
political, and cultural estrangement from the rest of the world. Boats have become a recurrent and a charged
symbol in contemporary work by Cuban and Cuban-American artists, inspired in craft and spirit by the imagi-
natively fabricated "balsas" or rafts used by those who make the perilous, and usually illegal, 90-mile journey
from the island to the United States.

Yet Kcho insists on a much broader reading of his work. It speaks to the more general lived experience of island dwellers all
over the world: the perennial confrontation with what he terms the "watery barrier" or the "liquid limit," the
natural phenomenon that contains and defines one's existence. The image of the ship is also connected to
memories of the artist's childhood—paper toys floated by little ones on lazy afternoons, the carpentry prac-
tices of his father. There is playfulness but at the same time a nostalgia for the warm safety of a (not so) long
ago youth, the security of the real and metaphorical homeplace. This interview was conducted in Spanish and
took place at the Barbara Gladstone Gallery in New York, shortly after the close of Kcho's solo show.

Kcho: My name is Kcho. Some people call me Alexis Leyva, but everybody has always called me Kcho. It was my father's
doing. I was born on the Isla de la Juventud, an island that is south of Havana, on February 12, 1970. I have been in New York
for four months.

KJ: How do you like New York?

Kcho: I like it very much. I've visited various places in the United States and this is a special city. You can't measure the
United States by this city; it's very different from the rest. It's like a way of life.

KJ: Let's begin with the obvious: the rafts. Is this an idea that you share with other Cuban artists of your generation?

Kcho: Yes. However, to talk about this I should talk a little about history, my relationship with traveling, and with
objects that are related to travel. My fascination with this idea began with the body of work prior to this one, in which the fun-
damental concept had to do with the shape of the island of Cuba; that is to say, life on an island, meaning that everything
evolved around it. In 1992, I made my first voyage out of Cuba. A work which resulted from that trip was called *Siempre fue
Verde (It Was Always Green)*. In it I used a symbol that I have used on other occasions, a paddle tree. It is a plant that has
a paddle instead of roots. And like you say, the theme is migration. It is a theme that concerns many artists in many parts of the
world. However, the first work in which I used the element of a boat, ship, or raft, or however you call it, is related to one thing,
my childhood. I completed *La Regatta (Regatta)* during 1993–1994. The implication was of a child's game. Later I began

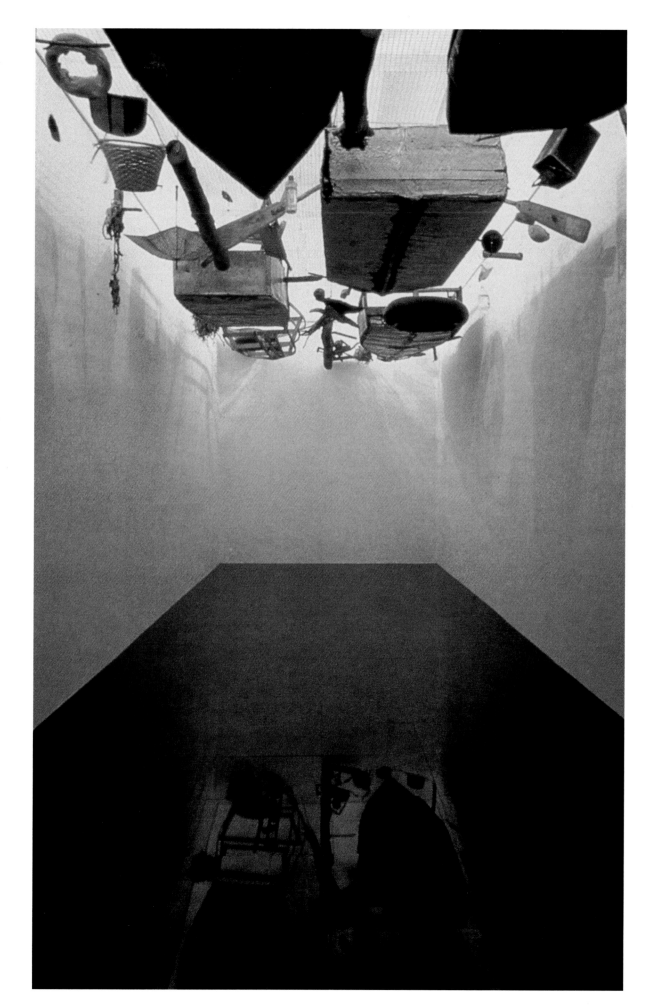

to take this concept in different directions; I began not only to construct objects but to utilize real objects. I manipulated these found things; my hand would either repair them or distribute them in space. They were works that depended a lot on energy. When objects already have a use, a prior history, that forms part of a work.

KJ: So, in the beginning your work drew on the idea of youth, and now it is about something different.

Kcho: Not really; the idea of youth is still present, the links to my childhood still hold. It was important to me that the work had the characteristics of a game, if a macabre game. These little ships have common, everyday meaning, referring to the migratory mentality of a person that lives on an island. To have a liquid medium as a limit always makes you think differently. A person that was born and raised on an island recognizes that he/she is on an island even if that limit does not really exist. For example, if you are on a continental mass and if you see the horizon, you know that you can continue walking. But the ocean produces something strange, a limit, like a barrier. You don't know what is beyond the horizon and you become a faithful believer that on the horizon there is something, even though you can't see it. There is a daily desire to evade or go beyond this limit that separates you from other things. This is the mentality of the isle.

KJ: So life is not about struggling against a barrier, but conquering it?

Kcho: It is the struggle to conquer or to eliminate a barrier. Let's take the example of a Cuban my age, born and raised with that existing limit, never knowing whether or not this limit can be surpassed. Some people are born and die on the island; they have never left Cuba. They know that beyond the blue horizon there is something, but they have never seen it. This is something very intense, and it always makes you think that you want to evade that limit. The mentality of migration is similar to this notion, and it is a mentality that is becoming stronger each day in various parts of the world, as if every day that passes people want to move to better themselves, and so on. This is the only issue that is a constant in Cuba. Cuba is not always going to be socialist or communist; the only thing that is permanent is that Cuba is always going to be an island, and always the ocean will be the limit. This is what interests me, the daily confrontation with the liquid limit that forces you to think in a certain way.

KJ: In your work the rafts do not float, they don't function as methods of physical transportation. Is this a sign of failure?

Kcho: No, I wouldn't say it is a failure, but I enjoy the illusion or concept of the works floating or functioning. They are recognizable forms in whatever material they are made of, and they should float, but they can't. I like the illusion that they should float more than the fact that they do float. The work is more about that than the idea of failure. It's like a manipulation.

KJ: More like an illusion, just as art is an illusion?

Kcho: Exactly, art is an illusion, so I'm not as interested in the ability of the object to function as I am in its ability to function as pure illusion.

KJ: Critics say a lot of the time, regarding your work, that it signifies the failure of Cuban society.

Kcho: A work of mine that has generated that type of comment is the work just purchased by the Walker, *Obras Escogidas (Selected Works)*. It is a ship constructed with some of the schoolbooks that I used, books that could have been used by any Cuban of my generation or the generation before mine. That is to say, a Cuban formed in the revolution received the type of information contained in these books. And what *Obras Escogidas* tries to make visible is the idea of social structure which always remains hidden. It is like putting skin on something that doesn't have skin. Many people look at this work and only see books on Marxism and say the piece is about politics. But there are also natural science books, math, and geography books. It is a work that talks about universal literature and the mix of ideas in formation.

KJ: What is the theme of the work called *A los Ojos de la Historia (To the Eyes of History)*?

Kcho: I like to use a lot of indeterminate figures in my work. Any person with an art background can identify the Tatlin spiral [Vladimir Tatlin's *The Monument to the Third International*, 1919–1920]; those without art knowledge can conclude that it is the Tower of Babel. Both are like an idea of a dream, the Tatlin spiral as well as the Tower of Babel. Tatlin's spiral is the utopian dream of an artist. It was impossible to build it at the time, and it is impossible to build it now. Tatlin's concept constituted a utopia in that sense, then it became the symbol of a society that was supposed to change the world. And all of a sudden, this other content that was given by history also failed, when the socialist camp disappeared and that ideology failed. So it's not a symbol anymore, it's just one more utopia. This is how I see it. My dream is to find a way to make Tatlin's spiral work. What about making a drainer? It didn't function as one thing, so why not another? So a utopia is given function. It's something sarcastic too . . . how do you filter coffee in Tatlin's spiral?

KJ: Going back to the rafts, why aren't there any passengers in them?

Kcho: It is because, to me, the objects are the people themselves; they are not ships, they are people. I don't think that there is an invention of human transportation that throughout history has had a significance that is so determined by the condition of that person. You can find small boats, made by Indians from the Amazon, all the way up to those cruise ships that you see in Miami that look like palaces. I think these vessels really define people. That's why I think ships are beings, beings with a life of their own, an idea, a path.

KJ: You mean it is not a human being, but a being.

Kcho: A being with its own life and determination. To me, each floating object is such. And I don't call them boats or ships or rafts. I like to call them floating objects, because for me it is a floating object. They are things that are part of everyday life. So this table between us can also be like a floating object.

KJ: In another metaphoric way, these boats can transport people that look at them, and in another sense you have traveled with these works, to show them. So though the ships cannot float, they are a means of mental transportation, and they *have* allowed you to travel, to come to the United States, to Europe . . .

Kcho: Yes, these works move all over the world. Let's say they are my company. They come with me wherever I go—to Korea, London, New York, Milan. They are like my family.

above:
A los Ojos de la Historia (To the Eyes of History) 1992
mixed media

opposite:
Extructures Similares (Similar Structures) 1996
from the
Columna Infinita II (Infinite Column II) series
charcoal on paper
87 x 59 in.
Private collection,
New York

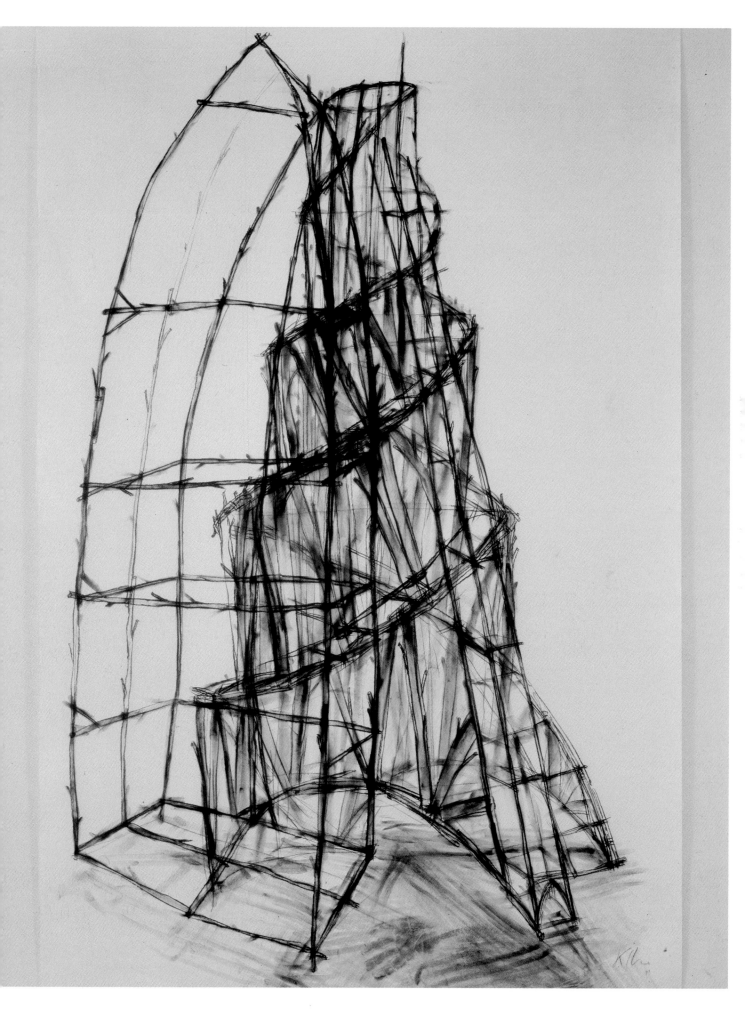

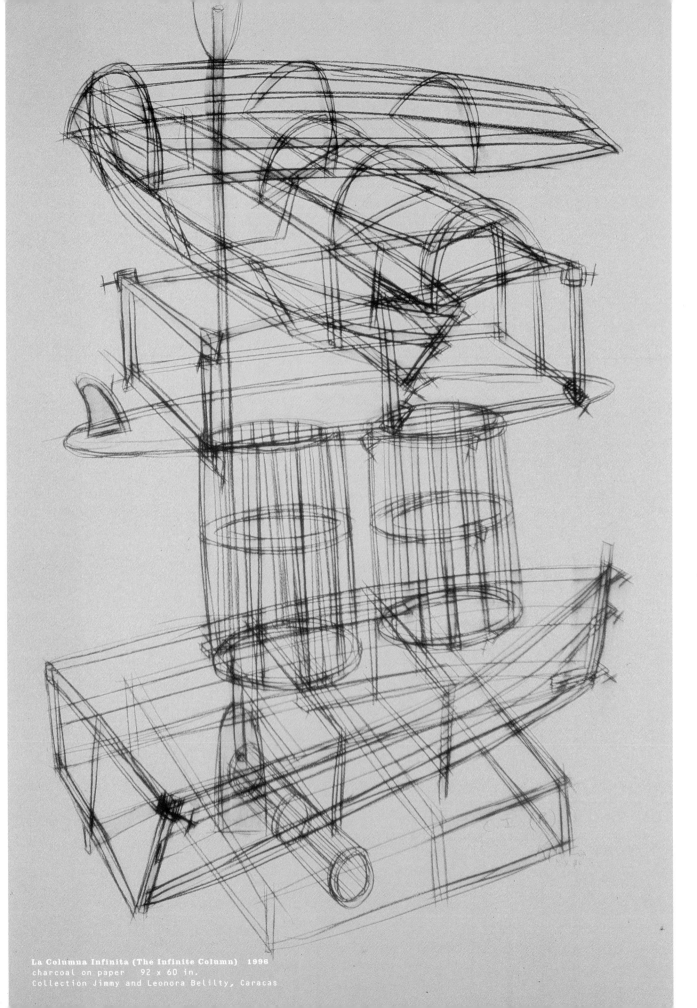

La Columna Infinita (The Infinite Column) 1996
charcoal on paper 92 x 60 in.
Collection Jimmy and Leonora Belilty, Caracas

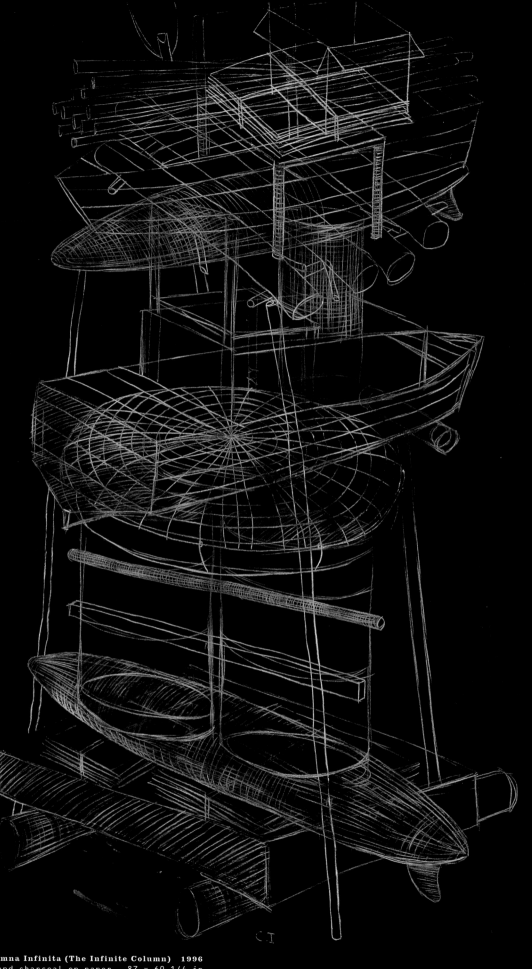

La Columna Infinita (The Infinite Column) 1996
chalk and charcoal on paper 87 x 60 1/4 in.
Collection Robert M. Kaye

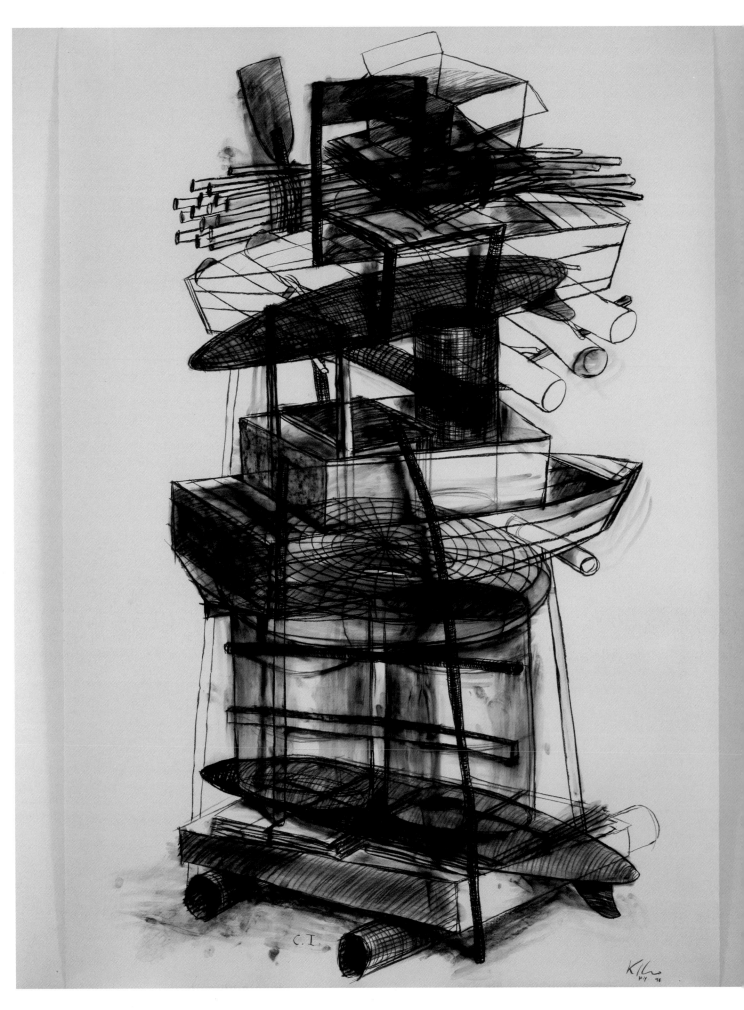

KJ: What other forms or artists influence you in your work? For example, people like Tatlin, poetry, music . . .

Kcho: Well, music is very necessary when I work. It is super important; it complements my process. I need music. Basically, what I listen to is jazz in its most traditional form and Afro-Caribbean music. I like Duke Ellington. Another favorite is Miles Davis. I have a lot of their music. I am constantly working with this type of music. In the context of art, let's say culture or specifically plastic or visual arts, a lot of things interest me. Russian avant-garde art, in its totality, interests me. At one time I was very interested in Italian art—Futurism and Arte Povera. It's like a process of apprehension and of utilization of things. For me a fundamental thing is to know history and to use it. When you don't have a knowledge of history, history uses you. When you don't know something, that something uses you, so it is important to know many things. The path you are going to take is clearer because you then begin to invent, to create, to grab the strings of the puppet and have everything under control.

KJ: Are there any specific artists that you like?

Kcho: For me art has a division, like stairs; there are two people that I consider gods—Picasso and Duchamp. These two people are very important. They gave us the possibility of thinking in another way. They gave us the opportunity to see in another way. To me, this is a god. Then there are the semi-gods; there are a lot of people in that group, people whose art I like a lot. And we are the mortals. We are here trying to do something. But in this world there have been many brilliant artists. We have Brancusi, for instance.

KJ: And Cuban artists, contemporary or historical?

Kcho: Wilfredo Lam is known as the most important Cuban artist in history. I like the universality I find in his works. And there are a lot of interesting artists in Cuba, artists of my generation and the generation before mine.

KJ: I do know some of the Cuban artists of the 1980s, such as Glexis Novoa, Tomás Esson, Marta María Pérez Bravo, José Bedia, Carlos Rodríguez Cárdenas, and Ruben Torres Llorca.

Kcho: I met a lot of these artists in Mexico when they lived there. When I arrived in Mexico there was a sense that in Cuba there weren't any more artists, that they had all left. It was an exaggeration of the 1980s, that all the artists were living in the United States and in Mexico. This was not true; in Cuba there are still many artists working. There's a variety of interesting work being done. Unfortunately, in the 1980s, that generation was very intense and complex but was left truncated. I hope it doesn't happen to this generation.

Something strange happened to me here in New York. I met a Cuban artist that I had never met before—right now I don't remember his name. I was with another Cuban artist named Carlos Garaicoa who had had an exhibition here. I asked this guy, "Are you also from Cuba?" He said, "No, no, I am from here." And I said, "Oh, you were born here?" He said, "No, I was born in Cuba." So then he *is* from Cuba; Cuban living outside Cuba. I say this because I also have a lot of family living outside of Cuba. Sometimes these people create mechanisms, very strange relationships with their motherland. Cuba is not Fidel lying on the ocean, Cuba is the land that gave birth to you, the land, the water, the plants, the animals, the garbage that you came out of. Cuba is not Fidel lying on the Caribbean. Cuba is something made by nature, and I am happy to have been born in Cuba, I love Cuba. It is my birthplace. For me, denying that is like rejecting your own mother. This is something that the land does not forgive. It is absurd to deny the land, especially when Cuba is so beautiful.

KJ: What about the artist group of your generation, called *Los Carpinteros* (The Carpenters)? Do they deal with the same questions and issues? And is this separate from artists of the 1980s generation? Are issues different for them?

Kcho: Well, I would say yes, it is possible that things are different. The relationship is different. In Cuba I have a lot of friends who are artists. Two artist friends who are particularly important to me are Israel Miranda (he lived and worked in Mexico with me) and Osvaldo Yiero. I just recently met him, because he just started to be known as an artist. We have common worries. For now, I get along with all the artists in Cuba. They are my friends. I hope there won't be any hate; that can be a by-product of the field we are in. I was talking about it here with *Los Carpinteros*. I told them that I hope it never happens to us. If there are any problems, I hope we can talk about them, whether they concern a gallery, the collectors, etc. But my generation right now is quite busy, and there is a certain harmony in the relationships and ideas . . . this is really nice.

My thinking process is similar to the ideas of other artists that I have a relationship with. I think that my generation has different thoughts from those of prior generations—different ideas and relationships with art and life. And the generation after mine will have a different one; I think it is evolution or invention, I don't know what to call it. For example, I was raised with the idea of studying art; I never thought of the future necessity of selling my art to survive. I never thought when I was twenty years old that I would be sitting here in front of you. I made objects just for the love of art, pure pleasure. But today, at the Institute of Arts in Havana, the artists seem to have a concern with selling their work in a way that people from my generation or the generation before mine didn't have. They ask you, "Did you sell? Oh yes? And who bought it? And how much?" In other words, there is a concern with the art market. And Cuba is a place where the art market does not exist; people have no idea what comprises an art market. Instead, they have this paradisal illusion; they still maintain an admiration for the world of art, for artists, for international figures. It is really funny when I go to Cuba, students see catalogues of the exhibitions I was in, and they ask, "Did you meet that artist? Did you talk to that person?"

This goes back to the idea of the liquid barrier and seeing what is on the other side, because a lot of Cuban artists that have left Cuba have never come back. This is an issue that Cubans drag with them. You are born and raised, become a man, and you never know if you will be able to cross that barrier, and there are people who, once they cross it, don't know if they are going to come back. They feel they can't leave the road open for a return. It is something that life has forced people to do. It is very sad. It's terrible to feel compelled to think that if you leave your country you are not going to be able to return. Such is the pressure that many Cubans who live elsewhere feel. They have a desire to go to Cuba, but they know they can't, because they left, and so there is something sour about their return.

I don't like to be in one place. I don't like to feel that I can't walk where I want to. I don't think anybody likes it. My mom

73

**El Camino de la Nostalgia
(Road of Nostalgia) 1994–1995**
mixed-media installation
dimensions variable

passed away, and if I wanted to go to visit the cemetery at five o'clock in the morning and sit on top of my mother's grave to talk to her, I want to be able to do it. I wouldn't like to spend twenty years suffering, thinking that I couldn't visit her. And there are things that are a lot more intense than this, things that make you step over that barrier many times. Here people worry about what is going to happen when they return to Cuba: will they be able to leave once they go? What is going to be the relationship with the island? Nobody knows. The only way to find out is to go to Cuba.

KJ: Is there a difference between constructing one of your pieces here in New York with new materials and making one with used materials?

Kcho: I don't think that way. My work has followed two paths, constructions with found objects and new constructions that I have created. They each have a different type of energy. There is an energy from use, from prior history that found objects possess, or the type that comes from my own hands. Basically this work here [*la Columna Infinita II*], the manner in which it was constructed, relates to many things. First of all, I am using C-clamps and raw wood. My father was a carpenter, so these materials are fundamental to me. It is work that is constructed with pressure. The fact that it exists because of pressure is like a game or a play on words. Life is full of pressures; we feel pressured by many things. For instance, there are a lot of people here, especially in the United States, that are waiting for me to make a political statement. Many people wanted me to start a political scandal. But this does not interest me. So pressure is very important. My work exists because of the pressure. There aren't any nails or glue, it is wood and everyday pressure. People are surprised, because I use C-clamps or because the wood is new. They say, "Why didn't you use old wood?" But it is wood with its own life, and it will eventually change color with time. And like my other works, it will have a life of its own.

KJ: This is my last question, and you may have already answered it, I don't know. Do you think your work deals with the idea of *Cubania* or of nationalism?

Kcho: You can say *Cubania* or *Cubanidad*. It is something that theorists have defined in Cuba—Fernando Ortiz and Nicolás Guillén, for example

KJ: Is it something natural for all Cuban artists or is it something that is constructed? Is *Cubania* a theory that one imposes upon a work of art, or is it something that is already present? For example, because the artists are Cuban, then automatically the work will have an aspect of *Cubania*?

Kcho: I guess it can be natural or it can be implanted. My work from about five years ago had a lot to do with that; it was very evident that I was a Cuban. I constructed Cuba many times; I used images such as the palm tree and other patriotic symbols. The island was a lot more evident as a metaphor. But later on, well, I think now things can be from anywhere, because they speak of a phenomenon that is universal. This world is made up of immigration. People will continue to move everywhere. This is a universal phenomenon.

Obras Escogidas (Selected Works) 1994
mixed media
28 x 106 x 40 in.
Collection Walker Art Center

Funny things have happened to me. For example, the exhibition *Cocido y Crudo (The Cooked and the Raw)* in Madrid that was organized by Dan Cameron. At the museum, the people who helped me mount my work asked me if I was Moroccan. Why Moroccan? Because of the *pateras*, they explained to me. Apparently Moroccans use a type of boat they call *pateras* to cross the strait of Gibraltar. So they were referring to that issue, of Moroccans crossing the strait of Gibraltar to go to Spain; it was a familiar idea. I said, "Do I look like a Moroccan?" They said, "Well, there are a lot of Moroccans in Spain." This is something that had never happened to me. I realized that anyone can be from anywhere, because if you saw the work I did in Korea called *Para Olvidar (To Forget)*, the ship is Korean. The materials are all from Korea. The idea was to construct this work with materials from that place. It has all these Korean texts. If you look at it and don't read the name of the artist, you may think that it was made by anyone, even someone from Korea, because commentary has universal application.

In Cuba there is a lot of talk among artists directed toward this *Cubania*. They make reference to geography. This was used a lot in the 1980s, and it is still being used a lot now. They make reference to the shape of the island, the symbols of *Cubania*, things that identify Cubans. It is one tendency or path used by Cuban artists. It became more visible in the 1980s, but in reality it began earlier. It is a road that Cuban art has taken for a long time, and refers often to the island itself, to the geography, to life on the island.

KJ: So are Cuban artists in the 1990s no longer working in this manner? Is the work more metaphoric and less direct?

Kcho: It is less direct. In December when I attended an exhibition in Havana, I was impressed at how a number of artists relied on the geography of the island. This is very Cuban, that the island be present in every work as a formal element. In some it is very evident and in others it is just a metaphor. For example, in Garaicoa's work, he makes reference to the architecture, the disintegration of the city of Havana. *Los Carpinteros* have many works that refer to the island itself, and others that are more allegorical—if you look at them, you could not make the assumption that the works were made by Cuban artists. However, in other works they speak about being Cuban; and then the idea of *Cubania* is a lot more direct. You can find many things in Cuba. At this moment it is very diverse.

Daydream Believer 1996 (detail) chalk on slate paint
Inaugural wall project, 1997: Museum of Contemporary Art, Chicago
Courtesy Museum of Contemporary Art, Chicago, and the artist
Photograph: Joe Ziolkowski

(LIKE HOME) **Gary Simmons** interviewed by Siri Engberg 7/10/96

Gary Simmons is an artist enamored with American popular culture, deftly referencing it in his work with the satiric wit and
biting social commentary of a political cartoonist. Because he is also an artist who refuses to shy away from
the use of either beauty or ambiguity, Simmons has created a body of work that interweaves material and mes-
sage in alluring, often explosive ways. From his early work with minimalist, racially charged sculptural objects
and installations in the mid-1980s to his large-scale chalk wall drawings in which image and content are
blurred by erasure with his hands, Simmons has continued to probe the capacity of nostalgic, oddly familiar
images to house memory and meaning.
The subjects of Simmons' recent wall drawings take the form of dreamlike recollections, communicated in the form of dis-
parate images culled as much from legends formed on film, in magazines, and in the world of sports as from
what was included in, or omitted from, history books. His pointed examination of the means by which social
stereotyping is imprinted on culture is often veiled in thoroughly romantic imagery: a ballroom crowned by a
chandelier formed from nooses, or a madly spinning gazebo. Like the environment of the cinema, Simmons'
spaces are enveloping, arresting, sometimes disquieting — a forum for the senses. The conversation that fol-
lows took place at the artist's studio in the Chelsea neighborhood of New York City.

SE: I remember first seeing your work in 1991 in the exhibition *Interrogating Identity* at the Walker Art Center. A
few pieces in that show — a pair of bronzed Reeboks and a wall piece with "Us" and "Them" embroidered on two towels — struck
me. I was interested in the minimalist beauty of the objects, and how that initial seduction led to a realization that the subject
was quite loaded. Is a drawing-in of the viewer through physical beauty something you're still working with?
GS: Yes, but a subtle beauty. I think the beauty relies on the shards and snatches of information we retain from a visual
image in our memory — that moment when something is familiar, but you just can't pinpoint it in your immediate experience. So
it haunts you. That's what I'm trying to translate. I'm trying to visualize the ghosts, if you want to call it that. I'm really drawn
to an object or a space, whether it's some structure or a landscape, that has a layered history — like a ballroom or an amusement
park. These are places that people have a shared but very personal relationship to, yet they define something larger and struc-
tural, a certain kind of political or perhaps romantic experience. Those definitions are blurred and come much slower. I think
some of the earlier work tended to be a little more straight ahead and clear in its intent.
SE: Very graphic . . .
GS: I think anybody making art is trying to construct a visual language with their work. Early on, I think I was trying to
mix a minimalist aesthetic with a social/political commentary. The problem was that the work, maybe because of its directness

clockwise **Double Grin 1993** Collection Joel and Nancy Portnoy
from upper left: **Toothy Grin 1993** Private collection
Triple "X" 1993 Collection Whitney Museum of American Art, New York
all works: oak, **The King 1993** Collecton the artist
Masonite, slate paint **Crazy Conductor 1993** Private collection
and chalk with fixative **8 Sack 1993** Private collection
48 x 60 in. **Triple Eye Maestro 1993** Collection Hirshhorn Museum and Sculpture Garden,
Smithsonian Institution, Washington, D.C.

in terms of subject matter, was received only as a racialized commentary. All of the art-historical referencing was getting lost in the reading. As I became more versatile with my own language, I found a comfortable leveling-off—a zone where I wouldn't mute the content but could buff the edges a little. So it was not as direct, and the viewer had to really move slower with the work. I'm still very happy with a lot of the early work, but for me it had become too channeled. I think now that the racial angle is just one of the different avenues people can enter into. There is more room to breathe, in a way.

SE: You had two very different art school experiences. Two coasts. Two groups of influential instructors.

GS: I had great art school experiences. I wouldn't trade them for anything. I studied with some great working artists, and that was important—to see how artists develop and frame their work in a historical sense, rather than just going from piece to piece and moving on. I studied with a great sculptor, Jackie Winsor. She used to say that when you made a piece of work, you should roll it down a hill, and whatever fell off didn't belong there in the first place.

SE: Let it live in the world first.

GS: It's true. You have to get rid of the fluff and the cover and all that, and boil it down to what the piece is about. I studied with Winsor and Joseph Kosuth. I studied with some great theorists in New York: Craig Owens, Douglas Crimp, and Donald Kuspit. But then I really wanted a different kind of experience, because at the School of Visual Arts, it was all about *making* lots of work. The theory was you'd come to your so-called style or ideas through making tons and tons of work. And so I wanted the opposite experience, and I went to California. At CalArts, you didn't make anything until you knew what the hell you were doing. I really felt tied to a lot of the California artists: Michael Asher, John Baldessari, Doug Huebler, and Catherine Lord. She was a big influence. People like Mike Kelley. Coming from New York and going out there was an eye-opener. Bruce Nauman is another person who, for my generation, is the guru of learning how to play with your language.

SE: Many of the issues of memory you're dealing with can be associated with childhood: your use of the MGM cartoon characters in the early wall drawings, or the schoolroom images you've incorporated into objects. In much of the earlier work, you're drawing from what metaphorically tends to evoke an American childhood. Do you consider your work to be "American"?

GS: Yes and no. Yes, in the sense that I tend to draw on a lot of images in American popular culture. Many of those images have a strong connection or association with the ideal of "America," especially with some of the cartoon work. But no, in the sense that the work has shifted. It's moved toward structures and 'scapes that represent a more universal experience, or at least the internationalization of these American images. The more I travel, the more I realize how work is read internationally, how it gets processed. That's been an interesting thing, and I think it's changed the work, too. Things can get dismissed. You know, "Well, that's an American experience, and we're not involved in that." I think that's the problem with being grounded in too specific a commentary or in an overly particular language. Like the scene in *Chaplin* when Robert Downey, Jr. is trying to explain why it is that he won't make a talkie. He uses the example of the ballet dancer who talks to the audience with a Russian accent and describes to them the dance he is about to perform. All the magic is gone. That's one reason I rarely use text. I want the drawings to call on something else.

SE: I'd like to go back to the beginning of the drawings. How did you first start working with the chalkboards?

GS: I'd been working in a studio in an old vocational school. The studio was in a part of the building where they stored old chalkboards. To work on a wall, I had to move all the chalkboards from one wall to another. I'd been agonizing in my work over what object was going to really absorb what I was trying to deal with. And here I am moving these things every day around the studio, and then—boom—it hits me. Here is this beautiful surface that has all kinds of loaded history. Everybody comes to it with a different kind of history. Everybody has a relationship to it. And there are all these art-historical references to Beuys and Twombly. So I started cutting them up, without touching the surfaces at all. The early pieces were really about black on black, like Reinhardt.

SE: Like *Disinformation Paragraph* from 1990, where the blackboards themselves form a wordless sentence?

GS: That piece was one of the big corners to turn with the work, because it really began to merge some of the ideas behind the process with a certain amount of implied text. I always liked the idea of suggesting text by taking away the voice.

SE: And how did the wall drawings begin?

GS: I think the first was in 1990. It's interesting because the drawings really started through the sculpture. I began working on them after I did a piece called *Pollywanna*? There was this live bird in the project . . .

SE: The cockatoo?

GS: She was an actress, actually. I got her from a place that rents animals for films. We couldn't keep her quiet on the perch. I had painted a section of the wall with blackboard paint. The bird kept flapping her wings trying to get away. And as I looked at this, it really kind of played with my perception. The gesture of this bird's wings became really cinematic. It was almost like some bad acid movie where there are "motion trails." So I tried to get at that sense of movement. It just kind of registered. And I went back to the studio and thought, "I've got to get that gesture down somehow."

SE: The drawings have become more narrative, tableaulike pieces lately. How has this developed?

GS: I have always been interested in the way memory is triggered and programmed. I like the fact that we will leave this room, and the next time we come in here we will have a memory of how we moved around this space. That memory, in turn, fragments the experience. That's always fascinated me, the way we "construct" memory. The way we feel when we go back and sit in schoolroom chairs. The same but different.

SE: So a lot of the imagery has been about the memory of locations for you?

GS: Yeah. I think it's all become about locations. A lot of it refers to architecture, landscape, seascapes, structures. I think those things imply the figure more than if I drew a figure. And to me that's a lot more powerful. It's like in a western, just before the gunslinger rides into town. You see a saloon with a hinged door hanging off, and there are always shot glasses or whiskey bottles half empty on the table. It's that idea of space again—where the cowboys *were*.

SE: What's absent is as important as what's present.

GS: Exactly. And so the drawings have become haunted with the use of those kinds of images, like the gazebo or the roller coaster—places that are familiar, and that one has a relationship to, generally some kind of romantic relationship. They're the traces, like a ghost image of your experience.

SE: Where do you find yourself collecting your visual references?

GS: All over. I take snapshots wherever I go. I'm also a magazine freak, in addition to practically living at the public library photo collection. Old movies are a big source for visual references, and sports. I'm a popular-image junkie. Now I'm really interested in barren landscapes and junkyards. I like the idea of stripped territories, collected bits of disjointed history all thrown together in one place.

I'm working on a project for a house in the desert. I want to do drawings in this house in the middle of nowhere—Death Valley, Vegas, someplace like that. I'm trying now to actualize the work in these kinds of barren places as well as making it about them. With the sky drawings, I want the sky to function as that kind of 'scape as well.

SE: Do you make photographs of spaces?

GS: Yes. In order to keep a kind of log of my understanding of a room, or if I see something I want to use later, I'll take photographs. I also keep tons of sketchbooks. I keep a visual diary—a lot of collage things, this and that. I never show them. It's the only way I really "get" a space or a feel for a project.

SE: Let's talk for a minute about space. When you're working on the wall drawings, or on more installation-oriented pieces, how does the space become a medium for you?

GS: I was really fortunate when I was a student to work with Robert Irwin for a short while. It was interesting to work with someone like that because he is all about space, adjusting to a space—how the work as well as the room adjusts. We worked on one piece at Wave Hill in the Bronx. There was this beautiful vista, a gorgeous view, clouds, a blue day, just like today, and there was an arbor. So we were sitting out there and nothing was happening. So finally we all said, "Robert, what exactly are we going to do here?" And he said, "Well, you know, I've been thinking about this space for two years." At that time, I didn't realize an artist could think about a project for two years. And he said, "I just walked this space." And I said, "Okay, well, what are we building?" And he said, "You know, that's just it. We're not building; we're going to lower the earth because this view is too beautiful." And it was. At that point, I really understood what he was talking about. "Because," he said, "this view is so beautiful you can't obstruct it with some big, ugly object in the middle of it. What we should do is change the viewer's perception of this view." So we made this garden that was maybe 50 x 100 feet or something and we lowered the space three feet and lined it with Cor-Ten steel. The point is that by doing that piece, I really understood what he meant by studying the space. When it was done, we walked down these little steps [and being] three feet down radically changed your view of where you were. I said, "This is how I want to approach my work—it's not just applying something to a wall." And ever since that experience, I think the space has always been a really important thing.

SE: Scale, too, seems to have become more of a concern for you. The work has become larger—almost cinematic—in its scale. The viewer becomes enveloped in it.

GS: And that's what I wanted. Irwin also taught me about not being afraid of scale. A drawing doesn't have to be scribbled on a piece of paper; it can also be skywriting—such as the piece I did in Chicago—in the air. It's all a matter of scale and how you approach your space and your relationship to it. So when I get into a space, and I can either make an object or a drawing, I want that space to really become aware to me, somehow, so I am very much aware of my relationship to the room. Specifically for drawing and painting, I think the cinematic point is on target. That perspective became almost my scale model.

SE: I see what you're doing as action drawing, in a way. I look at photos of you at the Lannan Foundation, where you're wearing a mask and erasing the wall with a huge cloud of chalk around you, and it reminds me of the famous images of Jackson Pollock flinging paint. Has the idea of physical action and working directly on the walls changed things for you?

GS: Yes, because first of all, when you draw or paint directly on the wall, you are implicating the gallery, museum, or institution into the issues of the work. That space is a part of your discourse. And then the reverse happens when the work is painted out. The work becomes, literally, part of the history of that space. I kind of like that when you think of it in relation to the idea of erasure to begin with.

SE: You're conceiving most of the imagery in advance of approaching the wall, but by the time you get to the erasure, it's a completely open field, so to speak.

GS: It's difficult to say when the drawings begin or are finished because it becomes a spontaneous process. This idea of erasure is interesting to me on many levels. There is a shifting between abstraction and representation that is always important, as well as the blurring of what is familiar with what is forgotten. That attempt to translate the no person's land between the familiar and the forgotten into the formal activation of a room drives me. That's how I decide where to begin and end.

SE: As you move between working with drawing and making objects, how does the relationship between two and three dimensions operate for you?

GS: Well, it's strange that the work has been linked to this two-dimensional surface, when I started out as a hard-edged kind of sculptor. The artists that were some of my favorite peers were people like Liz Larner—artists that had a very versatile base. It was always important to me not to get cornered—"Now you're a painter, that's all you do." I wanted to make sure the base was broad enough that I could play with installation or I could play with painting or drawing and all that.

SE: When does the work become installation?

GS: Well, that's how the drawings really emerged—they were about installation, constructing an environment. I think once the work begins to define a space in that way, it's about installation. It's not about "decal-ing" work on a space. It's more about using the architecture to help define an idea.

above:
Ghost Ship 1995
chalk on slate paint
15 ft. 5 in. x 38 ft.

below:
Oh S#*! 1995
chalk on slate paint
11 ft. 9 in. x 27 ft. 5 in.

Installation views:
Erasure Drawings,
Lannan Foundation,
Los Angeles
Photographs: Susan Einstein

82

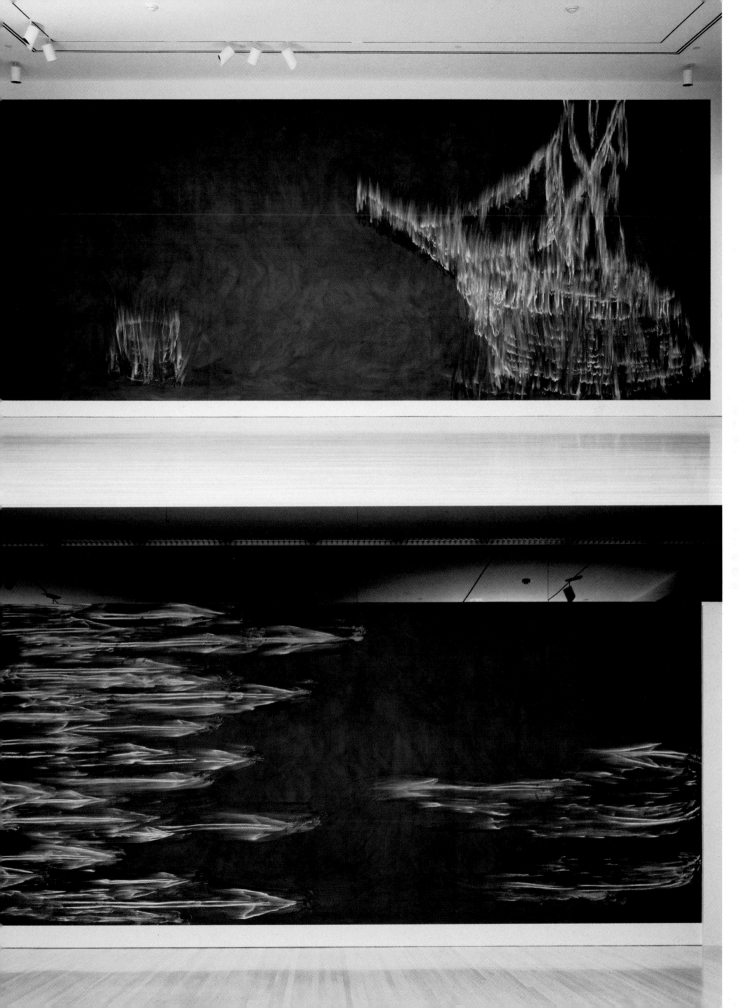

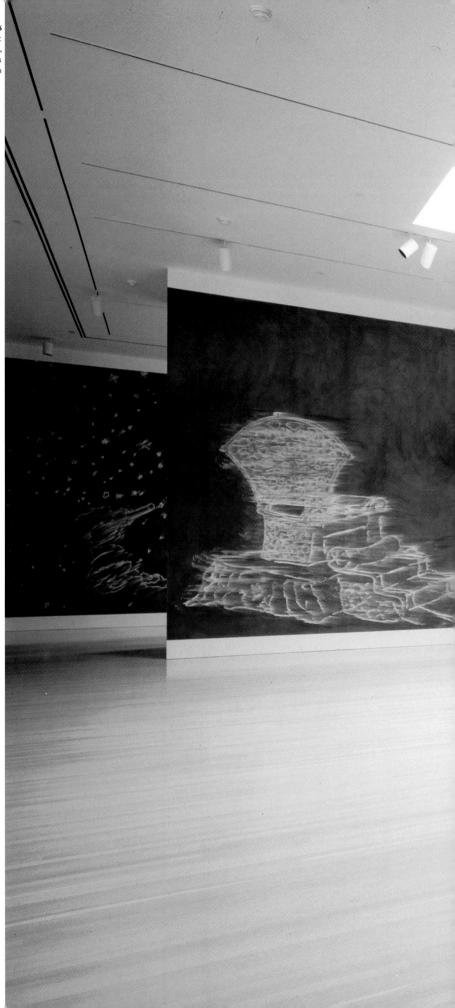

Ex Rex, The Ballroom 1995
chalk on slate paint
Installation view: **Erasure Drawings,**
Lannan Foundation, Los Angeles
Photograph: Susan Einstein

84

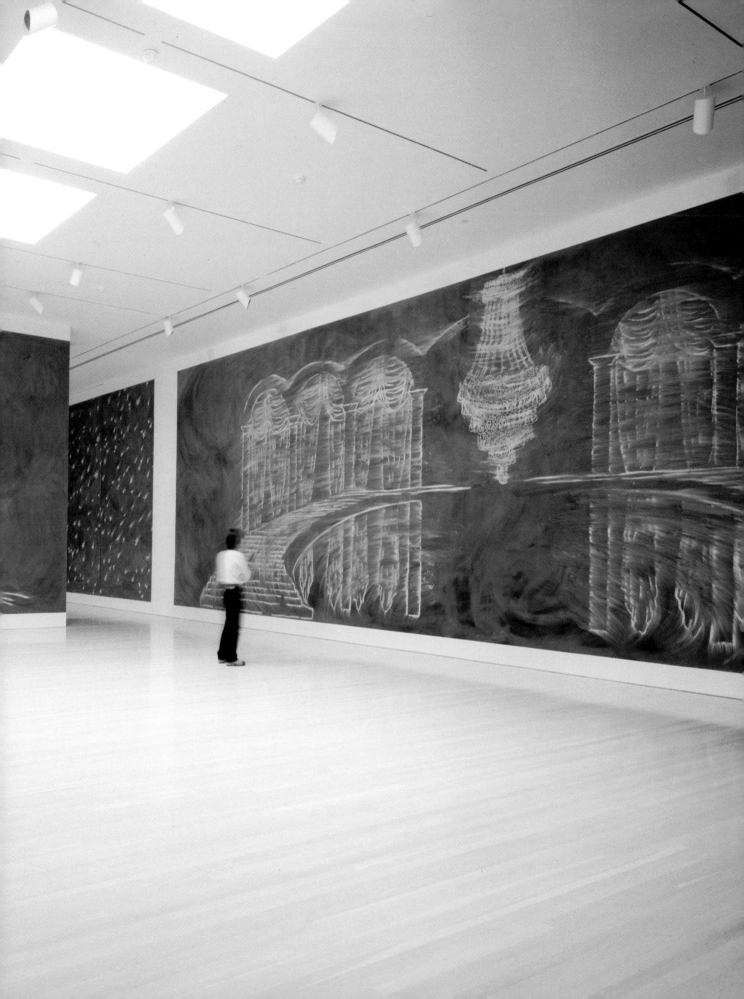

Gazebo 1996
chalk on slate paint
156 x 581 in.
Installation view:
Metro Pictures, New York, 1996
Collection Museum of
Contemporary Art, San Diego

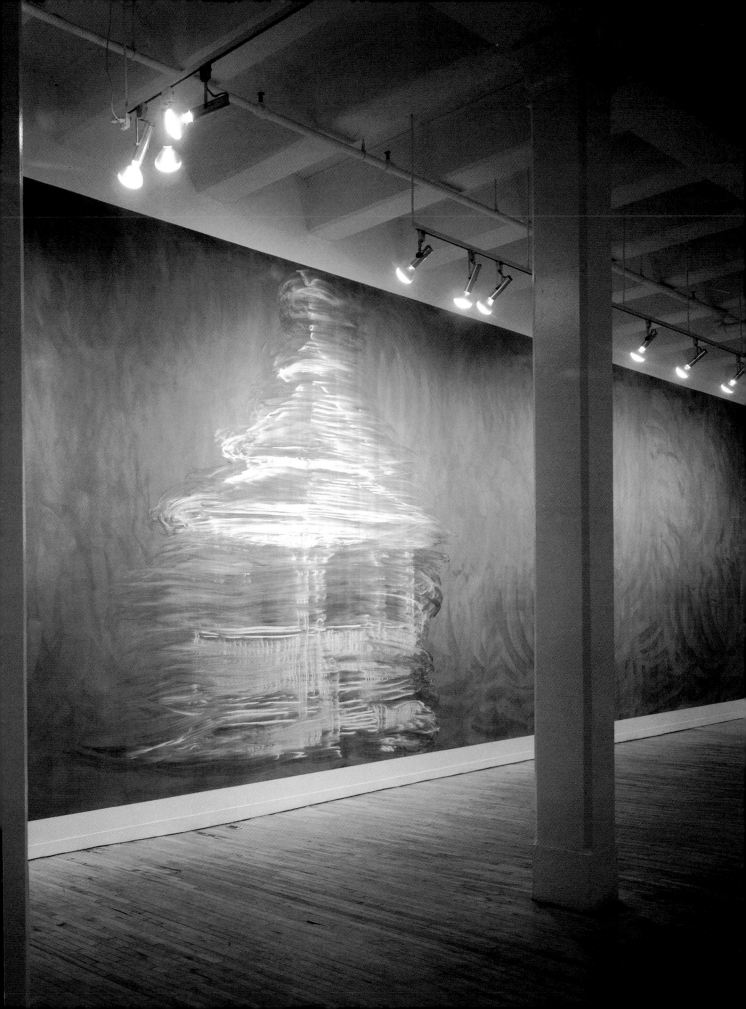

SE: You've also combined sound and organic materials such as flowers in some of your more recent installations. How does that sensory layer fold into all of this?

GS: Through wanting to saturate the viewer's senses. I started noticing the sensory mechanisms that went off with certain pieces. And that became interesting to me. The flowers [in the Whitney Biennial installation] were intensely red and white, and when we played with the lights, they just popped. I also played with the sense of walking into a florist's—which is one of my favorite experiences—where you're just overwhelmed by scent. I've always thought that it's almost as if you could taste the florist's room. So I tried to combine that sensation with saturating something visually. We lowered the temperature in the space so it was physically chilling. I tried to push the sensory points as far as I could and still load the piece with meaning.

SE: You've been in a lot of group shows over the years. A lot of them have been more thematic, "identity" shows. How do you feel your work has been positioned in some of these contexts?

GS: Thematic shows almost always do a disservice to an artist. They usually allow for only one interpretation of the work, as translator of that show's idea. Any other issues involved with the artist's work generally have to take a back seat. I think that's where a kind of ghettoization occurs. It's like forcing a square peg into a round hole; eventually it will fit, but you're going to take the edges off. Identity shows, especially, tend to be more about who the artist *is* than the work they're making. In my case, the work of course deals with racial issues, but there are many other layers that I try to work in. Emotional layers, like humor. Sensual layers, like scent. Other kinds of social commentary, about gender or class. That's why I've pushed the romantic images, for example.

SE: Where do you position yourself as the maker of an image in terms of the whole perception of it?

GS: An artist is a producer. I'm a kind of a tour guide. I don't want to be a preacher. I'd much rather be the tour guide, or not even the tour guide, but the bus driver of the tour. I think curators are probably the tour guides (laughs).

SE: Do you feel the work has been a success in that way?

GS: Well, for instance, I did a photo project where I went out and took these painted backdrops into different neighborhoods, photographed passersby, and then gave one photograph away and kept one for documentation. What it did do was draw in a lot of people who had never been in a gallery before. That was really successful to me, because I'd connected to some people who literally came in, shook my hand, and said, "I've never been to an art gallery before and now I would go because it's not that difficult." So you've made a slight crack in the dam that for some reason says the museum and the gallery are difficult places for people to enter. They'll go to see a film, but they won't come to an art gallery. They came in, and I felt pretty good about that. That was success to me. The bus driver was successful there.

89

Meyer Vaisman Interviewed by Douglas Fogle 6/20/96 NO PLACE

(LIKE HOME) **Meyer Vaisman** interviewed by Douglas Fogle 6/20/96

Meyer Vaisman has been active in the New York art world for more than a decade. In 1984 he founded International with Monument, one of the more successful cutting-edge galleries in the East Village. In 1984 Vaisman also started to have his own work shown, and in 1987 he appeared in an influential exhibition at Leo Castelli Gallery that also included Jeff Koons, Peter Halley, and Ashley Bickerton. While Vaisman's work from this period attempted to blur the boundaries between comedy and tragedy, often taking the artistic enterprise itself as the site of his investigation, he has recently taken a more sober turn in his subject matter. Creating installations out of actual rooms from his parents' home in Caracas, Venezuela, Vaisman has embarked on a project of historical excavation, tangentially investigating the displacement of his family from Eastern Europe to South America. It is the memory of this displacement that haunts the cinder-block structures he builds around actual rooms taken from his childhood home. This interview took place at the Walker Art Center on June 20, 1996.

DF: The first thing that really struck me when I looked at your installation at 303 Gallery in New York in the spring of 1996 was how different it really was. You seem to have come to a completely different space from where you started in the 1980s. Do you feel that you've made a significant transition from your earlier work?

MV: My work changes every two or three years. There are some concerns that are the same, dating back maybe eleven or twelve years ago when I began showing. The best way I could describe it would be (as a friend of mine pointed out) as the same piece of music—first played with a cello and then with a piano. The instrument changes, even though it's the same piece of music. My work has always been somewhat autobiographical. There is an element of portraiture in the work that runs all the way through. If you look at the turkeys that I did in the early 1990s, some of them were made with my own clothing. The work changes physically, but a lot of the same ideas that were in operation a dozen years ago still operate today.

DF: Portraiture would seem to be one of these key ideas. One could even consider the recent installations as self-portraits, in a way. But you've also used a caricature of yourself in your work. Where did you come across that?

MV: It was a portrait of me that a street artist made—a caricaturist outside of the Ufizzi in 1986. I ended up using it as a type of self-portrait, even though it's not a self-portrait because it was made by someone else. The one thing that is different about my current body of work is that the earlier work had a very clear sense of comedy as part of it, while I don't feel that my new work has any comedy at all. I'm referring specifically to the shanties, the rooms. For years I embarked on a project of trying to blur the difference between comedy and tragedy. And I think when I got to the turkeys I succeeded at that. You were looking at a dead animal and yet they were very, very funny. So they played on both themes at the same time. Once I finished with that series and embarked on this new one, I could not inject any kind of comedy. To me, this work is very tragic.

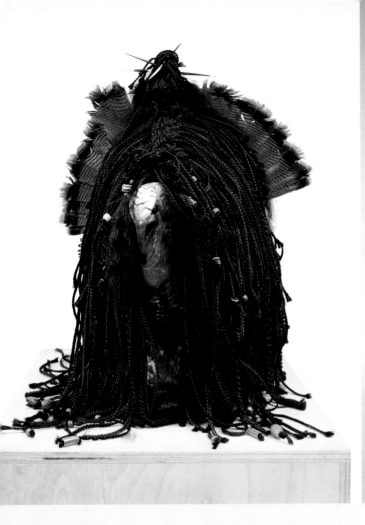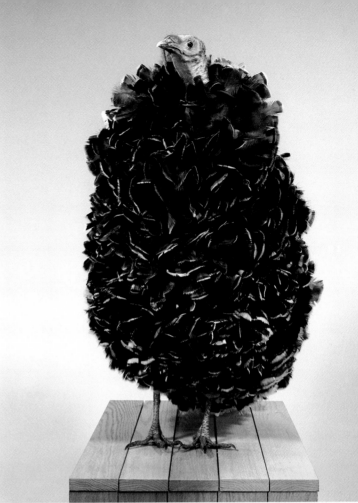
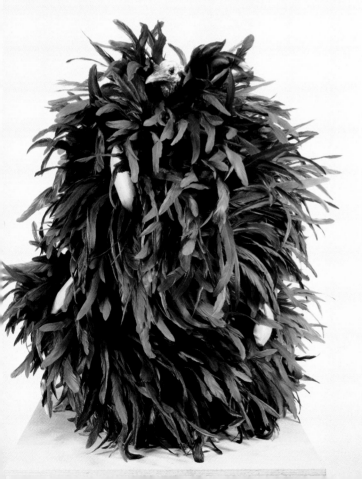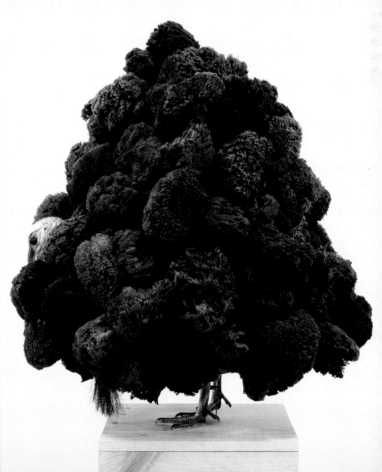

DF: Much of your earlier work was very self-critical of the role of the artist in the work. These new installations are constructed from actual rooms in your parents' home, which you take and put inside of cinder-block shanties. Do you feel that you've gone beyond a certain level of criticism to the point where you feel comfortable with a more sincere insertion of your own personal history into the work?

MV: I think what you are saying is true. I think in a certain way I used comedy as a kind of defense mechanism. You know the comedian is always onstage, and in this work I don't feel that I'm up onstage anymore. I'm down there with the audience. These rooms, even though they are very personal—they came from my house—have something about them that almost everybody, at least in the Western world, can relate to. I've heard many comments from people who say, "Yeah, it's your room, but I grew up in a room like that" or "I've seen so many rooms like that." So, I'm not being funny anymore, and I think that I'm not as defensive about my position as an artist in the world. Now I feel that I can be more earnest.

DF: So you feel more comfortable with your role as an artist?

MV: Yes. Up until 1993 I doubted it. And there are still times that I do doubt it. I think that's a very healthy attitude. I mean some of the best, the most interesting artists always doubt their position. And also doubt the whole endeavor as well.

DF: What's interesting to me about your career is that you've done so many different things in the art world. You were a very important gallerist at one point with your gallery International with Monument in the East Village, you've written, and you were also emerging as an artist basically at the same time that you were starting your gallery. Do you see that kind of blurring of boundaries as something that was specific to the 1980s? Do you feel that you would want to do that again?

MV: Participating in different ways still interests me. I wrote a piece for *Parkett* and I also wrote about a Venezuelan artist I was interested in for *Artforum*. It is something that I'd like to continue, but only when I really feel like I've got something to say. I don't feel like I have a so-called career in writing or as a gallery owner. I've found other involvements in the art world besides being an artist as fruitful, not just for me but for others, and it's something I'd like to continue at some point, but I don't know in what manner. Maybe I'll write a little more. I haven't really figured it out, but it is something that I do like.

DF: I think there is something interesting in your current work in which you reference your own personal family history in terms of having been displaced many times. You grew up in Venezuela, but your family is from Europe, right?

MV: They're from the Ukraine and Romania.

DF: The critic Jim Lewis once called you a poster boy for the multicultural, "a one man, walking, talking, multicultural

Meyer Vaisman's parents

artifact." The whole multicultural moment in certain ways has been about rescuing specific identities and putting them out there in a plurality. Much of your work is about deconstructing fixed notions of identity, so how do you position yourself vis-a-vis Jim Lewis' label? Was that a joke?

MV: Well, he phrased it as a joke, but it contains a truth. I do think the whole issue of multiculturalism has been taken in the wrong direction. I think people began seeing the idea of identity as a fixed subject. You can't talk about fixed identities any more. Perhaps with the exception of the Yanomamo tribe in the upper Orinoco River, there are few groups of people who have not seen outsiders, but it's very rare. So to talk about identity as a fixed subject is absolutely silly. I think what Jim referred to is that I embody different cultures. My parents came from the Ukraine and they emigrated to Venezuela in 1952. I was born there in 1960 and grew up in a very typical middle European home, but I would step outside my house and there I was in the middle of what is essentially a Caribbean city in South America. Later I moved to New York, which is, from my point of view, a city that doesn't really belong to anyone, which reinforced my feeling that one is really composed of many different identities. It is something that I tried to put forward when I did the turkeys. That was one very important theme, that yes, it is a turkey, but then it pretends to be a rabbit, and then it has a kimono on and it has many different lives to it.

DF: A kind of cross-dressing.

MV: Yes, something like that.

DF: Why turkeys, though?

MV: What I liked about the turkeys is that there is very little physical difference between the female and the male. They're differentiated by the fact that the male has an even number of tail feathers and the female has an uneven number of them. The male has what people in the know call a turkey beard, which is more like chest hair. But from afar you can't even see it. I also liked that the head of a turkey looks like human female and male genitalia mixed into one. It is an animal of the American continent, and that was very important to me. It is also incredibly stupid, and I liked that.

DF: The turkey is a very loaded image here in the States as well.

MV: Yeah, it is very loaded because of Thanksgiving, but beyond that the turkey is of this continent, not just North America but throughout.

DF: You were supposed to have represented Venezuela at the 1995 Venice Biennale, but your project was deemed inappropriate by the Venezuelan selectors?

MV: Yes. Venezuela derives its name from Venice. When Amerigo Vespucci was sailing around he came across a tribe of natives called the Guajiro who built shacks on stilts at the entrance of the mouth of Lake Maracaibo in what is today Venezuela. He derisively named it *Venezuela*, or "little Venice." In Spanish you can use the word *mujer*, which is "woman," but you can also say *mujerzuela*, which means a woman that's kind of trashy. Or *calle*, which means "street," becomes *callezuela*,

which means "shitty alley." So Vespucci saw Venezuela as a shitty Venice in a certain way. What I wanted to do was to re-create my childhood bedroom and the bedroom of my adolescence, one clad in a Guajiro shack and the other one in cinder or terra cotta blocks very commonly used in Latin America. I also wanted to have equal parts of water from the Venice lagoon and the Coqisivaco lagoon (which is where the Guajiro lived), circulate throughout the pavilion.

DF: In some sort of pipe structure?

MV: Yes, through clear hoses. What the government complained about was that they thought it wasn't proper for Venezuela to be represented by either a Guajiro shack or a common shanty. They read the work very literally, and they turned an artwork which I thought was much more sociological, historical, and psychological into a political piece by denying its entrance into the Biennale. That's essentially the story.

DF: There wasn't any political resonance for you at all in terms of a class analysis? It seems hard not to read them that way, at some level, because of the dramatic nature of the materials and the difference between the interior and the exterior. In the interior you have a very middle-class, if not bourgeois existence, and on the outside you have these very starkly constructed houses.

MV: You have to remember that shanties tend to be associated only with poverty, there and here as well. But a shanty is a form of organic architecture. A couple marries, they build one, they have a son and they build another room and they have a daughter and they build another room. Their mother comes from out of town and they build another room. They are built on top of one another, not unlike what you see in hill towns in Tuscany or Umbria or places in France—all over Europe, actually. The thing about shanties is that they are not finished on the outside, which does not mean that they are not finished on the inside. People don't care about the way they look from the street the way you would when you build a house in the United States. I think that this was inherited from Spanish architecture, where everything goes on in the interior of the house. So houses have an interior courtyard and all the rooms face in and the street means absolutely nothing. This was inherited by Spain from Moorish architecture. Given the influence of the Arabs in Spain and Portugal, and then Spain and Portugal's influence on this continent, I think that's what carried through. I mean, people associate it with poverty, but looking at it from a strictly architectural point of view, the shanty ignores the street in the same way that Arab houses in the twelfth century ignored the street. If you go into one, from the outside it looks like it's going to fall apart, but inside it looks like a regular house. There were no complaints about these installations in Venezuela. When I first showed one of the shanties in Caracas, I was curious to see what the reaction would be. The public reacted really well to it. They liked seeing a shanty inside a museum. And from what I heard, it kind of uplifted them, because they felt that if a shanty was in a museum then it must mean that they are not so bad as people say.

DF: So this reaction was actually the opposite of what kept it out of Venice. It legitimized it.

MV: The thing is, the same people who vetoed it from going to Venice loved it in Caracas. They liked the piece a lot but they just thought it wasn't proper for export.

DF: So Venezuela was trying to present itself within the context of the Biennale as a developed country rather than "developing."

MV: Precisely.

DF: So you didn't participate at all, then?

MV: No, I didn't.

DF: You've suggested elsewhere that you don't make critical art, that your art isn't social in the way we were just talking about. The reading you would give the project you proposed for Venice is not a political reading. It was more personal, historical, cultural, or sociological. You've even said that you don't think art is a good medium for enacting any kind of social meaning. Do you still feel that way?

MV: I feel that way when art is ardently political, or when it has a political point as its first facade, let's say. I do think art can have a political edge, and I think this work in particular does have it, but I don't think this is first and foremost.

DF: In past interviews you've mentioned the films of Stanley Kubrick. In fact, you did something of a playful interview with curator Trevor Fairbrother in which you invoked this wonderful scene from *Dr. Strangelove* where General Jack Ripper talks to Captain Mandrake about "purity of essence" and "precious bodily fluids." Are you fascinated by Kubrick in particular?

MV: I think he's one of the great artists of this century. I'm a great admirer, and I do think of him when I make my work. What I like about his movies is that there are no heroes, no villains, everybody's just the same. Everybody's a creep in the end. They're funny and not. I mean, he does what I would like to do with my work, but he does it on celluloid.

DF: The installations that you are doing now, the shanty rooms, do seem cinematic in some strange way. One views these rooms through holes in the walls set at different angles that a camera might be set at. You don't get the depth of field in the same way, but you definitely get a directed view. Do you think that cinema has influenced the way you see?

MV: Not cinema as a medium. Much more in the way Kubrick in particular thinks. But I see what you mean by controlling the viewpoint. Except there is no narrative. You almost have to create your own when you look into one of these rooms.

DF: In at least one of these rooms the viewing holes in the walls are framed by human pelvic bones. What made you choose a piece of a body to look through as a framing device?

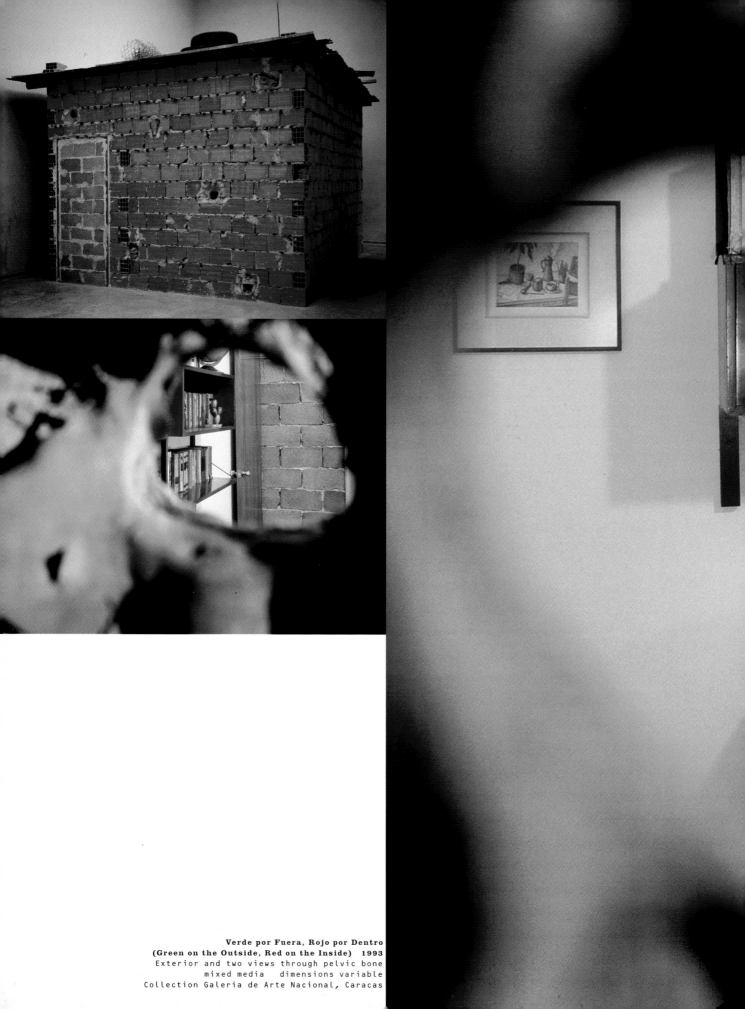

Verde por Fuera, Rojo por Dentro
(Green on the Outside, Red on the Inside) 1993
Exterior and two views through pelvic bone
mixed media dimensions variable
Collection Galeria de Arte Nacional, Caracas

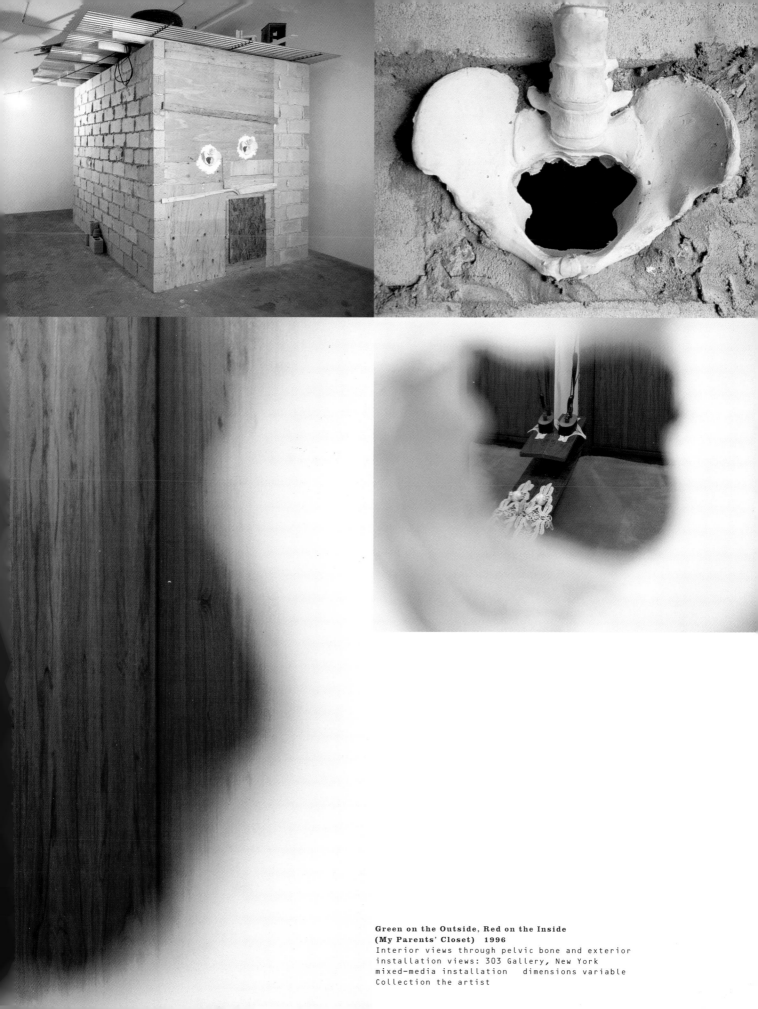

**Green on the Outside, Red on the Inside
(My Parents' Closet) 1996**
Interior views through pelvic bone and exterior
installation views: 303 Gallery, New York
mixed-media installation dimensions variable
Collection the artist

clockwise from upper left:
Propriedad Privada (Private Property) 1995 (front and back)
Collection Jimmy and Leonora Belilty, Caracas
Propriedad Privada (Private Property) 1995 (front and back)
Collection Salomon Mishaan, Caracas

both works: mixed media 27.2 x 25.6 x 13.4 in.

MV: That came about as a sort of unconscious accident. When I planned the first shanty that I showed at the National Gallery in Caracas, I was going to just make holes that you would use to look into the room. But I also wanted to have within the brickwork a certain sense of archaeology. So I cast female pelvic bones as well as pigs' skulls. These were put right into the brickwork and from afar you couldn't tell the difference. When you got up close you could see the skulls and the pelvic bones. But it hadn't occurred to me that you could look through the pelvic bones into the piece, and that's what I ended up using as a device, which worked out nicely because the work is so personal. The piece that I built in Caracas had female pelvic bones because I felt that I was entering into my mother's womb and looking into my life. The one I built at 303 Gallery in New York and then in Portugal used male pelvic bones because the shanty contained the dressing room from my parents' bedroom, so I felt that it had to be seen through me, therefore I chose a male pelvic bone.

DF: What interests you about the archaeological? Is it the sedimented layers of memory?

MV: Precisely. It was a sense of memory.

DF: So much of your work, especially this work, seems to be about memory. The archaeological as a model is a way of uncovering memory, or reconstructing memory and telling a story about something that happened, whether it is the truth or not. Is this the main motivating force behind your work now?

MV: Well, it is. I've gotten involved in what I guess I'd call a type of reverse archaeology. I also did a whole series of works in Venezuela in the summer of 1995 where I was building what looked like fragments of very typical walls all over the city of Caracas. On the back side of the wall, I embedded a number of objects that I stole from people's homes. I would break into the brick and glue the object with cement, so I was thinking of it as a kind of reverse archaeology where you actually put something in to create certain associations, as opposed to looking through and finding something.

DF: Embedding a kind of evidence into the structure.

MV: Yes, right.

DF: The question of memory has an interesting relationship to architecture. In his book *The Poetics of Space*, Gaston Bachelard talks about the way rooms physically hold certain phenomenological memories. When you think about your rooms, these were spaces that you physically inhabited at the different times of your life. And especially in the ones with the high-modern 1960s decor, one thinks of the way in which the functionalist notions of modernist structures (such as furniture design) remember the body and try to give a functional space for the body to work in. Do you think about these things?

MV: I do think about the architectural truth of it. I also think about what's outside and what's inside. In a sense, you could contrast the look of a shanty to the interior. Things operate on two levels. A couch pulls out and it becomes a bed, so the room itself does have a memory, an imprint of my body or those of the members of my family. One thing I found particularly disturbing when I rebuilt these rooms was to actually disassemble a piece of furniture and reassemble it again. I found it truly disconcerting to pound a nail through an already existing hole, to re-create something that already existed not only in the past, but in a totally different geographical place. So there are a whole set of associations that come forward as I build these pieces. As I was building the one in Portugal, I remembered that my house in Venezuela and all the furniture in it was built by Portuguese bricklayers and carpenters. So there was this room in this house that was built by Portuguese in Venezuela—part of it was sent to Portugal and was built again by Portuguese, using the same holes, the same wood, etc. Those are things that only I know about the work, but I do find them interesting in the way that memory is construed and what it means. I find that I get into really horrible moods when I build these rooms. It kicks up a lot of things in ways that the other work never did. I had a wonderful time making the turkeys. I don't enjoy building these structures.

DF: Which makes it interesting that you're still doing them. The house that you take the rooms from is still owned by your parents in Venezuela?

MV: Yeah, they still live there.

DF: What do they think of you ripping the rooms apart?

MV: Well, they're not too happy about it (laughs).

DF: Do you rebuild them as you leave?

MV: I leave big empty rooms.

DF: Because you take the paneling and everything, right? You take the walls?

MV: Everything. All the furniture, the carpet, the lamps, the built-in closets, everything. The room becomes a shell to be occupied by something else later, because the furnishings never go back. Once it's out of there, it's out.

DF: That strikes me as violent, an excising of your own history—literally, physically, and phenomenologically.

MV: I totally agree with you, but I do find, in terms of the way parents relate to children and vice versa, that in my case it ended up being very, very fruitful, because I was removing this kind of false sense of who I was and giving them a sense of who I am today.

DF: Earlier you said that these are not comedic but tragic works. Is this where tragedy comes back into it? Is it the tragedy of the conception of oneself, whether it's the parental conception of you as this seventeen- or fifteen- or thirteen-year-old, as opposed to what you've become?

MV: Yes, I find them totally tragic. Even in the setup of the rooms, even the furniture. Before I made the first piece I was

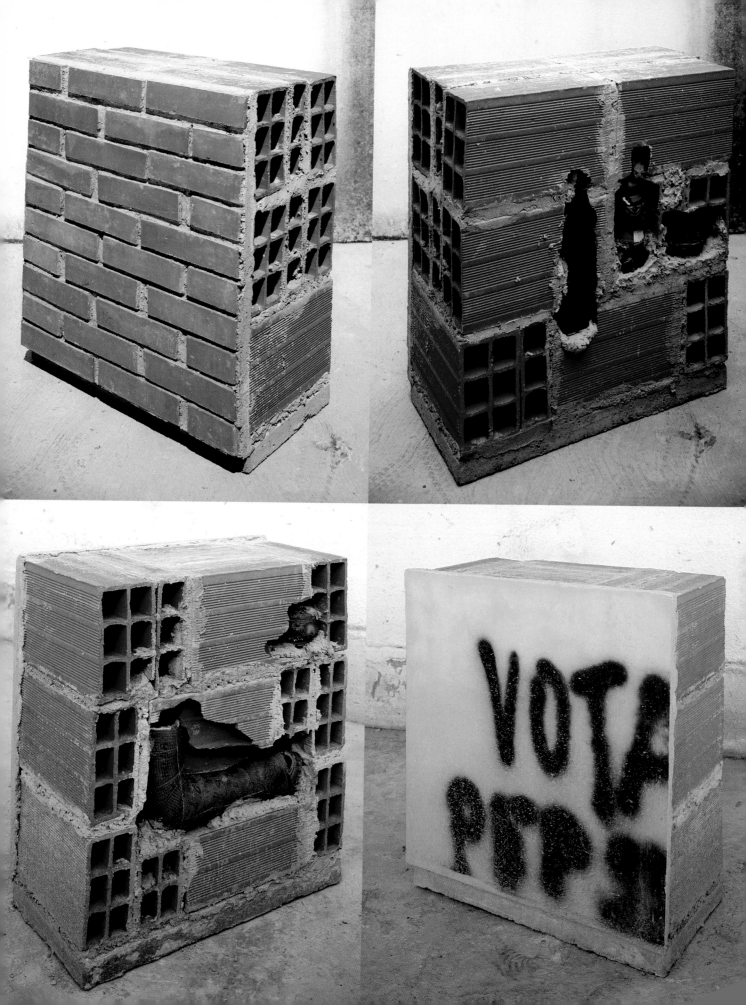

Miranda en la Carraca
Series of Ecktachrome prints for
Artforum (Summer 1995)
Photographs by Jose Antonio Hernandez-Diez

describing to a friend what I was going to do, and he said, "You mean it? You still have the rock posters and this and that?" And I said, "No, I wasn't allowed to have posters in my room." It's a really sad room, and somebody suggested that it doesn't look like a room of a teenager, but more like the room of a widower. The only visual material that you find in it are a lot of books. But what kind of books? Dostoyevsky, chronicles of World War II, *Exodus*. Nothing that would interest a regular teenager.

DF: No comic books or rock magazines.

MV: Nothing of the sort. It truly looks like the room of a widower. And the only pictures are black-and-white photographs of my brothers and me, and a picture of my grandfather. A kind of patriarchy without the figure of the father.

DF: You've been on the move since you were seventeen or eighteen?

MV: I was eighteen when I left. I went to Miami for a year and a half and since then I've lived in New York. I wanted to be an engineer. I was going to be a mechanical engineer because it felt like it would be really useful to design machinery and those sorts of things.

DF: It's different from what you're doing now. When you went to New York, did you know you wanted to be an artist?

MV: No, I went to New York to study at Parsons School of Design to become a graphic designer. And then after a little bit of a stint at that, I decided I was just going to be an artist, period. It never occurred to me that I could be an artist. It just did not seem like a useful thing to be. And I guess maybe that was very clear in my work up until the turkeys. That I didn't think it was useful to society.

DF: Has this manifested itself in a certain cynicism toward the art world?

MV: I think the art world needs to be made fun of, seriously. I try to imagine what somebody who is outside of it would think of it. Because to me it's just totally weird, even though I've been in it for twelve years. So poking a little fun at it is not a bad thing, and I'm certainly not the first to do it. Not the first and not the best that has done it, either. There are many other artists who got on that dirt road which took them to great places.

DF: Are you thinking of Duchamp?

MV: Among others.

DF: If Duchamp is seminal to your agenda, are there other artists that really influenced you when you were younger?

MV: I've always liked the spirit of Duchamp as well as Warhol, Picabia, and Dali. But you know, Bosch is a great favorite of mine, and Goya is another one.

DF: In terms of Goya's relation to royalty and the way in which he was both getting fed by them but also quite critical?

MV: Absolutely.

DF: Does your latest work get read in terms of a kind of cultural authenticity that would make you nervous at all?

MV: I think people see the work with a great deal of suspicion, and some of the criticism has been that I'm just riding this wave of multiculturalism. The interesting thing is that artists and curators and critics throughout Latin America have no problem with me at all. It's only from this end, because all of a sudden art outside of the United States and Europe was recently "discovered," much like Columbus discovered the "Indies" in 1492. And so they don't have a problem in Latin America; the problem comes from here. I told somebody recently that my work was accepted in the 1980s because my last name was not Hernandez. But today they see it with suspicion because my last name is *not* Hernandez. So people have to figure out where I fit in all this. I don't fit in anyplace, and I think that makes them uncomfortable.

DF: And not fitting in anyplace has to do with your own history. You live here, but you've grown up somewhere else, and then you studied somewhere else.

MV: My parents are middle European and theirs is a complicated, complex history. I think my work reflects that, and the problem is that people want to be smart and neat and they want to understand that an artist is from Latin America or an artist is from the 1980s or whatever. A critic friend of mine from South America told me recently that somebody said to him, "Well, you know he can't be from South America; he was an artist of the '80s." That statement has an implicit kind of a racism in it, but I'd bet few people would see it.

DF: Well, you were a willing participant in this very commercial wave in the 1980s, but a very critical voice at the same time. The whole aftermath of that scenario seems as though it's going to code the way a lot of people will read your work, whereas it's really quite different from what they're imagining.

MV: Yeah, I can see that, but I just think there's a lot of hypocrisy in the way some of the art made during the 1980s was dealt with. Essentially, I think that's a very superficial way of looking at it. I remember that when I did the show with the turkeys, people had by that time written me off. But the turkeys were well received and people would say to me, "God, you know you're not an artist of the 1980s, you're an artist of the 1990s." And I thought, "What the fuck does that mean?" I'm neither of those. I think I'm an artist of the next millennium. I don't think in terms of hemlines, or decades. I think an artist's work only gets interesting after ten or maybe fifteen years, and I don't see why people have to be pigeonholed into one thing or another.

DF: Do you think that was because of the capital-intensive nature of the 1980s art market and its subsequent crash?

MV: I think it all has to do with money and nothing else, period. It has nothing to do with the work itself.

DF: How many of these projects are you going to do with the rooms? Do you have another set of projects in mind?

M V: I have some works in mind that are somewhat related to them—although they may look similar, they explain exactly the opposite thing. They're totally impenetrable. This is a series of sculptures that I'm thinking about. And I have other ideas.

D F: Impenetrable in the sense that you can't read them or that you can't actually see inside them?

M V: They actually relate to impenetrable spaces. When I built the shanty in Portugal inside the museum space, all of the artists in the show were supposed to do a piece outside and a piece inside. For my inside piece I was given this great big room and I didn't really want to do a piece inside, so I told the curator I'd do something when I got there, which had him scared. They gave me this very beautiful room to work in, and what I did was block up its entrance with cinder blocks. So I'm working with that idea as well.

D F: There's a wonderful scene in the Orson Welles film *Touch of Evil*. The opening tracking shot goes back and forth across the U.S./Mexico border and you've got Charlton Heston playing a Mexican with Janet Leigh as his wife. The film itself is all about the border and this pathology of the border, and Heston is a character who is, of course, the law.

M V: I haven't seen it, but I understand what you're saying. In a sense, how long can one sit on the fence? And to me that's a very interesting position to take. It's the only position I can take as a artist, given my personal history and the history of my family, which is the history of people displaced for a long time in the Ukraine and Romania who end up in Venezuela. And I cannot do any other kind of work from what I do, truly.

D F: If you're an artist of the next millennium, what's the next millennium?

M V: I don't want to think about it right now, but I just read how all computers are going to crash in the year 2000. I don't understand the mathematics of it, but it seems like the world's going to crash because of the computers. I kind of like that.

(LIKE HOME) **Kara Walker** interviewed by Liz Armstrong 7/23/96

In 1994, an exhibition at the Drawing Center in New York caught my attention (and that of a lot of other people as well). It was dominated by a large panoramic tableau, made simply yet forcefully out of cut black paper, with the provocative title of *Gone: An Historical Romance of the Civil War As It Occurred Between the Dusky Thighs of One Young Negress and Her Heart.* It was one of the first public appearances of the "young Negress" of the title, whose unsentimental journey through the historical fiction of the antebellum South has been subsequently traced by Walker in a growing body of drawings and silhouettes. What I felt in the Drawing Center's panorama was the fantastic force of a fairy tale combined with the cocky ambition of history painting. The artist's fresh voice, her aggressive portrayal of humor, sexuality, and violence, and her seductive use of the nineteenth-century technique of silhouette all contributed to the work's impact. She was an artist about whom I immediately wanted to know more. I had a chance to sit with Kara in July to talk about her work.

LA: Could we start by talking about what it would look like if we were at your studio rather than sitting in the Walker Art Center's Print Study Room?

KW: I keep at least one section of the wall filled with images of popular racism, Americana of the sort African-American intellectuals find compelling as collector's items. Actually, several of the postcards and posters I keep are contemporary reproductions of nineteenth- and early twentieth-century advertising images: some are authentic, and some are recent images that are reminiscent of an earlier brand of racism, a less self-conscious brand. Like an Annie Liebowitz postcard of Whoopi Goldberg (an avid collector of Afro-Americana, herself) immersed, spread-eagle, in a bathtub full of milk. It's obviously meant to be provocative, but pinned up next to an old card featuring a cartoon of a classically posed, nappy-headed nude black girl, intended as a parody of beauty, it's problematic.

The reason I collect these images is really for their sheer strangeness, the almost open-endedness of meaning—you know, because racism is so *direct*, there's usually no difference between an insult and an end result. But, as an artist looking at what for better or worse is artwork, I sense the love/hate relationship these earlier artists must have had for their subject. Blacks, or in the case of these images, niggers, coons, pickaninnies, mammies, and so on, are rendered not only as second-class and subhuman, but also as picturesque peasants. Every possible variation on the general theme *race* gets a place in my picture file. Exoticism and creolization and lust and romance and the Civil War and cinema and hate groups . . . these are all areas of interest.

I'm currently reading *The Narrows* by Ann Petry, and there's this great little passage that reminds me of how I inherited a racist mind. "There wasn't much about The Race that he didn't know. Abbie kept telling him all the things he could, and could not, do because of The Race. You had to be polite; you had to be punctual; you couldn't wear bright-colored clothes, or loud-

colored socks; and even certain food was forbidden. Abbie said that she loved watermelons, but she would just as soon cut off her right arm as go in a store and buy one, because colored people loved watermelons. She wouldn't buy porgies because colored people loved all the coursefleshed fish and were particularly fond of porgies. She wouldn't fry fish, she wouldn't fry chicken, because everybody knew that colored people liked fried food. She was always on time, in fact, way ahead of time, because colored people were always late, you could never count on them, they had no sense of responsibility . . ."[1] You see, there is a clearly drawn blank space defined here by all this denial. My black hole, my silhouette, is informed by these same sorts of "reasoning" as well as the confusion of facing myself as an *undesirable colored person* in the eyes of other people.

LA: In addition to your collection of black Americana, what else would we find in your studio?

KW: Well, there's just this one big room. When you get to my work, I usually have a couple of things going at all times. And I work on drawings and watercolors, which is the easiest, most traditional way of processing ideas or creating a new storyboard or story line for the larger work. And I have a few cut silhouette pieces, black paper pieces, either fixed to a wall or on some cardboard waiting to be put into production. I have pieces on canvas that are a little bit earlier, when I was uncertain how to get away from painting proper, on a large table in the middle where all of this happens.

LA: Did you study painting at the Rhode Island School of Design?

KW: And the Atlanta College of Art before that.

LA: Do you make drawings on a daily basis?

KW: I keep an ongoing record of drawings and some short, short, short writings that are a thrust for the large wall drawings. With the drawings I kind of see myself dredging the muddy bottom of my mind for stereotypes and archetypes. The writings usually set up a loose kind of narrative or analogy, like the idea of *utopia* as something implicit in the word "freedom". . . the North, Liberia; all of these destinations for the black utopia, or the perils of leadership, you know. For sophisticated Americans there is a heightened expectation for *successful* black leadership, so I began a short story about a would-be Sojourner Truth / Harriet Tubman leading "her people" back to Africa on a sinking ship. It started to get surreal so I quit for now. There's another tale about a woman named Eli Whitney, after the inventor of the cotton gin, who runs a still and meets several white "gentlemen" in the woods regularly so that they can sample her brew. She does this because desperate and drunk men are easier for her to control.

When I started this body of work I was trying to explode a lot of the ideas about race and sexuality and all this identity business; I wanted to do it without becoming a didactic know-it-all. I needed to expose all my contradictions. Drawing was sort of novel for me only in that I had this kind of pseudo death-of-imagery monologue in my head preventing me from picking up a pencil for a time.

LA: Your drawings reference a nineteenth-century style of cartooning . . .

KW: Yeah, but I think that's almost by accident. It's just the way I draw. Actually, I think the first batch of drawings that I did were blatantly trying to reference that nineteenth-century kind of style. Or actually not even 19th century, but more of a colonialist kind of spirit, using a calligraphic hand and pen-and-ink washes and things like that. It was a little bit overstated. But I liked the drawings, and where they took me was kind of cathartic.

LA: Are the drawings studies for your larger pieces?

KW: They aren't directly studies. When I do the actual studies for a piece, like the Drawing Center piece, I use a long narrow sheet of paper and sketch out scenes, but they still get reworked. When I get to working on a piece on-site, I have a lot of leeway, and it's very exciting for me to go into a place and then have another idea or have an image that plays off of something.

LA: So you're saying when you're on-site making the silhouettes, there's some improvisation that takes place?

KW: Yes, a little bit.

LA: You talked about referencing literature and also about your own writing.

KW: I do some writing, but nothing complete. It's important for me that I have lots of little works and short stories that operate in the same way as the small watercolors and the small drawings. I'm trying to set up a narrative of myself that references — well, what does it reference? — that references a fictional construct through which I tend to view much of my life. A fiction — I mean like a novel, with a heroine and an almost discernible plot. In my case, the plot suggested a lot of suppressed, self-imposed racism. It was racism in parentheses. Kind of between the lines. It was only recognizable in the closest situations. It really blossomed in romantic situations, so I started thinking about the historical romance and that kind of thing.

LA: You mean reading historical romances?

KW: Reading them, and actually having my life seem like a bad novel. This is what I'm getting at. And not just any old bad novel, but a very specific bad novel that is set in the South, with all of the dripping Spanish moss and illicit desires and politics and stuff that come with history and blackness. And all the problems that come up in interracial relationships — how walking with somebody white in the street would automatically trigger a response that was one hundred fifty years old, terms like "nigger lover" or "race traitor." It thrust me and the other person into a situation that we're thinking we had surpassed in the 1990s. [I thought] the thirty years or so between the Civil Rights movement and where I am today had somehow wiped all of that out, you know, and we were all getting along and holding hands. So I grew up in this environment of loving and respecting the "other" and being very open to everyone and having that turn on me.

LA: Is that because of your age or is that also because of moving from California?

KW: California to Georgia. It's definitely both, because I came from a blissfully ignorant childhood, in what I think of as the quintessential multicultural paella or gumbo or lo mein into an adolescence in a black and white environment suspended in a sticky discourse of dominator / dominated that is as heavy as the humidity. I felt like I had been sold into slavery.

LA: The silhouettes are all black and that sameness draws you in; they're very seductive.

Look Away! Look Away!
Look Away! 1995
cut paper
Installation views:
Center for Curatorial
Studies, Bard College,
Annandale-on-Hudson,
New York
The Rivendell Collection for
Late Twentieth-Century Art
on permanent loan to
the Center for Curatorial
Studies, Bard College
Courtesy Center for
Curatorial Studies

104

1 Ann Petry, *The Narrows* (Boston: Beacon Press, 1953), pp. 138–139

KW: Part of the challenge I posed for myself in coming up North, or getting out of Atlanta—whichever you want to say—was to look for a format I could seduce. Painting wasn't working for me at the time, it's too seductive automatically. I thought I could act out a couple of roles I was unwittingly playing down South, that I could kind of embody an assortment of stereotypes and cull the art out of them . . . as the tantalizing Venus Noir, the degraded nigger wench, the blood-drenched lynch mob. I wanted to seduce an audience into participating in this humiliating exercise/exorcise with me.

The black silhouette just happened to suit my needs very well. I often compare my method of working to that of a well-meaning freed woman in a Northern state who is attempting to delineate the horrors of Southern slavery but with next to no resources, other than some paper and a pen knife and some people she'd like to kill. The silhouette speaks a kind of truth. It traces an exact profile, so in a way I'd like to set up a situation where the viewer calls up a stereotypic response to the work—that I, black artist/leader, will "tell it like it is." But the "like it is," the truth of the piece, is as clear as a Rorschach test.

LA: Let me ask you about the work you made at the Drawing Center: *Gone: An Historical Romance of the Civil War As It Occurred Between the Dusky Thighs of One Young Negress and Her Heart*. Is this the first large silhouette and the first starring role for the "young Negress"?

KW: Yes. In school I was still making small canvas pieces or drawings; I didn't know how I was mounting them and I was having a lot of technical difficulties, so this Drawing Center piece was really the first. The Negress name had popped up a few times in school, and really I was just culling it from one source, which was *The Clansman* by Thomas Dixon, Jr. There is a reference to a "tawny Negress: would she be the arbiter of our social life and our morals?" I don't have the exact quote, but she is definitely a bad girl.

LA: So she's trouble?

KW: She's trouble, but she doesn't really do anything. She just sits there, though she is described all over the place. You know, the shifty eyes, the cunning mind, power hungry, dark . . .

LA: Even as your images, like the one at the Drawing Center, revive the history of the Civil War, do you also see them as

The End of Uncle Tom and
the Grand Allegorical Tableau
of Eva in Heaven 1995
cut paper
Installation view:
La Belle et la Bête,
Musée d'Art Moderne de
la Ville de Paris
Collection Jeffrey Deitch,
New York

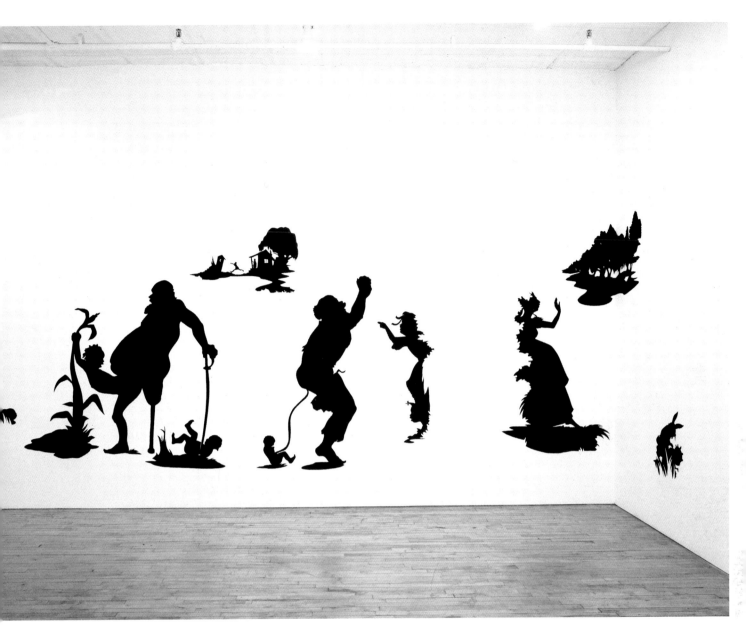

contemporary fables?

KW: Let's see. How does a fable actually work? A fable usually has a moral at the end, which is maybe the only difference.

LA: The ambiguity of the silhouettes does so much for you. The blank space of the figures allows them to have a duality—as in some of the scariest fairy tales. When you generate these images, are you actually allowing yourself to take on the persona of the young Negress?

KW: I'm "channeling" the Negress.

LA: But how about the other characters?

KW: I'm channeling them all.

LA: Is there also an effort to try to imagine yourself in this history and place more than a hundred years ago?

KW: I think really the whole problem with racism and its continuing legacy in this country is that we simply *love* it. Who would we be without it and without the "struggle"? In its absence, in the middle-class black America I grew up in, I guess I was overcome by the need to re-create a race-based conflict, a need to feel a certain amount of pain—to feel the fire hoses on my back, and the rope around my neck, and the chains around my feet—back, back, back into history. I methodically planted these seeds, like the song "My Mind's Playin' Tricks on Me." So in keeping with a tradition of explorers and artists who made concrete images of historic events without having ever participated in them, I set out to document the journey. Only problem is that I am too aware of the role of my overzealous imagination interfering in the basic facts of history, so in a way my work is about the sincere attempt to write *Incidents in the Life of a Slave Girl* and winding up with *Mandingo* instead. A collusion of fact and fiction that has informed me probably since day one.

LA: I read that in Atlanta there's a tourist site called the Cyclorama. Is that a large panoramic silhouette?

KW: I guess there are only two cycloramas left in this country. It's a 400-foot painting in the round, about 50 feet tall or so, of the Battle of Atlanta. And it's a painting with a diorama in front, so you have this great 3-D visual effect. They've fixed it up recently so you can sit on a platform. There's a little light show highlighting special moments in the battle that Atlanta lost

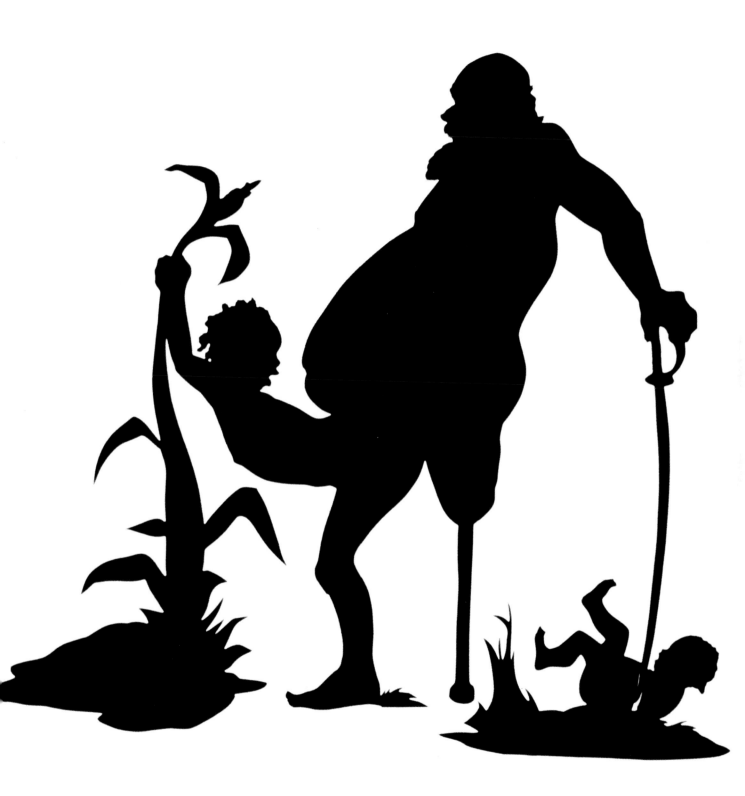

African't 1996
cut paper
Installation view: **Conceal / Reveal**
Site Santa Fe, New Mexico
Collection Eileen and Peter Norton,
Santa Monica

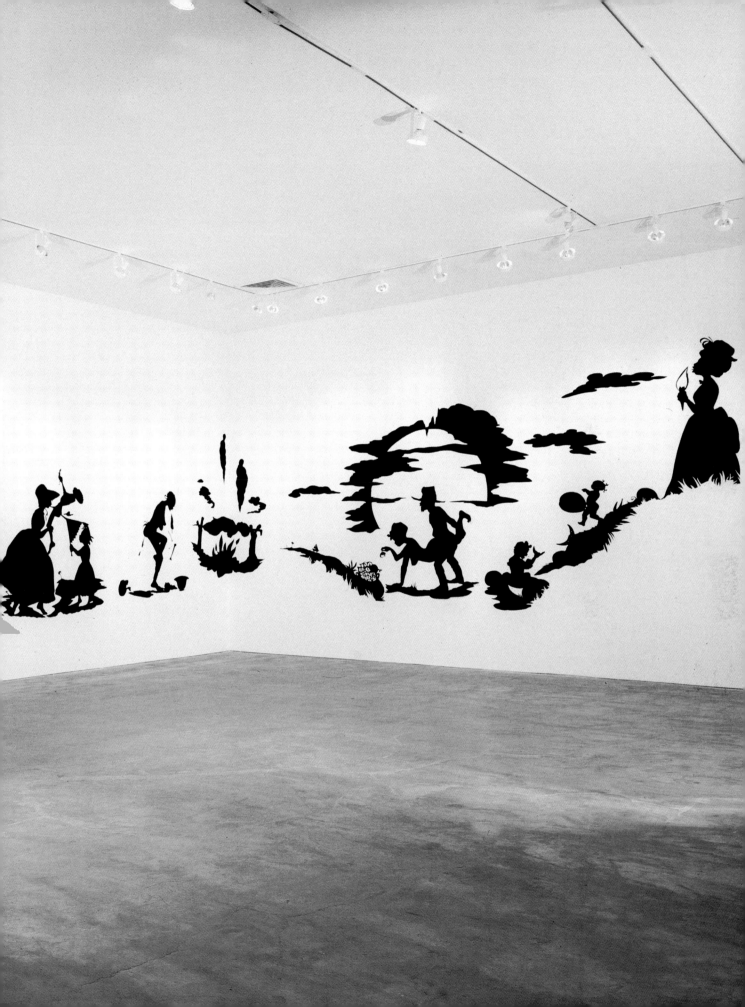

Untitled (Free Northern
Girls) 1994
ink on paper
7 7/8 x 8 1/4 in.
Collection
Walker Art Center

Untitled (Final Solutions)
1994
ink on paper
9 3/4 x 6 1/2 in.
Collection
Walker Art Center

just before it got burned down.

LA: Is there a narrator? What is the point of view?

KW: There's a narrator. It's very neutral. It tries to be historical fact. They talk a fair amount about the painting itself and what such-and-such represents, and who so-and-so was, and it doesn't get too involved in the problems of the Civil War. They do have a film before you enter the Cyclorama that has the re-creators doing a little battle, which is narrated by James Earl Jones—another nod to multiculturalism!

LA: I was very struck by the invitation you made for your show at Wooster Gardens. In it you refer to yourself as "a free Negress of noteworthy talent." This is obviously meant to be provocative, but what else are you trying to do in these cards?

KW: Well, actually, thinking about the length of the card, I wanted to make something that was the antithesis of most contemporary art-gallery invitations, which tend to be simple and to the point, minimal. And I always had a love for old broadsides advertising the big show. You advertise a cyclorama exhibition or the "great grand touring" something. (And usually the more florid the language, the worse the end result.) Silhouette artists, even, had very elaborate cards for their very simple services. I guess the "free Negress of noteworthy talent" is a nod to our remarkable forebears.

LA: And what has the reaction been to your use of the word "Negress"?

KW: Well, there are lots of sophisticated people who get very amused by this backhanded insult to myself, which is, of course, always how black people get really successful.

LA: Well, it's how most humor works.

KW: But "of noteworthy talent" is actually meant to be vain. I wanted to be a little bit arrogant. The voice in the back of my head says, "She's really interesting, we're very proud of her." And it was also a little bit of a reference to slave narratives that were published with the assistance of abolitionists, who would usually issue some kind of disclaimer as to the creditworthiness of the story, the truthfulness of the story. You know, "Isn't it remarkable that this black person has risen out of slavery . . ."

LA: Do you feel a responsibility to anything other than your own art-making?

KW: I don't know that I can. I've seen so much really responsible art. I've seen a lot of art exhibits that were less about the art and more about social issues. And it's kind of that audience that I'm responding to. Maybe those grand historical paintings were overdone, but I think they're amazing in the way that they tell us a story and another story, and the way there are stories between the way the fingers are intertwined. I think that's just remarkable, and I'd like to see more of that coming out from a black community of artists, but I'm not a politician. I don't want to be a politician. My favorite story right now, for the last couple of years anyway, is *The Satanic Verses* by Salman Rushdie. And that got all the worst possible kind of political reaction. And I think the way he weaves a story, and weaves in and out of religious text—that's what I want to aim for. I do have a slightly epic vision, and that's always going to come out of this collusion of fact and fiction.

LA: Very few artists are making work on this scale with the ambition of history painting. Let's talk about another specific work that you made for the Musée d'Art Moderne de la Ville de Paris: *The End of Uncle Tom and the Grand Allegorical Tableau of Eva in Heaven*. Who was Eva?

KW: Eva is from *Uncle Tom's Cabin* and was a little martyr. She willed herself into that role—at least, that was my reading of the story. She's a sweet Christian girl.

LA: And where does Eva specifically appear?

KW: She is the centerpiece of the story, wielding an axe that is actually supposed to be aimed at her own head. Toward the end of her story in the novel, she cut off locks of her hair and gave them to all the slaves who were adoringly watching her fade away into oblivion. And Uncle Tom kept a little lock of her blond hair before he went off to Simon Legree's plantation.

LA: In the left side of one of the panels, there's this incredible image of four women—girls and women—suckling each other. What was this meant to be a metaphor for?

KW: History. My constant need or, in general, a constant need to suckle from history, as though history could be seen as a seemingly endless supply of mother's milk represented by the big black mammy of old. For myself I have this constant battle—this fear of weaning. It's really a battle that I apply to the black community as well, because all of our progress is predicated on having a very tactile link to a brutal past.

LA: One last question. In talking about the Negress you once said, "I always think of her as in control, even in outlandish, perverse situations." Were you talking about this ongoing character we see in the work?

KW: Well, I don't know that she's in the imagery so much as making it. I'm trying to think of an example or parable. There was a slave narrative written by a white woman who was not a slave, in England, based on slave narratives that she had read. She was so fascinated that she wrote her own. I don't think it was even discovered right away that it was false. That kind of wishful thinking—the situation she sort of imagined herself in—is a little bit the same sort of stance that this Negress takes. She's removed from it all and immersed in it all in an almost too fantastic way.

NO PLACE

Unless otherwise noted, all images courtesy Wooster Gardens, New York, and Kara Walker

(LIKE HOME) VOLATILE MEMORIES by Douglas Fogle

"Nothing sorts out memories from ordinary moments. Later on they do claim remembrance when they show their scars."[1]

The classical art of memory was built upon a foundation of trauma. As we learn in Cicero's *De oratore*, the ancient Greek poet Simonides of Ceos was said to have discovered a powerful mnemonic technique while attending a banquet given by Scopas, a nobleman of Thessaly. Upon reciting a panegyric in praise of his host, Simonides was hastily called outside the hall by a messenger, whereupon the roof of the banquet hall precipitously collapsed, crushing the unsuspecting guests beyond recognition. The distraught kinsmen of the victims, unable to claim their dead, turned to the sole survivor of this tragedy for help. Having been so deeply affected by the emotional intensity of the event, Simonides was able to vividly recall the precise location of each guest at the banquet, thereby allowing the mourning kinsmen to identify the bodies of their loved ones within the congestion of the rubble.[2]

Such are the grim origins of the art of memory, a systematic intellectual technique that allowed its user an intensified ability to remember various types of information ranging from names and dates to entire passages from an oration. By mentally linking an imaginary architectural space with a particular piece of information, this mnemotechnic "no place" acted as a kind of synthetic memory storage device by which one could instantaneously recall specific facts by entering various rooms within this phantasmatic structure. In the case of Simonides, trauma precipitated an ability to put forgetfulness permanently in abeyance, imposing an architectural order on knowledge so rigorous that even the dead could not escape remembrance.

In 1955, French filmmaker Alain Resnais traveled to Auschwitz, where he would encounter an altogether different site of architectural remembrance. Ten years after the liberation of the death camps, Resnais sought to document their horror in a film entitled *Nuit et brouillard (Night and Fog)*, in which he intercut black-and-white documentary footage with his own muted color shots of the empty architectural remnants of this derelict monument to bureaucratic barbarism. The film takes its title from the name of a particular category of prisoners in the concentration camps whom Heinrich Himmler labeled "night and fog," after an incantation placed on the dwarf Alberich in Richard Wagner's *Der Ring des Nibelungen*. Like Alberich, the night and fog prisoners simply "disappeared" into a cloud of mist without a trace, never to be confronted with their alleged crimes in a court of law and thereby becoming the untraceable victims of a willful and violent forgetting.

In Resnais' film, a tracking shot pans across a landscape whose colors have been drained as if the artist's palette had been watered down a bit too much. Barbed wire, dilapidated buildings—all looking banal in their styleless functionality—this is the landscape of terror, shrouded in night and fog, that he sought to capture in his visit to Auschwitz. But Resnais doubted the ability of the camera to capture the true memory of the traumatic events

of the Holocaust, and Jean Cayrol's narration for this film poses Resnais' trepidation as a question: "How to discover what remains of the reality of these camps when they were despised by those who made them and eluded those who suffered there? No description, no shot can restore their true dimension." Caught between this Scylla and Charybdis of memory and forgetting, Resnais asks how one records and thereby remembers the unthinkable. His answer is that one cannot, yet one must try. Such is the paradoxical condition of remembrance after the ultimate human tragedy.

In the postwar world, the certainty of Simonides' art of memory has been replaced by a troubling sense of forgetfulness, for it is by now almost a cliché to state that the current generation has no sense of memory whatsoever. Subject almost from birth to the ahistorical temporality of cathode ray transmissions, ours has been labeled an amnesiac culture, suffering from a pathology that transforms the ebb and flow of world historical events into freeze-dried and eminently digestible sound bites. This is a landscape haunted by the powerful specters of CNN and MTV, in which the evocative mnemic powers of the Proustian madeleine have been usurped by the timeless electronic inertia of Marshall McLuhan's global village. Like the volatile memory in a computer processor that disappears when the machine is turned off, our memories are similarly held in a kind of tenuous stasis, threatening to violently disappear when the transmission ends and the screen goes blank. In effect, one could argue that we are caught up in a crisis of memory and an epidemic of forgetting.

But the strange thing about the "no place" that constitutes the microcosm of the silicon chip is that even though volatile memory disappears with the turn of a switch, it leaves its spectral index in the digital ether of the computer's magnetic core. It is almost as if memory's untimely erasure ensures that its ghost will remain in the machine, a dormant and mute testimony to the occurrence of events far too terrible to remember yet impossible to completely forget. This volatile memory plays itself out in the current historical juncture with the stigmatic eruption of political and cultural upheavals across the globe. One need look no further than Bosnia-Herzegovina or Rwanda to realize that this decade has been marked by the violent remembrance of centuries-old disputes that have manifested their effects as genocidal atrocities. Indeed, as Friedrich Nietzsche suggested in discussing the willfulness of memory and forgetting in the human animal, "man could never do without blood, torture, and sacrifices when he felt the need to create a memory."[3]

It is perhaps then not so much that the current generation fails to remember, but rather that the nature of memory itself has been misunderstood. For memory does not operate according to the rigorously teleological strictures of historical analysis, as some might believe, but rather comes and goes with a spasmodic irregularity, erupting into consciousness with the impact of hysterical symptoms, provoking outbreaks of cultural paralysis, aphasia, and anaesthesia throughout the body politic. It is this tumultuous space that is being charted in the work of an emerging generation of artists who actively engage the pathological semaphore of memory, demonstrating the paradoxical possibility of remembering within the confines of a purportedly amnesiac culture.

Cultural amnesia is put in a tentative stasis in the "erasure" drawings of Gary Simmons, where memory rests precariously on their slate surfaces in constant danger of being consigned to the oblivion of forgetting. For Simmons the chalkboard acts as a "magic writing pad"—the children's toy consisting of a wax tablet with a plastic sheath—on which are inscribed the fragments of a cultural imaginary that have fled from the realm of conscious apprehension. Culled from the recesses of America's media archive, Simmons' iconography isolates fragments of racist cartoon imagery from early MGM films or the intricate romanticized architecture of the American landscape—a gazebo, a roller coaster, or a lighthouse. These haunting, ghostlike images seduce us with their diluted beauty while the explosive quality of their partial erasure triggers the remembrance of long-forgotten memories. But like frames of film caught in the sprocket of a projector, Simmons' drawings are but momentarily frozen just prior to their erasure, standing in as memorial markers of a civilization spinning out of control.

Kara Walker practices a seduction of an entirely different type in her silhouette cutout drawings. Disinterring her images from the psychosexual racial dynamics of the antebellum South, Walker engages in historical disruption through a perversely Romantic mise-en-scène. In these beautifully troubling romance vignettes, remnants of the traumatic legacy of slavery resurface as narrative elements within grotesquely kitsch epics where the rigid dialectic of master and slave is subverted by the sadomasochistic complicity of her entire cast of characters. Gone are the "screen memories" described by Freud—the passive images of the mammy or the sambo—which provided an insidious and false cover for the poison in our culture's history. In their place Walker has left the screen, where the violent fantasies of the American collective unconscious play out their remembrances in a shadow theater where the power dynamics of sexual perversity stand in for history in a landscape taken from the set of *Gone with the Wind*. For Walker, memory is a Grand Guignol romance novel where the traumas of history manifest their hysterical effects as perverse elements in a clichéd plotline where the strychnine masquerades as sugar.

In Meyer Vaisman's installations, personal archaeology replaces memory as the artist literalizes Simonides' metaphor of architectural mnemonics, concretizing it within the gallery space. By excising entire rooms from his childhood home in Caracas, Vaisman conducts a kind of reverse archaeology, reconstructing and entombing

these highly personal domestic interiors within the hastily built cinder-block structures that populate the urban landscape of Latin America. These middle-class European-style rooms have been held in a kind of memorial stasis since his youth like some prehistoric fly caught in a sheath of amber. Both home and not home, Vaisman's displacement of these bourgeois fragments reactivates them as architectural memento mori in an exorcism that invokes the sedimented layers of personal and cultural memory embedded within their walls. Peering into these interiors through portals framed at times by human pelvic bones, we become voyeurs in a family drama where parents and children fail to recognize one another across a gulf that spans generations and geographic locations. Unlike Simonides' banquet hall with its orderly recollection of the dead, Vaisman's rooms exhibit a far more tragic sense of memory infused with uncertainty and loss, creating archaeological monuments to the gap between internal and external perceptions of self, whether they are based on architecture, parental vision, or class.

Kay Hassan mines another vein of the relationship between memory and place. In his installations, indices of the itinerant and the homeless provoke a sense of uncanny unease in the viewer—uncanny as in Freud's use of the word *unheimlich* with its double entendre of both "strange" and "homeless."[4] There is indeed a kind of cultural homesickness at work in Hassan's installations, which re-create the makeshift dwellings and possessions associated with forced travel, triggering an emotional recollection of the absent peripatetic wanderers and refugees that populate a modern world of political and economic turmoil. In the suitcase, the bundle, the bicycle, and the shanty, Hassan references both the specific homelessness manifested by the oppressive policies of the former apartheid regime of South Africa as well as a more general sense of homelessness effected by the pervasive colonial suppression of indigenous cultural memory. If remembrance is intimately tied to a sense of place, then Hassan's installations provide us with mnemic road maps with which to navigate the oblivion of the itinerant and the displaced in a landscape forged by the legacy of the enforced cultural homelessness of apartheid.

In the photographs and video installations of Willie Doherty, the politics of memory and place collide with any stable conception of home, littering its exploded wreckage across a landscape scarred by the collective trauma of Northern Ireland's "troubles." For Doherty, our unconscious archive of media and cinematic images of war contaminates our perception of civil conflict, reducing the complex historical circumstances of Northern Ireland into the linguistic dichotomies of terrorist and victim, innocent and guilty. Choosing to live and work within the contested borders of his native Derry, Doherty's images depict the aftereffects of a series of non-incidents, the possible remnants of violent events that may or may not have taken place. In an ambiguous cibachrome photograph of a burned-out car, or a video depicting point-of-view shots of an interchangeable assassin and victim, Doherty directly addresses the technological amnesia of an oversaturated and highly managed media culture. Calling into question our reliance upon the truth value of the news broadcast or newspaper report to make sense of the world, Doherty at the same time stresses the power of mediated language in constituting our own collective memory.

Zarina Bhimji's photographs and installations investigate the body and its thresholds, walking a precarious tightrope between the reverie of personal remembrance and the horrors of questionable science. By resuscitating remnants of a nineteenth-century fascination with taxonomic classification, Bhimji's lusciously saturated color photographs of physiological anomalies belie a profound questioning of the physical and epistemological violence of these forensic systems, which were employed to provide evidence of the so-called abnormal, deviant, and pathological. Bhimji's concern with the politics of identification manifests itself as well in her interrogation of the eugenicist pseudoscience of Sir Francis Galton, whose spurious theories of physiology were used to bolster profoundly racist and classist sociological theories in the nineteenth century. The artist's eerily blurred, long-exposure photographs of people of mixed ethnic backgrounds confound Galton's twisted dream of a pure race, while at the same time evoking the melancholy memory of lost loved ones that Roland Barthes associated with the phenomenological experience of photography in his book *Camera Lucida*. Whether in an installation of children's *kurtas* (Indian-style shirts) or through her sensual use of the photographic medium, Bhimji's work negotiates a cultural field traversed by displacement and loss, offering us a challenging corrective to a history of vision riven with the capriciousness of power.

In the films of Nick Deocampo, memory weaves a restless Ariadne's thread through the convulsive history of the Philippines that culminated in the fall of the Marcos dictatorship and the rise of a struggling democracy. Alternating between an aggressively didactic cinema verité style and a far more poetic "magic realism," Deocampo's celluloid meditations approach history with a fractured, subjective lens, illustrating the complex and tenuous character of political and social change through an investigation of the marginalized figures who populate the everyday world. The plight of child prostitutes, the life of a gay exotic dancer, the parable of Abraham and Isaac, the troubled legacy of Manila's colonial history—these are the subjects of Deocampo's project of "counter memory," that phrase coined by Michel Foucault to describe a new kind of historiography where the marginal and the everyday take precedence over world historical figures. For Deocampo, one cannot separate the life of the individual from that of the society, and it is in the memories of the marginalized that he finds something of the truth of history as well as

a mirror in which his own personal history is reflected. Whether employing an allegorical or documentary mode, all of Deocampo's films contribute to the edifice of his historical project, in which the particularity of personal memory comingles with the tumultuous events of Philippine political history, resulting in filmic poetics that constantly question and incessantly provoke.

In the work of Kcho (Alexis Leyva Machado), remembrance and forgetfulness float across a sea littered with the flotsam and jetsam of a migratory populace. Using found materials to construct rudimentary evocations of ad hoc sea vessels, Kcho's work explores the ontological condition of living on an island, such as his native Cuba, in a world where travel and migration are now the norm. Suggesting that such a life necessitates travel across both metaphorical and actual bodies of water, Kcho constructs a fleet of ships with materials found wherever he happens to be—Havana, Madrid, New York, Kwangju, or Milan. In each case, Kcho's chosen materials hold specific, embodied memories of their former functions that circulate around his sculptures like currents in a slow-moving river. Carpenters' C-clamps hold together a precarious column of boat frames in New York while a regatta of children's sailboats constructed from driftwood weigh anchor in Havana. Textbooks from his revolutionary education are sewn together to create a vessel in Cuba while Korean beer bottles form the watery medium for a rowboat in Asia. Far too easily read as poetic indictments of a failed political utopia, Kcho's sculptures are more profitably seen as an aesthetic investigation of that migratory "no place" that constitutes the global condition of late modernity, where people, objects, and memories float across seas of forgetfulness. It is this tension between travel and home, memory and forgetting that suffuses Kcho's sculptures with their evocative powers, placing the dreamlike space of utopia (literally "no place") at the core of the modern human condition.

Perhaps our culture does suffer from a willful amnesia, that active forgetting that Nietzsche identified as the condition of possibility of an animal that can make promises. But forgetting is never total, and in this excursion through the spaces of "no place" we have seen memory manifest an incendiary volatility, erupting unpredictably in torrents of remembrance and simultaneously making itself felt quietly like small eddies on the edge of white-water rapids. Gone is the ordered, rational certainty of Simonides' art of memory with its facade of virtual architecture. In its place stands a memory that shifts, feints, is elusive, but which nonetheless serves its purpose. These memories are written in the interstices of the rubble and the ruins—scratches in a vinyl recording marking the echoes of traumas that resurface with each renewed playing. Operating like one of Italo Calvino's "invisible cities," this no place of memory "does not tell its past, but contains it like the lines of a hand, written in the corners of the streets, the gratings of the windows, the banisters of the steps, the antennae of the lightning rods, the poles of the flags, every segment marked in turn with scratches, indentations, scrolls."[5] As if in direct response to Alain Resnais' skepticism over the atrophy of memory in the wake of an intense cultural amnesia, these artists have managed to decipher the scratches and hieroglyphs left on these invisible cities, cutting through the night and fog of forgetfulness and restoring to consciousness those repressed memories that had been condemned to oblivion.

1 Chris Marker, **La Jetée** (New York: Urzone, Inc., 1992).

2 See Francis Yates, **The Art of Memory** (Harmondsworth: Penguin, 1966).

3 Friedrich Nietzsche, **On the Genealogy of Morals** (New York: Vintage Books, 1967), p. 61.

4 See Anthony Vidler, **The Architectural Uncanny: Essays in the Modern Unhomely** (Cambridge: MIT Press, 1992).

5 Italo Calvino, **Invisible Cities** (Harcourt & Brace Company, 1974), p. 11.

NO PLACE

(LIKE HOME) PLACE OF MOVEMENT by Deepali Dewan

". . . the idea of a journey does not necessarily involve physical transport; the movement implied may very well be psychic. Immobile travel demands an activation of the imagination, a nomadism of the mind, an irreverence for temporal and spatial boundaries."[1]

In the opening pages of Salman Rushdie's novel *The Satanic Verses*, we find the two main characters, Gibreel Farishta and Saladin Chamcha, in midair. Victims of an airplane explosion, they are the only survivors among the passengers on a flight bound for London from New Delhi. The flight is full of migrants, those leaving their homelands for a place that was once the heart of the Empire. Rushdie presents the explosion simultaneously as reality and fantasy, as a metaphor for the violence of displacement and as the birth, or rebirth, of the characters into a new context: "Mingling with the remnants of the plane, equally fragmented, equally absurd, there floated the debris of the soul, broken memories, sloughed-off selves, severed mother-tongues, violated privacies, untranslatable jokes, extinguished futures, lost loves, the forgotten meaning of hollow, booming words, *land, belonging, home*."[2] At the end of the chapter, we find our protagonists on an English beach, rubbing their eyes like newborns just offered up by the sea. Yet this bit of information is an afterward to what occupies the author's narrative space—the state of being midair. This air-space, Rushdie writes, is the "soft, imperceptible field which had been made possible by the century and which, thereafter, made the century possible . . . the place of movement and of war, the planet-shrinker and power-vacuum, most insecure and transitory of zones . . ."[3] It is in this place of movement, the space in between places, a transitory zone, a "no place," that our protagonists are borne into the postcolonial. Rushdie does not describe their contact with ground, and despite their sudden appearance on the beach, one gets a sense that they are still in motion, moving through the old categories of organization—nation, citizenship, homeland, ethnicity, culture—that have become shifting plate tectonics with unstable boundaries.

Movement is a trope of our times. Although people have migrated across the globe for centuries, a set of comparatively recent historical circumstances has fostered an atmosphere of movement of unprecedented intensity in the number of peoples it engages. The cast of characters often cited in this theater of transit are those displaced by colonial or neocolonial forces. They are economic and political refugees, exiles, and postcolonial migrants, among others. Although these categories are highly contested and far from absolute in representing political and personal circumstances, together they begin to describe the increasing movement of peoples between sites all around the globe. As a result, fixed notions of "home" are being toppled, decentered, rethought, and remade. For many today, comfort is not found in the search for origins or "home," but rather in an acceptance of the hybrid nature of one's existence. To come from many places at once, to belong to more than one place, to embody many cultural identities is, in one sense, an overwhelming experience characterized by both loss and a sense of placelessness. Yet such complex foundations also necessitate an internalized sense of home or place that is not deviant or dualistic,

but characteristic of what is increasingly becoming the norm: a single, yet layered state of existence. This internal "no place" defined by motion is the midair space that Rushdie describes for his characters as well as for himself. Writing about exiled or expatriate writers, he contends that "we will not be capable of reclaiming precisely the thing that was lost; [but] that we will . . . create fictions, not actual cities or villages, but invisible ones, imaginary homelands, Indias of the mind."[4]

Yet to consider migrations at the end of the twentieth century in terms of the physical displacement of peoples across national and cultural boundaries alone is perhaps too simple, and tells only part of the story. Rather, migrancy as metaphor of this era describes a greater collective condition or mode of being that is defined by physical movement. No longer the domain of the migrant alone, it is a trend shaped, in part, by increasingly mobile, shifting environments created by the pervasive reach of media and the globalization of commercial enterprises. But even so, the migrant space thrives as an internalized space. This transitory zone, characteristic of the end of the twentieth century, has been referred to as an "in-between space" by postcolonial theorist Homi K. Bhabha. "In the fin de siècle," he contends, "we find ourselves in the moment of transit where space and time cross to produce complex figures of difference and identity, past and present, inside and outside, inclusion and exclusion."[5] The physical laws of space fail to illuminate postmodern geographies that demand a complex reorganization of temporal and spatial relationships. These relationships are guided by perception that reconfigures time and distance according to maps of the mind. This arena of movement is an internalization of those very notions—distance, place, home—that have been identified by external markers.

"No place," then, is a new kind of "some place." The "air-space" described by Rushdie occupies a psychological realm beyond the social and cultural. "To be at home everywhere/in this moving world" is, as poet Meena Alexander contends, a state of mind.[6] These landscapes of the mind open up fertile ground for creative response. The works of the artists in *no place (like home)* draw on the liminal spaces of memory where the contours of meaning are deliberately blurred. They are about both place and placelessness, at once fixed in time while freely crossing its boundaries.

The work of both Zarina Bhimji and Kay Hassan engages physical movement, yet ultimately transcends a purely physical experience. In Bhimji's early work, the inclusion of objects of personal significance bear the markers of memory, indirectly alluding to a cultural specificity that references her own experiences of displacement. Identity is constantly in transit; thus, movement is abstracted and internalized within the body. Her later work, which explores ambiguity in issues of power, access, and memory, manifests a sense of movement with a disregard for fixed meanings. Similarly, the physical movement of peoples is directly addressed by Kay Hassan's installations, which combine technicolor paper constructions made from found poster materials that depict South Africa's refugee population, such as nomadic squatters who live in makeshift shacks on unoccupied land, and found objects such as suitcases, bicycles, and bundles ready for transport. Like pervasive media advertisements, growing migrant communities mark a prominent and permanent aspect of the postcolonial environment, and like the poster materials that Hassan recycles, the images stand as metaphors for dislocation and relocation.

The repeated use of boats in the work of Kcho and the focus on places of transit, such as border crossings, in the work of Willie Doherty reference the centrality of movement but, more importantly, they point to psychological states characterized by a migratory consciousness. For Kcho, the plant imagery, paddle shapes, and boats in his work reflect the tension between rootedness and travel, the attachment to home and the desire for the next horizon. Like Cuba, the boat is an island and in itself a metaphor for choice, the vehicle for—at the least—an extended spiritual journey. Choosing to use local materials to make installations, Kcho draws from a shared cultural language that transcends Cuba-specific associations to address the fluidity of cultural and geographic specificity. Likewise, the subject matter of Willie Doherty's photographs—roads, border crossings, and other sites located in and around the border town of Derry, his home and birthplace in Northern Ireland (the only European state under colonial rule)—both addresses and transcends local signification by allowing the viewers' own memories and perceptions to provide meaning. Echoing the images of violence often published and circulated in the British news media, they point out how that pervasive media increasingly constructs and determines our conceptions of place.

Also drawing upon local materials in his recent work, Meyer Vaisman encloses sections of the international-style decor of his parents' middle-class home in Caracas, Venezuela, within an exterior resembling the shanties housing much of the country's urban population. In this way, he conflates the local and the global. By using local materials to construct the exteriors, he makes shanty structures that transcend specific connections with Caracas and become dwellings for urban poor everywhere. Filmmaker Nick Deocampo, like Willie Doherty, focuses his work on his homeland of the Philippines; like Northern Ireland, it has a long, wounding history of colonial rule. Deocampo's films document the continuing effects of colonial history in the Philippines; though an independent nation since 1934, it is still contoured by neocolonial interests. The lives of many Filipinos that Deocampo documents are marked by movement and occupy the in-between spaces demanded for survival.

In the work of Gary Simmons and Kara Walker, movement is represented in perhaps the most abstracted sense. Gary Simmons' chalkboard drawings feature images plucked from the liminal spaces of memory. Drawing on the visual vocabulary of an American collective subconscious shaped by the debris of the media age, his work leads the viewer to a space in between what is remembered and forgotten, what is fact and fantasy. It is a space of memory that is unstable, blurred, and constantly in transit. The act of erasure blurs not only the image, which looks as if it is in motion, but its meaning as well. Likewise, Kara Walker's silhouette environments blur the boundaries of time, history, fantasy, and narrative structure. Drawing from romance novels and slave narratives, Walker creates her own Gothic fairy tales of master and slave in which traditional distinctions between oppressor and oppressed are made ambiguous by the psychosexual dimensions of interracial desire and codependency. Historical modes of depiction collide with taboo imagination, and fact and fiction fuse to create a dark drama that overturns traditional limits of the accepted and the forbidden, intentionally denying any sense of consensual identification.

The phrase "no place like home" ironically contains both the longing for a fixed location that is home—that which Dorothy yearned for in the 1939 film *The Wizard of Oz*—as well as, when read literally, the absence of a place that can be called "home." Being born in the last thirty-odd years of the "post-" or "neo-" colonial era, the artists in this exhibition have matured with this sense of nomadism that pervades the contemporary consciousness, whether they physically travel the world or not. This sense of movement can be described as Rushdie's "air-space" that is an in-between space, a transitory zone that may be linked to physical movement but is not bound by it and often transcends it altogether. The work of each artist manifests this movement in an engagement with ambiguity and a lack of fixed meaning. Further, their work transcribes a sense of placeness, while at the same time being closely connected with the specificities of place present in each of the artists' experiences and memories. In this way, the emphasis is removed from a physical sense of movement and located, in large part, in a spiritual nomadism shaped by the emotional over the cerebral, and the intuitive over the rational.

1 Nancy Spector, **Felix Gonzalez-Torres** (New York: Solomon R. Guggenheim Museum, 1995), pp. 75 and 81.

2 Salman Rushdie, **The Satanic Verses** (Dover, Delaware: The Consortium, 1988), p. 4.

3 Ibid., p. 5.

4 Salman Rushdie, **Imaginary Homelands** (London: Granta Books, 1981), p. 10.

5 Homi K. Bhabha, **The Location of Culture** (New York: Routledge, 1994), p. 1.

6 Meena Alexander, "Moving World." **Amerasia Journal,** vol. 22, no. 19, 1996, p. 248.

ARTIST BIOGRAPHIES

ZARINA BHIMJI
NICK DEOCAMPO
WILLIE DOHERTY
KAY HASSAN
KCHO
GARY SIMMONS
MEYER VAISMAN
KARA WALKER

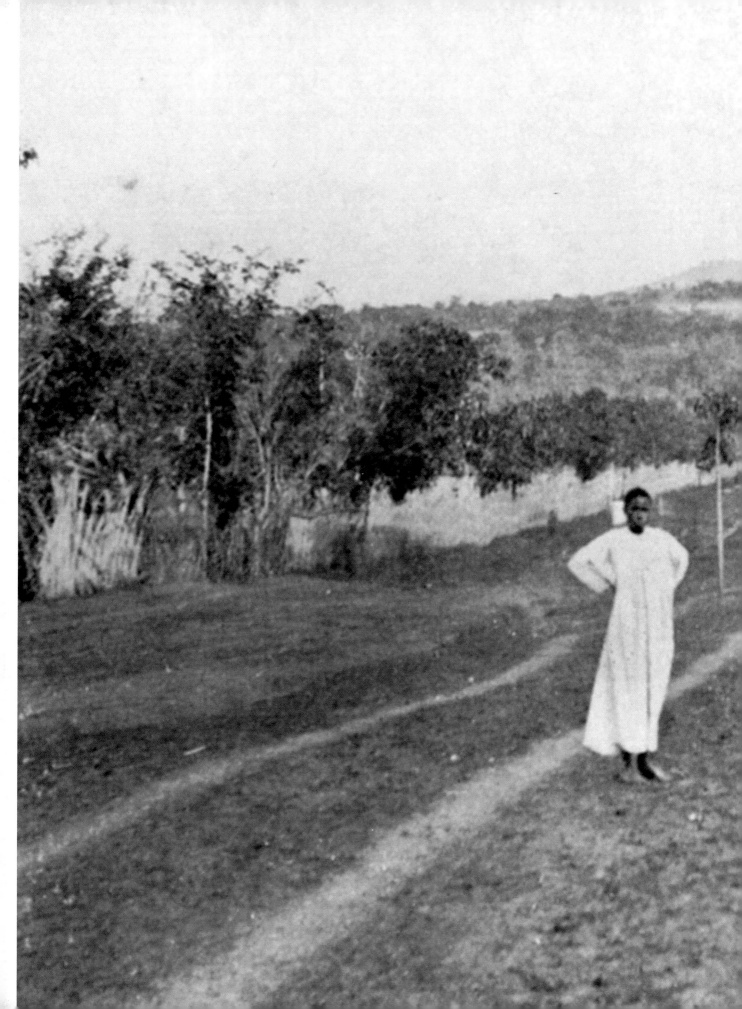

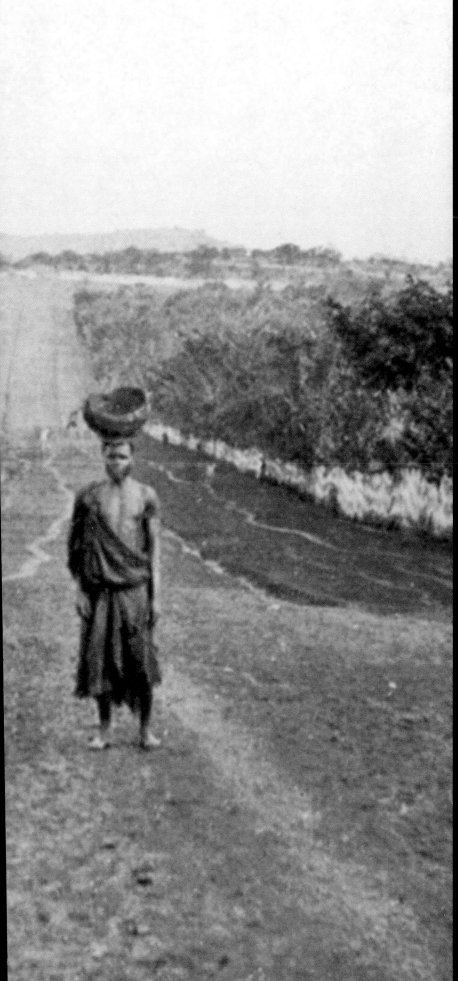

ZARINA BHIMJI
born Mbarara, Uganda, 1963

Education

1988–1989	Slade School of Fine Art, University College London
1986	B.F.A., Goldsmiths' College, University of London
1982–1983	Leicester Polytechnic

Solo Exhibitions to 1990

| 1995 | Kettle's Yard, University of Cambridge* |
| 1992 | *I will always be here*, Ikon Gallery, Birmingham* • |

Selected Group Exhibitions

1996	*In/Sight: Contemporary African Photography*,
	Guggenheim Museum, New York*
1995	*Impossible Science of Being*, Photographers' Gallery, London*
1994	*Revir/Territory*, Kulturhuset, Stockholm*
	INIVA, London
	Art in Hospitals, Public Art Development Trust,
	Charing Cross Hospital, London
1993	*Antwerp '93*, MuHKA Museum, Antwerp*
1992	*Whitechapel Open*, Whitechapel Art Gallery, London
	Critical Decade, Museum of Modern Art, Oxford
1991	*A Place for Art? 2*, The Showroom, London
1990	*Selections 5*, Biennial Exhibition from Polaroid Collection,
	Photokina '90, Cologne* •
	Intimate Distance, Photographers' Gallery, London* •
	Fabled Territories (New Asian Photography in Britain),
	Leeds City Galleries/Viewpoint Gallery, Salford* •
	The women in my life, Acton Community Workshop, London •
	In Focus, Horizon Art Gallery, London
	From object to image, Watershed Media Center, Bristol*
	Black Markets, Cornerhouse Gallery, Manchester •
	Shocks to the System: 90s Political Art,
	South Bank Centre, London*

Selected Bibliography

1995	*Time Out* (March 22–29).
	Portfolio 21.
	Warner, Marina, "A Chilling Bedside Manner." *The Independent*
	(March 4).
	Minter, Nicky. "Bhimji's Body." *Varsity Arts* (February 24).
	The Daily Telegraph (February 18).
	The Guide (March 11–17).
	Corky Richard. *The Times* (February 11).
1994	"Hidden Gems." *The British Journal of Photography* (March 24).
1993	*Creative Camera 321* (February/March).
	Irvine, Jaki, "Zarina Bhimji: I Will Always Be Here." *Third Text 22*
	Womens Art 51 (March/April).
1992	*Audio Arts Magazine 12:1* (June).
	The List (September/October).
	Spare Rib (July).
	Bazzar B21 (Summer).
	The Guardian (May 6).
1991	*Creative Camera* (April/May).
1990	*Feminist Review 3*.
	Bhimji, Zarina, "Live for Sharam and Die for Izzat," in *Identity*,
	Jonathan Rutherford, ed. London: Lawrence & Wishart.
	Art Forum International (November).

* Exhibition catalogue available
• Traveling exhibition

Archival photograph of Ugandan road,
circa 1900
Courtesy Zarina Bhimji

IN CASABLANCA

The road to Casablanca is fogged with memory.
Inside a movie house we watch
Bogart take Ingrid's hand, while Sam
Plays on the piano-- this is
Your favorite scene, and this is
My last memory of you...

You sit there enraptured by the thought
That love, maybe, can outlast the war--
All wars! But I know deep inside you,
You think, that's what movies are all about--
The illusion to keep us going.
When we get home things will be different.

There will be no pianos, and worse,
No hands to touch; no longer will
Those love-struck eyes meet mine
In the heat of a better-forgotten past;
Because no longer is there any illusion
In a life between you and me.

I realize that. I too feel the pain.
And that's why I go to the movies a lot
Lured by the tune from the piano
And the image of two lovers kissing.
(Even though illusion, grant me the fantasy
To see in movies what I cannot see in life!)

Now you're gone, lost in my fogged memory.
Silly it is but with your absence
I learn to look at you more closely:

NICK DEOCAMPO
born Mandaluyong City, Manila,
Philippines, 1959

Education

1989	M.A., New York University, New York
1981–1982	Atelier Varan, Paris
1981	A.B., University of the Philippines, Manila

Written Works

Counter-Cinema/Counter-Consciousness: Anthology of Essays on Philippine Cinema (forthcoming).

1996 *Beyond the Mainstream: The Films of Nick Deocampo.* Manila: Anvil Press.

1993 "History of a Hidden Cinema: Independent Cinema in the Philippines." *Encyclopedia of Philippine Arts.* Manila: Cultural Center of the Philippines.
"Homosexuality as Dissent/Cinema as Subversion: Articulating Gay Consciousness in the Philippines." *Queer Looks.* New York: Routledge Press.

1992 "Emergence of a Radical Cinema in Asia." Festival catalogue, Asian Film Festival, Amsterdam, Holland.

1991 "The Male Dimension: Jay Javier's Photographs." *Manila Chronicle.*
"Fact and Fatalism: The AIDS Situation in the Philippines." New York: Ms. Foundation (commissioned by the United Nations Development Program).

1989 "Notes on Women and Their Role in the Philippine Movie Industry." *Asian Cinema Studies Newsletter* (New York).
"Some Notes on Women in Philippine Cinema." *Cinevue.*

1986 *El Cortometraje: Surgimiento de un nuevo cine filipino.* Bilbao, España: Certamen international de cine documental.

1985 *Short Film: Emergence of a New Philippine Cinema.* Manila: Communication Foundation for Asia.

Filmography / Videography

1995 Writer/Director/Country Producer: *Private Wars*, 16mm, 65 minutes
Writer/Director: *The Sex Warriors and the Samurai*, 16mm, 26 minutes

1996 Best Documentary, Film Academy of the Philippines

1995 Best Documentary, 5e Mondial de la Video, Brussels

1993 Writer/Director/Producer: *Isaak*, 35mm, 10 minutes
Line Producer: Filipino Short Films produced by the Manila Film Festival: *Ang Bantay, Maalinsangan ang gabi, Trip*, 35mm, 59 minutes

1992 Writer/Director/Country Producer: *Memories of Old Manila*, 16mm, 22 minutes
Prix du Court Metrage (Best Short Film), Fribourg International Film Festival, Switzerland
Country Producer: *Continuing Lives: Women of the Bases*, video, 10 minutes

1991 Director/Producer: *Ynang-bayan: To be a woman is to live at a time of war*, 16mm, 60 minutes
Best Documentary Award, Film Academy of the Philippines, Manila Silver Medal, KRITIKA Awards for Film, Manila

1990 Director: *A Legacy of Violence*, video, 50 minutes
Best Documentary, 12th International Super-8mm Film and Video Festival, Brussels
Director/Producer: *Let this film serve as a manifesto for a new cinema*, Super-8mm, 20 minutes
Special Prize, 4th CCP Short Film and Video Festival, Manila

1987 Director/Producer: *Revolutions Happen Like Refrains in a Song*, Super-8mm, 50 minutes
Director/Producer: *Homage to Filipino Artists*, Super-8mm, 30 minutes

1985 Director: *Children of the Regime*, Super-8mm, 50 minutes

1983 Director: *Oliver*, Super-8mm, 45 minutes

Nick Deocampo, "In Casablanca," 1985
Courtesy Nick Deocampo

David Sharrock on the controversy over the Government's use of TV ads to get its message across in Northern Ireland

Selling the peace

TWO BOYS play together on a golden beach while Van Morrison croons drowsily in the background. "Wouldn't it be great if it was like this all the time?" asks Belfast's most famous musician, as the words of Time For The Bright Side fill the television screen. Cut to News At Ten.

What can it all mean? In Northern Ireland, ten months after the IRA suspended its campaign of violence, the answer is obvious. But the methods adopted by the Government to convey the message that peace is good have remained controversial ever since it committed more than £1 million to buying television advertising space seven years ago.

The first commercial was broadcast in January 1988. It set the tone for those which followed: strong storylines coupled with slick production values and the sort of graphic violence you'd expect to see in a Michael Winner movie, rather than a public information broadcast. The Future charted the decision of a young Belfast Everyman — catholic or protestant, working class — to inform on the paramilitaries. "What have these hard men ever done for me?" he asks to a backdrop of images of burning vehicles, abandoned building sites and a paramilitary punishment squad performing a knee-capping. It ends with a confidential telephone number on a blank screen and the words: Don't Suffer It, Change It.

"The brief was to get people to do something to help the security forces," says Andy Wood, information director at the Northern Ireland Office. "The first one had a look about it which informed all the subsequent ads. They had to be journalistically credible, using a mix of real news footage with actors and recreated scenes from real life. And they had to be balanced, in the sense that neither paramilitary side was singled out."

In 1993 the Northern Ireland Office and McCann Erickson Belfast — the agency which has produced all the ads — launched a series which took the technique further. In a little over two minutes Northern Ireland's TV audience was treated to a mini-drama about two weddings, a shooting and two widows. In the follow-up a baby is born, his father goes out to kill, goes to prison, and only realises that his son has grown up just like him at his funeral.

This time the even more graphic violence — slow motion segments of rattling machine-guns and lurching bodies — is combined with a new ingredient. The "hard men" are portrayed as real people, capable of repentance, with suffering wives, neglected sons and grieving families. After the ceasefire, the content was re-examined for evidence that there was more to the campaign than met the eye.

It almost looked as though the Government had been preparing the public for the ceasefire, according to Martin McLoone, lecturer in media studies at the University of Coleraine. "There was a clear shift in the portrayal of terrorists from hooded godfathers of crime to misguided human beings. Yesterday's enemies could become tomorrow's friends."

It is a claim which is rejected by Andy Wood. "The premise that we were warming up the public for another round of political talks falls down because I wasn't aware of the secret contacts. We predated the news breaking by five months. We did recontextualise the terrorist, but not as part of a masterplan."

Once the paramilitary ceasefires began to take hold the Northern Ireland Office launched another TV campaign under the title Time To Build, with the theme of transformation. "For too long we've all been prisoners of the past," says the female voice-over. "Now's the time to change, to live, to build." A gun becomes a starting pistol to the Belfast marathon, a hand takes a pair of scissors to the white tape at the scene of another atrocity and a new bridge is opened for business.

Today the last in a series called Time For The Bright Side gets its first broadcast airing. This one is a collage of personalities from Northern Ireland, including Kenneth Branagh and George Best. The other ads include toddlers playing together, youngsters telling jokes and a celebration of the landscape. All feature Van the Man at his dreamiest.

"It wouldn't be so bad if they were just anodyne, patronising and insulting, but I think they could be damaging," says Belfast television critic and columnist Linda Gilbey. "It takes years to crack the code of Northern Ireland language, where nobody admits to bigotry and everyone mouths platitudes like 'ach sure, wouldn't it be a great wee place if it wasn't for the Troubles' but then goes home to talk and act differently. We already know what we feel and we don't need expensive good-looking ads to tell us that. But the NIO is encouraging complacency at a time when everyone should be being forced to challenge themselves about what we are prepared to sacrifice for the sake of building a peaceful future."

MARTIN McLoone believes that close study of the ad campaign reveals the Government's overall strategy in Northern Ireland. "The 'Transformation' ad contained a remarkable set of images in which the weapons of war became instruments of leisure. It seems to be a slow preparation for the release and reintegration of large numbers of prisoners back into the community.

"They're very sentimental and saccharine, they're saying that the future belongs to the children. But there's no denying the fact that we are enjoying the peace and that's what they reinforce. The latest set seems to show that there's a slow holding operation going on here. Perpetuating the feelgood factor is a perfect description."

Andy Wood and David Lyle, chief executive of McCann Erickson in Belfast, are unrepentant about massaging the current upbeat mood. "I don't see anything wrong with spending public money on something which is welcomed and enjoyed by a lot of people," says Wood. "Feeling good underpins the absence of violence."

And far from lacking substance, Lyle contends, "the babies advertisement is the first of its kind to confront the fact that our divisions are socially conditioned. It's also about restoring pride in people who for 25 years had nothing good to say about Northern Ireland."

WILLIE DOHERTY
born Derry, Northern Ireland, 1959

Education

1978–1981 Ulster Polytechnic, Belfast

Solo Exhibitions to 1990

1997 Kerlin Gallery, Dublin
1996 *In the Dark: Projected Works by Willie Doherty*, Kunsthalle Bern, Bern*
 Musée d'Art Moderne de la Ville de Paris, Paris*
 Alexander and Bonin, New York
 The Only Good One Is a Dead One, Edmonton Art Gallery,
 Edmonton, Alberta* •
 Galleria Emi Fontana, Milan
1995 Kerlin Gallery, Dublin
 Galerie Peter Kilchmann, Zürich
 The Space Between, video installation, El Puente de Vizcaya, Bilbao
 Galerie Jennifer Flay, Paris
1994 *At the End of the Day*, British School at Rome*
1993 *The Only Good One Is a Dead One*, Arnolfini, Bristol* •
 They're All the Same, Centre for Contemporary Art, Ujazdoski Castel,
 Warsaw
 It's Written All Over My Face, Commissions and Collaborations,
 BBC Billboard Project
 30 January 1972, Douglas Hyde Gallery, Dublin
 Galerie Jennifer Flay, Paris
1992 Tom Cugliani Gallery, New York
 Oliver Dowling Gallery, Dublin
 Galerie Peter Kilchmann, Zürich
1991 Tom Cugliani Gallery, New York
 Galerie Giovanni Minelli, Paris
 Kunst Europa, Six Irishman, Kunstverein Schwetzingen
1990 *Unknown Depths*, John Hansard Gallery, Southampton •
 False Dawn, Irish Exhibition of Living Art, Dublin
 Billboard Project, Irish Exhibition of Living Art, Dublin
 Imagined Truths, Oliver Dowling Gallery, Dublin
 Same Difference, Matt's Gallery, London

Selected Group Exhibitions

1996 *Face à la Histoire 1933–1996*, Centre Georges Pompidou, Paris*
 Being & Time: The Emergence of Video Projection, Albright-Knox
 Art Gallery, Buffalo, New York
 Language, Mapping and Power, Orchard Gallery, Derry*
 ID, Stedelijk Van Abbemuseum, Eindhoven*
 Circumstantial Evidence, University of Brighton*
 Happy End, Kunsthalle Düsseldorf
 The 10th Biennale of Sydney, Australia
 Devant l'Histoire, Centre Georges Pompidou, Paris
 *Distant Relations: A Dialogue Among Chicano, Irish, and Mexican
 Artists*, Santa Monica Museum of Art, California
 NowHere, Louisiana Museum of Modern Art, Humlebaek
1995 *Sites of Being*, The Institute of Contemporary Art, Boston
 Willie Doherty, Andreas Gursky, Moderna Museet, Stockholm
 Trust, Tramway, Glasgow
 It's Not A Picture, Galleria Emi Fontana, Milan
 IMMA Collection: Photoworks, The Irish Museum of Modern Art, Dublin
 Distant Relations, Ikon Gallery, Birmingham •
 Double Play—Beyond Cognition, Sint-Niklaas City Academy, Belgium
1994 *Cocido y Crudo*, Museo Nacional Centro de Arte Reina Sofia, Madrid*
 *Willie Doherty, Peter Doig, Anthony Gormley, and Shirazeh Houshiary:
 The Turner Prize 1994*, Tate Gallery, London
 Willie Doherty/Mona Hatoum/Doris Salcedo, Brooke Alexander,
 New York
 Points of Interest, Points of Departure, John Berggruen Gallery,
 San Francisco
 From Beyond the Pale: Selected Works and Projects, Part 1,
 Irish Museum of Modern Art, Dublin
 Kraji Places, Moderna Galerija Ljubljana, Museum of Modern Art,
 Slovenia*
 The Spine, De Appel, Amsterdam*
 The Act of Seeing (Urban Space), Foundation pour l'Architecture,
 Brussels
1993 *An Irish Presence*, Venice Biennale, Venice
 Prospect 93, Frankfurter Kunstverein, Graz, Austria*
 Critical Landscapes, Tokyo Metropolitan Museum of Photography,
 Tokyo*
 Krieg (War), Neue Galerie, Graz, Austria*
1992 *Time Bandits*, Galeria Fac-Simile, Milan
 Moltiplici Culture, Convento di S. Egidio, Rome*
 13 Critics 26 Photographers, Centre d'Art Santa Monica, Barcelona*
 "Outta here", Transmission Gallery, Glasgow

 Beyond Glory: Representing Terrorism, College of Art, Maryland
 Institute, Baltimore
1991 *Storie*, Galeria il Campo, Rome •
 Shocks to the System, Royal Festival Hall, London* •
 Europe Unknown, WKS Wawel, Krakow*
 A Place for Art?, The Showroom, London
 Political Landscapes, Perspektief, Rotterdam
 Outer Space, Laing Art Gallery, Newcastle •
 Denonciation, Usine Fromage, Darnetal, Normandie* •
1990 *The British Art Show*, McLellan Galleries, Glasgow* •
 A New Tradition, Douglas Hyde Gallery, Dublin*
 XI Photography Symposium Exhibition, Graz, Austria

Selected Bibliography

1996 Heartney, Eleanor. "Willie Doherty at Alexander and Bonin."
 Art in America (September).
 Hand, Brian. "Swerved in Naught." *CIRCA Art Magazine* (Summer).
 Frankel, David. "Wille Doherty—Alexander and Bonin."
 Artforum (May/June).
 Higgins, Judith. "Report from Ireland—Art at the Edge (Part II)."
 Art in America (April).
 Volk, Gregory. "Willie Doherty—Alexander and Bonin."
 ARTnews (April).
1995 Kastner, Jeffrey. "Ten Artists to Watch Worldwide: Willie Doherty,
 Northern Ireland." *ARTnews* (January).
 Maul, Tim. "Willie Doherty." *Journal of Contemporary Art 7.2*.
 Rowlands, Penelope. "Willie Doherty: Jennifer Flay."
 ARTnews (Summer).
1994 Blazwick, Iwona. "Interview with Willie Doherty."
 Art Monthly 172 (December/January).
 Cameron, Dan. "Social Studies." *Art & Auction* (November).
 Cork, Richard. "Muting the Howls of the Philistines." *The Times*
 (London) (July 23).
 Kastner, Jeffrey. "Willie Doherty: Matt's Gallery." *Frieze 14*.
 Morgan, Stuart. "The Spine: de Appel, Amsterdam." *Frieze 16* (May).
 Renton, Andrew. 'Willie Doherty: Matt's Gallery." *Flash Art*
 (January/February).
 Schaffner, Ingrid. "Willie Doherty, Grey Art Gallery." *Artforum*
 (December).
 Smith, Roberta. "Willie Doherty, Mona Hatoum and Doris Salcedo."
 The New York Times (November 11).
 Smith, Roberta. "Bluntly, the Tragedy of 'the Troubles.' "
 The New York Times (September 9).
1993 Jennings, Rose. "Willie Doherty: Matt's Gallery." *Time Out*
 (December).
1992 *La Recherche Photographique 13*.
 The Irish World (February 22).
 Time Out (February 13).
 Lubbock, Tom. *The Independent* (March 3).
1991 Drier, Deborah. "Same Difference: A Project by Willie Doherty."
 Artforum (May).
 Village Voice (February 20).
 Artforum (January).
 Art in America (April).
 Scanlan, Patricia. "Outer Space." *Variant 10* (Winter).
 "They're All the Same," a project for *Frieze 2*.
1990 Hutchinson, John. "An Acute Angle on Ireland." *The Sunday
 Independent* (June 10).
 Dickson, Malcolm. "Permanent Curfews." *The List* (June 29).
 Jennings, Rose. "Same Difference, Matt's Gallery." *City Limits*
 (October 18–25).
 Time Out (October 17–24).
 Irvine, Jack. *CIRCA Art Magazine* (September/October).

* Exhibition catalogue available
• Traveling exhibition

"Selling the Peace,"
The Guardian (Manchester) (July 4, 1995).
Article courtesy Willie Doherty

KAY HASSAN
born Alexandra, Johannesburg,
South Africa, 1956

Education

1989	Schule für Gestaltung, Basel, Switzerland
1986–1988	Scholarship from the French Government to study printmaking under S. W. Hayter at Studio 17, Paris
1978–1980	Rorke's Drift Art Center, Kwa-Zulu, Natal

Selected Exhibitions to 1990

1996	*Colours: Kunst aus Südafrika*, Haus der Kulturen der Welt, Berlin*
	Earth and Everything, Bristol
	Hitchhikers, Generator AA Space, Johannesburg
	Insights: Four South African Artists, Wright Gallery, New York
	Life of the Miners, Workers' Library and Museum, Johannesburg
1995	*Contemporary Art from South Africa*, Deutsche Aerospace, Munich*
	FNB Vita Art Show, Johannesburg Art Gallery, Johannesburg
	Hassan, Koloane and Mautloa, Newtown Gallery, Johannesburg
	Body Politic, Gertrude Psoel Gallery, Johannesburg
	Kwangju Biennale, Kwangju, South Korea*
1994	*Places of Power*, Newtown Gallery, Johannesburg
1993	The Berman Gallery, Johannesburg
1992	*Two Decades of Fine Art*, FUNDA, Soweto, Johannesburg
1990	Thupelo, Johannesburg

Selected Bibliography

1996	Ferguson, Lorna and Thomas Mulcaire. "Johannesburg: A fake interview, or what we think they said." *Flash Art* (Summer).
	Enwezor, Okwui and Octavio Zaya. "Moving In: Eight Contemporary African Artists." *Flash Art* (January/February).
	Heartney, Eleanor. "Report from Korea." *Art in America* (April).
	Martenstein, Harald. "Alte Batterien sehen anders aus." *Der Spiegel* (May 24).
1994	"Ein Forum Für das neue Südafrikaka." *Aktuell* (November).
	"Südafrikanisches Neuland im doppelten Sinn." *Mündner Markur* (October 20).
1993	Coulson, Michael. *Financial Mail* (April 2).
1990	Watt, Judith. "Art in Triptych." *Sunday Times Magazine* (Johannesburg).

* Exhibition catalogue available

Photographs of Johannesburg by
Kay Hassan, 1996
Courtesy Kay Hassan

KCHO
(Alexis Leyva Machado)
born Nueva Gerona, Isla de la Juventud,
Cuba 1970

Education

1984–1990 Escuela Nacional de Artes Plásticas, Havana
1983–1986 Escuela Elemental de Arte de Nueva Gerona,
 Isla de la Juventud

Solo Exhibitions to 1990

1996 Barbara Gladstone Gallery, New York
 Studio Guenzani, Milan
1995 Fundación Pilar i Joan Miró, Mallorca
 No Juego, Centro Wilfredo Lam, Havana
 El Camino de la Nostalgia, Centro Wilfredo Lam, Havana
1994 *Buscando el Parecido*, Galería Habana, Havana
1993 *Kcho: Drawings and Sculptures*, Galería Plaza Vieja, Fondo Cubano
 de Bienes Culturales, Havana
 Galería de Arte Contemporáneo, Mexico City
1992 Museo Nacional Palácio de Bellas Artes, Havana
1991 *Paisaje Popular Cubano*, IV Bienal de la Habana, Centro de Arte 23
 y 12, Havana
1990 *Paisaje Popular Cubano*, Galería de la Escuela Nacional de Artes
 Plásticas, Havana

Selected Group Exhibitions

1996 *Cuba Siglo XX: Modernidad Y Sincretismo*, Centro Atlantico de Arte
 Moderno, Las Palmas, Spain •
 Interzones, Kunstforeningen D1, Strand, Copenhagen
 Les Cent Jours d'Art Contemporain de Montréal, Centre International
 d'Art Contemporain de Montréal, Canada
 The Red Gate, Museum van Hedendaagse Kunst, Gent, Belgium
1995 *International Istanbul Biennial*, Istanbul
 Campo, Fondazione Sandretto-ReRebaudengo per l'Arte, Turin* •
 Kwangju Biennale, Kwangju, South Korea*
 Our Century, Museum Ludwig, Cologne
 Dialogues of Peace, United Nations Headquarters, Geneva
 1st Johannesburg Biennial, Johannesburg*
 Havana-Sao Paolo: Casa de las Culturas del Mundo, Berlin
1994 *Cocido y Crudo*, Museo Nacional Centro de Arte Reina Sofia, Madrid*
 22 Bienal de Sao Paulo, Fundacíon Bienal de Sao Paulo, Brazil
 Kunst und Breinig, Stadt Stolberg, Kreis Aachen, Germany
 5th Bienal de La Habana (Selection), Forum Ludwig, Aachen,
 Germany
 La Otra Orilla, 5th Bienal de La Habana, Castillo de los Tres Reyes del
 Morro, Havana*
 Centro Wilfredo Lam, Havana, Cuba
1993 *Cómprame y Cuélgame*, Centro de Desarrollo de las Artes Visuales,
 Havana
 Centro Cultural Arte Contemporáneo, A.C. Fundación Cultural
 Televisa, Mexico City
 The First International Print Biennial, Mastricht, Holland
1992 *La Década Prodigiosa: Plástica Cubana de los 80's*, Museo
 Universitário del Chopo, Mexico City
 Un Marco por la Tierra, Centro de Desarrollo de las Artes Visuales,
 Havana
 1st Biennial Barro de America, Museo de Arte Contemporánea Sofia
 Imber, Caracas
 La Ronda Cubana, Van Reekum Museum, Apeldoorn, Holland*
 Arte Cubano Actual, Centro Cultural Arte Contemporáneo, Fundación
 Cultural Televisa, Mexico City
 Von dort aus: Kuba, Forum Ludwig, Aachen, Germany*
1991 *4th Bienal de la Habana*, International Workshop of Ephemeral
 Sculpture, Havana
 Los Hijos de Guillermo Tell, Museo Alejandro Otero, Caracas*
 Biblioteca Luis Angel Arango, Bogotá
 Centro de Arte 23 y 12, Havana

Selected Bibliography

1996 Davis, Susan A. "Art Is a Cuban's Vessel to Freedom." *The New York
 Times* (March 17).
 Schwabsky, Barry. "KCHO." *Artforum* (Summer).
 Budney, Jen. "No Place Like Home." *Flash Art* (May/June).
 Levin, Kim. *Village Voice* (March 20).
 Kimmelman, Michael. "KCHO." *The New York Times* (April 5).
 Macri, Teresa. "La grande onda di un isolano." *Il Manifesto* (July 11).
 Hoptman, Laura. *TRANS > 1:2*.
 Ramirez, Yasmin. "KCHO at Barbara Gladstone." *Art in America* (June).
1995 Steinmetz, Klaus. "Dialogos de Paz." *Art Nexus 18*.

Cho, Yoon-jung. "Cuban Artist wins Grand Prize." *Korea Herald*
 (September 21).
Cho, Yoon-jung. "Four awardees honored at biennale." *Korea Herald*
 (September 21).
Cho, Sang-hee. "Human Suffering Depiction in Artistic Vision Trend
 of Winning Pieces at Kwangju Biennale." *Korea Times*
 (September 22).
Cho, Sang-hee. "Cuban Alexis Leyva Kcho Wins Grand Prize."
 Korea Times (September 21).
Kent, Sarah. "Cuban heal." *Art* (March).
Zaya, Octavio. "The Cuban Quagmire." *Flash Art* (October).
Brea, Jose Luis. "Cocido y Crudo." *Flash Art* (May/June).
Melo, Alexandre. "Transoceanexpress." *Parkett 44*.

1994 Anselmi, Inés. "Kunst, Macht und Marginalitat." *Kunstforum*
 (November).
 Esterow, Milton. "Viva Socialismo! Viva Benetton!" *ARTnews*
 (September).
 Anselmi, Inés. "Kunst der Periphere im Zentrum." *Der Kleine Bund*
 (June 4).
 Camnitzer, Luis. *New Art of Cuba*. Austin, Texas: University of
 Texas Press.
 Cantor, Judy. "Art in Cuba." *Miami New Times* (June 9–15).
 Vicent, Mauricio. "Una gran balsa llamada Cuba." *El Pais* (May 15).
 Wise, Michael Z. "Tweaking the Beard of the Maximum Leader."
 The New York Times (June 12).
1993 Medina, Cuauhtemoc. "EXILIO En la calle Republica de Cuba."
 Revista Poliester 4.
 Mosquera, Gerardo. "Los hijos de Guillermo Tell." *Revista Poliester 4*.
1992 Montero, Hortensia. "Desde el paisaje." *Revista Bohemia La Habana*
 (May).
 Mosquera, Gerardo. "Kcho." *Arte en Colombia Internacional 49*.
 Mosquera, Gerardo. "El rustico del nuevo arte." *Revista Revolucion
 y Cultura*.
 Murphy, Jay. "Testing the Limits." *Art in America* (October).
 Murphy, Jay. "The Young and the Restless in Havana." *Third Next
 Magazine 20*.
1991 Pini, Ivonne. "Los hijos de Guillermo Tell." *Art Nexus 2*.
 Rubiano, German. "Barro de America." *Art Nexus 52*.

* Exhibition catalogue available
• Traveling exhibition

Untitled study by Kcho, 1996
Courtesy Kcho
Photograph: Pedro Abascal

GARY SIMMONS
born Brooklyn, New York, 1964

Education

1990 M.F.A., California Institute of the Arts, Valencia, California
1988 B.F.A., School of Visual Arts, New York

Solo Exhibitions to 1990

1996 Metro Pictures, New York
 Boom, Bang! Galerie Philippe Rizzo, Paris*
1995 Metro Pictures, New York
 The Contemporary, New York
 Gary Simmons: Erasure Drawings, Lannan Foundation, Los Angeles*
1994 *Directions: Gary Simmons*, Hirshhorn Museum and Sculpture Garden,
 Smithsonian Institution, Washington, D.C.*
1993 Galerie Philippe Rizzo, Paris
 Metro Pictures, New York
1992 Roy Boyd Gallery, Santa Monica
 Jason Rubell Gallery, Miami
 The Garden of Hate, Whitney Museum at Philip Morris, New York*
1991 Roy Boyd Gallery, Santa Monica
 Simon Watson Gallery, New York
1990 White Columns, New York

Selected Group Exhibitions

1996 *Fragments: Proposts por a una colleccio de fotografia contemporania*,
 Museu d'Art Contemporani, Barcelona*
 a/drift: Scenes from the Penetrable Culture, Bard College,
 Annandale-on-Hudson, New York
 Imagined Communities, Oldham Art Gallery, London*
 Under Capricorn: Art in the Age of Globalization, Stedelijk Museum,
 Eindhoven* •
 Getekend, Amerika!, MK Expositieruimte, Rotterdam*
 *Inklusion/Exklusion: Art in the Age of Postcolonialism and Global
 Migration*, Steirischer Herbst 96, Graz, Austria
 *Defining the 90s: Consensus-Making in New York, Los Angeles, and
 Miami*, Museum of Contemporary Art, Miami
1995 The Fabric Workshop/Museum, Philadephia
 Configura 2 – Dialog Der Kulturen – Erfurt 1995, Erfurt, Federal
 Republic of Germany*
1994 *Lousy Fear*, Randolph Street Gallery, Chicago
 Labor and Leisure, John Michael Kohler Art Center, Sheboygan,
 Wisconsin
 *Black Male: Representations of Masculinity in Contemporary American
 Art*, Whitney Museum of American Art, New York* •
 Urban Paradise: Gardens of the City, PaineWebber Art Gallery,
 New York
1993 *1993 Whitney Biennial*, Whitney Museum of American Art, New York*
 The Theater of Refusal: Black Art and Mainstream Criticism, Fine Arts
 Gallery, University of California at Irvine* •
 Contacts Proofs, Jersey City Museum, New Jersey
1992 *The Politics of Difference: Artists Explore Issues of Identity*,
 University Art Museum, University of California, Riverside
 The Big Nothing or Le Presque Rien, The New Museum of
 Contemporary Art and French Cultural Services, New York
 How It Is, Tony Shafrazi Gallery, New York
 Back Talk, Randolph Street Gallery, Chicago
 Songs of Innocence/Songs of Experience, Whitney Museum of
 American Art at Equitable Center, New York
 Wall Drawings, The Drawing Center, New York
 Dissent, Difference, and the Body Politic, Portland Art Museum,
 Portland* •
1991 *Interrogating Identity: The Question of Black Art*, Walker Art Center,
 Minneapolis* •
 The Subversive Stitch, Simon Watson Gallery, New York
 Someone or Somebody, Meyers/Bloom Gallery, Santa Monica
 Schwarze Kunst: Konzepte zu Politik und Identitat, Neue Gesellschaft
 für Bildende Kunst, Berlin
1990 *Earth*, Krygier/Landau Contemporary Art, Santa Monica
 Membership Has Its Privileges, Lang & O'Hara, New York
 Spent: Currency, Security and Art on Deposit, New Museum of
 Contemporary Art at Marine Midland Bank, New York
 All Quiet on the Western Front?, Espace de Dieu, Paris
 Official Language, San Francisco Art Institute Galleries, San Francisco
 Total Metal, Simon Watson Gallery, New York

Selected Bibliography

1996 *Time Out New York* (March 13–20)
 Karmel, Pepe. "Gary Simmons." *The New York Times* (March 22).
 "Gary Simmons." *The New Yorker* (April 1).

Genies, Bernard. "L'art au bout du fusil." *Le Nouvel Observateur*
 (April 4–10).
Schoenfeld, Alissa. "Gary Simmons." *Critical Review* (April 1).
Colman, David. "Pretty on the Outside." *George* (June).
"Art as Idea." *Scholastic Art* (April/May).
Eskin, Leah. "Gone With the Wind." *Chicago READER* (July 5).
Volk, Gregory. "Gary Simmons at Metro Pictures." *Art in America*
 (October).
1995 Tate, Greg. "Start Black-Owned Conceptual Bomber." *Vibe 3:1*
 (February).
Nochlin, Linda. "Learning from Black Male." *Art in America* (March).
Howell, George. "Gary Simmons: Erasures." *Art Papers* (March/April).
"If They Built a Memorial to the War in the Streets." *The New York
 Times Magazine* (April 9).
Newhall, Edith. "Installation: Now Growing in SoHo." *New York
 Magazine* (May 1).
Eccles, Tom. " Gary Simmons at The Contemporary and Metro
 Pictures." *Art in America* (July).
Pagel, David. "The Writing's on the Wall." *The Los Angeles Times*
 (September 24).
Knight, Christopher. "Social Studies on the Blackboard."
 The Los Angeles Times (October 5).
Pagel, David. "Gary Simmons." *Frieze 24* (September/October).
"More Reduction & Erasure at Lannan (But it's not what you
 think . . .)." *Flash Art* (November/December).
Albertini, Rosanna. "Gary Simmons – Lannan Foundation."
 Art Press 208 (December).
Rugoff, Ralph. *Artforum* (December).
Perchuck, Andrew. "Gary Simmons – Lannan Foundation."
 Artforum (December)
Knight, Christopher. "Art: Canvassing the Year of Brilliance."
 The Los Angeles Times (December 31).
1994 Avgikos, Jan. "Gary Simmons at Metro Pictures." *Artforum* (January).
Cose, Ellis and Peter Plagens, "Black Like Whom?" *Newsweek*,
 (November 14).
Gardner, Paul. "Light, Canvas, Action: When Artists Go to the Movies."
 ARTnews (December).
1993 Ray, Gene. "Gary Simmons." *Flash Art* (January/February)
Matussek, Matthias. "Kunst als Schauprozess." *Der Spiegel* (April 12).
Cotter, Holland. "Gary Simmons: Metro Pictures." *The New York
 Times* (October 8).
Brumfield, John. "Marginalia: Life in a Day of Black L.A. or,
 The Theater of Refusal." *Art Issues 29* (September/October).
Agboton-Jumeau, Jean Charles. " Gary Simmons and M. Franklin
 Sirmans at Galerie Rizzo." *Forum International*
 (October/November).
Solomon, Deborah. "A Showcase for Political Correctness."
 The Wall Street Journal (March 5).
Smith, Roberta. "A Whitney Biennial with a Social Conscience."
 The New York Times (March 5).
Knight, Christopher. "Crushed by Its Good Intentions."
 The Los Angeles Times (March 10).
1992 Ramirez, Yasmin. "Gary Simmons." *Art in America* (December).
1991 Smith, Roberta. "The Subversive Stitch." *The New York Times* (July 12).
Smith, Roberta. "Interrogating Identities." *The New York Times*
 (March 17).
Gipe, Lawrence. "Gary Simmons." *Flash Art* (October).
Nesbitt, Lois. "Interrogating Identity." *Artforum* (Summer).
1990 Anderson, Michael. "Gary Simmons." *Art Issues* (March/April).
Gardner, Colin. "Gary Simmons." *Artforum* (March).
Ischar, Doug. "Articulating Subjectivity." *Artweek* (January 18).

* Exhibition catalogue available
• Traveling exhibition

Studio still of Yul Brenner in
Westworld, 1973
8 x 10 black-and-white photograph
Courtesy Gary Simmons

MEYER VAISMAN
born Caracas, Venezuela, 1960

Education

1978–1979 Miami Dade College
1980–1984 Parsons School of Design

Solo Exhibitions to 1990

1996 *Green on the Outside, Red on the Inside (My Parents' Closet)*,
 303 Gallery, New York
1995 *Private Property*, Espacio 204, Caracas
 Off Shore Gallery, East Hampton, New York
1994 *Turkeys*, Galerie Templon, Paris
1993 *Meyer Vaisman Obras Recientes*, Centro Cultural Consolidado,
 Caracas* •
1992 *Recent Work*, Galerie Templon, Paris
 Jason Rubell Gallery, Palm Beach
 Jablonka Galerie, Cologne
 Turkey, Leo Castelli Gallery, New York
1991 Akira Ikeda Gallery, Tokyo
 Mario Diacono Gallery, Boston
 Jay Gorney Modern Art, New York
1990 Sonnabend Gallery, New York
 Jablonka Galerie, Cologne
 Editions Ilene Kurtz, New York
 Waddington Galleries, London
 Casino Knokke, Knokke-Heist, Belgium
 Jay Gorney Modern Art, New York

Selected Group Exhibitions

1996 *Inklusion/Exklusion: Art in the Age of Postcolonialism and
 Global Migration*, Steirscher Herbst 96, Graz, Austria*
 Interzones, Kunstforeningen, Copenhagen*
 Everything that is Interesting is New, Athens School of Fine Arts
 (The Factory), Athens*
1995 Museum of Modern Art, New York
 Limiares-Threshold, Fundação de Serralves, Oporto, Portugal*
 Space of Time, Center for the Fine Arts, Miami*
 Ars 95, Museum of Contemporary Art, Helsinki*
 Border Crawl, Kukje Gallery, Seoul*
1994 *Roma: Meyer Vaisman and Thomas Struth*, Edition Julie Sylvester,
 New York
 Das Jahrhundert des Multiple—Von Duchamp bis zur Gegenwart,
 Deichtorhallen Hamburg, Germany*
 Das Americas, Luisa Strina Gallery, São Paulo, Brazil*
 The Label Show, Museum of Fine Arts, Boston
1993 *Nuevas Aquisiciones 1991–2*, Galeria de Arte Nacional, Caracas
 Genetische Kunst, Eroffnung Der Ausstellung, Landesmuseum,
 Linz, Austria
 Tutta La Strade Portano A Roma, Pallazzo delle Esposizioni, Rome*
 Building a Collection, Museum of Fine Arts, Boston
 Edition Julie Sylvester, New York (with Franz West)
 American Art of the 80s, Galerie Nikolaus Sonne, Berlin
 CCCS-10, Arte Venezolano Actual, Galeria de Arte Nacional, Caracas
1992 *The Writing on the Wall*, 303 Gallery, New York
 American Art of the 1980s, Museo d'Arte Moderna e Contemporanea
 di Trento e Rovereto, Trento, Italy*
 Tatoo, Andrea Rosen Gallery, New York
 Post Human, FAE Musée d'Art Contemporain, Pully/Lausanne,
 Switzerland* •
1991 *El Jardin Salvaje*, Fundacio Caixa de Pensions, Sala de Exposiciones,
 Madrid
 Anni Novanta, Galleria Comunale d'Arte Moderna, Bologna •
 Objects for the Ideal Home: The Legacy of Pop Art, Serpentine
 Gallery, London
 Gold, Stuttgart Kunstverein, Stuttgart
 Altrove: Imagine e Identita, Fra Identita e Tradizione, Museo d'Arte
 Contemporanea Luigi Pecci, Prato, Italy
 Deplazamientos: Aspectos de la Identidad y las Culturas, Centro
 Atlantico de Arte Moderno, Las Palmas de Gran Canaria, Spain
1990 *Mike Kelley, Tim Rollins & K.O.S., Meyer Vaisman*, Jay Gorney
 Modern Art, New York
 Pharmakon, Nippon Convention Center, Makuhari Messe
 International Exhibition Hall, Tokyo
 Figuring the Body, Boston Museum of Art, Boston
 Una Art de la distinction: Les Années '80, Centre d'Art Contemporain,
 Abbaye Saint-Andre, Meymac, France

Selected Bibliography

1996 Ponce de Leon, Carolina. "Meyer Vaisman at 303," *Art in America*

(October).
"La Oficiana." *TRANS> 1:2*.
Hollander, Kurt. "Contra la pered/Against the wall," *Poliester*
(Spring).
Karmel, Pepe. *The New York Times* (April 12).
Mohomey, Robert. *Time Out* (April 10–17).
Carlos, Isabel. "Limiare-Threshold." *Flash Art*.
1995 Fuenmayor, Jesus. "Venezia/Venezuela: A Project for Arforum."
 Artforum (Summer).
 Ayerza, Josefina. "Global Art." *Flash Art* (May).
 Oberto, Ignacio Enrique. "Meyer Vaisman: Un premio en Venecia que
 no fue!" *El Universal* (Caracas) (January 8).
 Leibovici, Elisabeth. "Biennale de Venise: la Venezuela censure Meyer
 Vaisman, son représentant." *Liberation* (Paris) (January 3).
1994 Wisotzki, Ruben. "El palafito de Meyer Vaisman en el Gran Canal de
 Venicia." *El Diario de Caracas* (December 6).
 "Me siento immundamente despreciado. Meyer Vaisman furioso retiró
 su candidatura." *El Nacional* (Monterrey, Mexico) (January 23).
 Brillembourg, Carlos. "Green on the Outside, Red on the Inside."
 artist's project for *BOMB*.
 Decter, Joshua. "Stupidity as Destiny." *Flash Art* (October).
 Hollander, Kurt. "The Caracas Connection." *Art in America* (July).
 "Meyer Vaisman at Galerie Daniel Templon." *Le Monde* (March 31).
 Marchand-Kiss, Christophe. "Meyer Vaisman." *Beaux Arts* (April).
 Vaisman, Meyer. "I Want to Be in America." *Parkett 39* (Spring).
1993 Amor, Monica. "Meyer Vaisman: explorador de significados."
 Art Nexus 7.
 Arrango, Olga Marin. "Una sonrisa plastica." *El Espectador* (Bogota)
 (June 29).
 Basualdo, Carlos. "Realizaron en Venezuela una muestra y un
 simposio internacional." *La Maga 101* (Buenos Aires).
 Carillo, Aracely. "Sorprendera Vaisman en MUMO." *El Diario*
 (Monterrey) (November 15).
 Diaz, Mariela. "La divina comedia de Meyer Vaisman." *Economia Hoy*
 (Caracas) (March 11).
 Fairbrother, Trevor. "Vaisman Flips the Bird." *Parkett 35*.
 Lewis, Jim. "Talking Turkey: Meyer Vaisman in Conversation with
 Jim Lewis." *Frieze* (January/February).
 Ochoa, Guillermina. "De Goblelinos y Pavos 'Disfrazados' Meyer
 Vaisman y su Ideal del Arte Contemporaneo." *El Sol De Mexico*
 (September 28).
 Ponce de Leon, Carolina. "Animo irrisorio y provocador."
 El Espectador (June 27).
 Johnson, Ken. "Meyer Vaisman at Leo Castelli." *Art in America*.
 Vaisman, Meyer. "Turkey X-Ray." a project for *Frieze*
 (January/February).
1992 Bankowsky, Jack. "The Sweet Smell of Success." *Artforum* (May).
 Cameron, Dan. "Before and After." *Frieze* (September/October).
 Guevara, Roberto. "New York/Vaisman." *El Nacional* (Caracas)
 (October 20).
 Larson, Kay. "Meyer Vaisman." *New York Magazine* (October 26).
 Levin, Kim. "Meyer Vaisman." *The Village Voice* (October 3).
 Lewis, Jim. "Poultryculturalism: Meyer Vaisman Dresses the Bird."
 Artforum (November).
 Troncy, Eric. " A Cowboy Is Dead." *Artscribe International* (February).
1991 Ayerza, Josefina. "Abstracts from a Conversation with the Artist."
 Lacanian Ink (Fall).
 Cameron, Dan. "History as Fiction." *Artspace* (Fall).
 Kandel, Susan. "History as Fiction's a Provocative Show." *Los Angeles
 Times* (August 29).
 Lewis, Jim. "Home Boys." *Artforum* (October).
 Tallman, Susan. "Meyer Vaisman at Jay Gorney." *Art in America*
 (June).
1990 Bonito, Oliva Achille. "Superart." *Giancarlo Politi Editore* (Milan).
 Cameron, Dan. "Meyer Vaisman: A Comedy of Ethics." *Flash Art*
 (Summer).
 Graham-Dixon, Andrew. "The Unpleasant Taste of Success."
 The Independent (London) (November 10).
 Kent, Sarah. "On Meyer Vaisman." *TimeOut London* (November).
 Larson, Kay. "Back to Nature." *New York Magazine* (April 2).
 Smith, Roberta. "Meyer Vaisman." *The New York Times* (March 16).
 Hixson, Kathryn. "Meyer Vaisman." *Arts Magazine* (February).

* Exhibition catalogue available
• Traveling exhibition

**Verde por Fuera, Rojo por Dentro
(Green on the Outside, Red on the Inside) 1993**
Installation view and detail:
Serralves Foundation, Porto, Portugal, 1995
Courtesy Meyer Vaisman

KARA WALKER
born Stockton, California, 1969

Education

1994 M.F.A., Rhode Island School of Design
1991 B.A., Atlanta College of Art

Solo Exhibitions to 1990

1997 San Francisco Museum of Modern Art, San Francisco
 Renaissance Society, Chicago
1996 *From the Bowels to the Bosom*, Wooster Gardens, New York
 Bernard Toale Gallery, Boston
1995 *In Dixie's Land*, Center for Curatorial Studies, Bard College,
 Annandale-on-Hudson, New York
 The High and Soft Laughter of the Nigger Wenches at Night,
 Wooster Gardens, New York

Selected Group Exhibitions

1996 *New Histories*, Institute of Contemporary Art, Boston*
 Conceal/Reveal, Site Santa Fe, Santa Fe, New Mexico
 No Doubt, Aldrich Museum, Ridgefield, Connecticut*
 Body Language, Mills Gallery, Boston
1995 *La Belle et la Bête*, Musée d'art Moderne de la Ville de Paris, Paris*
 Now Is the Time, Tony Shafrazi Gallery, New York
 Landscapes, Borders, Boundaries, Nexus Contemporay Arts Center,
 Atlanta
 Paul Morris Gallery, New York
 Drawing Show, Bernard Toale Gallery, Boston
1994 *Selections 1994*, The Drawing Center, New York
 Summer Group Show +2, Steinbaum/Krauss Gallery, New York
 An Historical Romance, Sol Koffler Gallery, Providence, Rhode Island
1993 *1993 Invitational New Talent Exhibition*, MU Gallery, Boston
 Rough Trade, Sol Koffler Gallery, Providence, Rhode Island
1992 *Angry Love*, Pavillion Exhibit, Arts Festival of Atlanta
 National Black Arts Festival/Emerging Artists, Arts Exchange,
 Atlanta
 Into the Light, 1992 Nexus Biennale, Nexus Contemporary
 Arts Center, Atlanta
 Black Women Artists, YMI Cultural Center, Asheville, North Carolina
1991 *Black Men: Image/Reality*, New Visions Gallery, Atlanta
 The Naked People Show, 800 East, Atlanta
 Swan Song, Gallery 100, Atlanta
 The Earth Factory Show, Hasting Seeds Building, Atlanta
 Rated RX: Pathological Conditions, New Visions Gallery, Atlanta
 One/Another, North Arts Center, Atlanta

Selected Bibliography

1996 Aberro, Alexander. "Kara Walker." *Index* (January).
 Doran, Anne. "Kara Walker, From the Bowel to the Bosom."
 Time Out (March 13).
 Levin, Kim. "Art Short List—Kara Walker." *Village Voice*
 (March 13–19).
 Pederson, Victoria. "Gallery Go 'Round." *Paper Guide* (April 4).
 "Wooster Garden." *New York Daily News* (April 28).
 Camhi, Leslie. "Cutting Up." *Village Voice* (April 9).
 Haye, Christian. "Strange Fruit." *Frieze 30* (September/October).
 Vincent, Stephen. "Portrait of the Artist: Kara Walker."
 Art & Auction (December).
 Doran, Anne. "Kara Walker: A Dissection from the Bowels to the
 Bosom." *Grand Street 58*.
 Golden, Thelma. "Oral Mores: A Postbellum Shadow Play."
 Art Forum (September).
1995 Aberro, Alexander. "Kara Walker." *PCN* (August).
 "Seven Up, Critical Edge." *Art & Auction*.
 Locke, Donald. "A Room with a View, A Stroll Through Nexus'
 Art Garden." *Creative Loafing 24* (June 3).
 Smith, Roberta. "Kara Walker." *The New York Times* (May 5).

 * Exhibition catalogue available.

Studio still of Arletty in
Les Perles de la coursonne, by Voinquel, 1937
Greeting card courtesy Kara Walker

LENDERS TO THE EXHIBITION
Alexander and Bonin Gallery, New York
Zarina Bhimji
Nick Deocampo
Willie Doherty
Barbara Gladstone Gallery, New York
Kay Hassan
Kcho
Matt's Gallery, London
Penny and David McCall, New York
Ron and Ann Pizzuti, Cleveland
Gary Simmons
Meyer Vaisman
Kara Walker

Library of Congress Cataloging-in-Publication Data

no place (like home): Zarina Bhimji, Nick Deocampo.
Willie Doherty, Kay Hassan, Kcho, Gary Simmons, Meyer
Vaisman, Kara Walker. -- 1st ed.
p. cm.
Catalog of an exhibition held at the Walker Art
Center, Mar. 9-June 8, 1997.
Includes bibliographical references.
Contents: no place (like home) / Richard Flood --
Interviews -- Volatile Memories / Douglas Fogle --
Place of Movement / Deepali Dewan.
ISBN 0-935640-55-X (alk. paper)
1. Art, Modern--20th century--Exhibitions. 2.
Installations (Art)--Exhibitions. I. Flood, Richard,
1943- . II. Fogle, Douglas, 1964- . III. Dewan,
Deepali. IV. Walker Art Center.
N6487.M56W356 1997
709'.0407--dc21
 97-664
 CIP